From Snapshots to Great Shots

Jeff Carlson

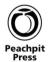

Canon PowerShot G12: From Snapshots to Great Shots Jeff Carlson

Peachpit Press 1249 Eighth Street Berkeley, CA 94710 510/524-2178 510/524-2221 (fax)

Find us on the Web at www.peachpit.com
To report errors, please send a note to errata@peachpit.com
Peachpit Press is a division of Pearson Education

Copyright © 2011 by Peachpit Press
All photography © as credited in the caption of each image

Associate Editor: Valerie Witte Production Editor: Rebecca Winter

Copyeditor: Liz Welch Composition: Jeff Carlson Indexer: Joy Dean Lee Cover Image: Jeff Carlson Cover Design: Aren Straiger

Interior Design: Riezebos Holzbaur Design Group

Notice of Rights

All rights reserved. No part of this book may be reproduced or transmitted in any form by any means, electronic, mechanical, photocopying, recording, or otherwise, without the prior written permission of the publisher. For information on getting permission for reprints and excerpts, contact permissions@peachpit.com.

Notice of Liability

The information in this book is distributed on an "As Is" basis, without warranty. While every precaution has been taken in the preparation of the book, neither the author nor Peachpit shall have any liability to any person or entity with respect to any loss or damage caused or alleged to be caused directly or indirectly by the instructions contained in this book or by the computer software and hardware products described in it.

Trademarks

All Canon products are trademarks or registered trademarks of Canon Inc.

Many of the designations used by manufacturers and sellers to distinguish their products are claimed as trademarks. Where those designations appear in this book, and Peachpit was aware of a trademark claim, the designations appear as requested by the owner of the trademark. All other product names and services identified throughout this book are used in editorial fashion only and for the benefit of such companies with no intention of infringement of the trademark. No such use, or the use of any trade name, is intended to convey endorsement or other affiliation with this book.

ISBN-13: 978-0-321-77161-2 ISBN-10: 0-321-77161-3

987654321

Printed and bound in the United States of America

DEDICATION

For Kimberly, Toby, and Laurence, who encouraged my passion for photography.

ACKNOWLEDGMENTS

I'm a pretty self-contained author. I write and package my books, which generally means I hand Peachpit a completed manuscript that they can take to the printer. I'm never alone, of course—editors, copyeditors, proofers, indexers, and others contribute to the finished product.

I'm saying this not to boast, but to help you understand that there's no way I could have been a self-contained author on this book. Without the incredibly hard work of the people listed here, I'd be standing in a field somewhere hoping for golden late-afternoon sunlight and making lists of all the photos yet to be shot. My sincere thanks go out to:

Valerie Witte, for being an excellent editor and also making the process of contacting photographers and requesting permissions as smooth as possible.

Rebecca Winter, for her eagle eyes looking at the layout and making the production process a breeze.

Liz Welch, for catching the silly errors I make over and over again, and making me seem more competent than I usually feel.

Joy Dean Lee, for doing the index under a lot of time pressure.

Jeff Revell, for starting the *From Snapshots to Great Shots* series and providing the foundation on which to build this book.

Laurence Chen, for his invaluable assistance back when I first started to take photography seriously.

Glenn Fleishman, for early lunches, afternoon coffees, and reality checks as deadlines began looming.

Kim Ricketts and Jenny Gialenes, for sharing our little office space in Seattle.

Katie Lacey, for becoming an impromptu model when I needed to capture a few final photos.

Everyone who contributed to the Flickr groups, for trusting your outstanding images to our little experiment.

Ellie Carlson, for charming me in ways I can't describe.

Kimberly Carlson, for laughter and patience and support and love.

Contents

INTRODUCTION	viii
The G12 Great Shots Community	Χ
CHAPTER 1: THE POWERSHOT G12 TOP TEN LIST	1
Ten Tips to Make Your Shooting More Productive Right Out of the Box	1
Poring Over the Camera	2
Poring Over the Camera	4
1. Charge Your Battery	5
2. Keep a Backup Memory Card	6
3. Set Your JPEG Image Quality	6
4. Avoid Using the Auto ISO Setting	8
5. Set Your Focus	9
6. Set the Correct White Balance	11
7. Adjust the Viewfinder Diopter	13
8. Know How to Override Auto Focus	13
9. Review Your Shots	14
10. Hold Your Camera for Proper Shooting	18
Chapter 1 Assignments	19
CHAPTER 2: FIRST THINGS FIRST	21
A Few Things to Know and Do Before You Begin Taking Pictures	21
Poring Over the Picture	22
Choosing the Right Memory Card	24
Formatting Your Memory Card	24
Using the Right Format: RAW vs. JPEG	26
The Lens and Focal Lengths	28
What Is Exposure?	34
Motion and Depth of Field	37
Chapter 2 Assignments	41
CHAPTER 3: THE AUTOMATIC MODES	43
Get Shooting with the Automatic Camera Modes	43
Poring Over the Picture	44
Auto Mode	46

Scene Modes	47
Low Light Mode	54
Quick Shot Mode	55
Why You Will Rarely Want to Use the Automatic Modes	57
Chapter 3 Assignments	58
CHAPTER 4: THE CREATIVE MODES	61
Taking Your Photography to the Next Level	61
Poring Over the Picture	62
P: Program Mode	64
Tv: Shutter Priority Mode	66
Av: Aperture Priority Mode	71
M: Manual Mode	75
How I Shoot: A Closer Look at the Camera Settings I Use	78
Chapter 4 Assignments	79
CHAPTER 5: MOVING TARGET	81
Shooting Action, Stopping Motion, and More	81
Poring Over the Picture	82
Stop Right There!	84
Using Shutter Priority (Tv) Mode to Stop Motion	86
Using Aperture Priority (Av) Mode to Isolate Your Subject	88
Manual Focus for Anticipated Action	90
Keep Them in Focus with Servo AF	91
Keeping Up with Continuous Drive Mode	92
A Sense of Motion	93
Tips for Shooting Action	96
Chapter 5 Assignments	98
CHAPTER 6: SAY CHEESE!	101
Settings and Features to Make Great Portraits	101
Poring Over the Picture	102
Automatic Portrait Mode	104
Using Aperture Priority Mode	104
Metering Modes for Portraits	106
Using the AE Lock Feature	108
Focusing: The Eyes Have It	108
Detect Faces	111

Use Fill Flash for Reducing Shadows	113
Tips for Shooting Better Portraits	114
Chapter 6 Assignments	123
CHAPTER 7: LANDSCAPE PHOTOGRAPHY	125
Tips, Tools, and Techniques to Get the Most	
Out of Your Landscape Photography	125
Poring Over the Picture	126
Sharp and In Focus: Using Tripods	128
Selecting the Proper ISO	130
Selecting a White Balance	132
Taming Bright Skies with Exposure Compensation	133
The Golden Light	135
Where to Focus	137
Easier Focusing	139
Making Water Fluid	139
Directing the Viewer: A Word about Composition	141
Advanced Techniques to Explore	145
Chapter 7 Assignments	153
CHAPTER 8: MOOD LIGHTING	155
Shooting When the Lights Get Low	155
Shooting When the Lights Get Low	155
Shooting When the Lights Get Low Poring Over the Picture	155 156
Shooting When the Lights Get Low Poring Over the Picture Raising the ISO: The Simple Solution	155 156 158
Shooting When the Lights Get Low Poring Over the Picture Raising the ISO: The Simple Solution Stabilizing the Situation	155 156 158 158
Shooting When the Lights Get Low Poring Over the Picture Raising the ISO: The Simple Solution Stabilizing the Situation Focusing in Low Light	155 156 158 158 161
Shooting When the Lights Get Low Poring Over the Picture Raising the ISO: The Simple Solution Stabilizing the Situation Focusing in Low Light Shooting Long Exposures	155 156 158 158 161 163
Shooting When the Lights Get Low Poring Over the Picture Raising the ISO: The Simple Solution Stabilizing the Situation Focusing in Low Light Shooting Long Exposures Using the Built-In Flash	155 156 158 158 161 163 164
Shooting When the Lights Get Low Poring Over the Picture Raising the ISO: The Simple Solution Stabilizing the Situation Focusing in Low Light Shooting Long Exposures Using the Built-In Flash Compensating for the Flash Exposure	155 156 158 158 161 163 164
Shooting When the Lights Get Low Poring Over the Picture Raising the ISO: The Simple Solution Stabilizing the Situation Focusing in Low Light Shooting Long Exposures Using the Built-In Flash Compensating for the Flash Exposure Reducing Red-Eye	155 156 158 158 161 163 164 167
Shooting When the Lights Get Low Poring Over the Picture Raising the ISO: The Simple Solution Stabilizing the Situation Focusing in Low Light Shooting Long Exposures Using the Built-In Flash Compensating for the Flash Exposure Reducing Red-Eye Slow Synchro	155 156 158 158 161 163 164 167 168
Shooting When the Lights Get Low Poring Over the Picture Raising the ISO: The Simple Solution Stabilizing the Situation Focusing in Low Light Shooting Long Exposures Using the Built-In Flash Compensating for the Flash Exposure Reducing Red-Eye Slow Synchro Flash and Glass	155 156 158 158 161 163 164 167 168 170
Shooting When the Lights Get Low Poring Over the Picture Raising the ISO: The Simple Solution Stabilizing the Situation Focusing in Low Light Shooting Long Exposures Using the Built-In Flash Compensating for the Flash Exposure Reducing Red-Eye Slow Synchro Flash and Glass 2nd Curtain Sync	155 156 158 158 161 163 164 167 168 170 170
Shooting When the Lights Get Low Poring Over the Picture Raising the ISO: The Simple Solution Stabilizing the Situation Focusing in Low Light Shooting Long Exposures Using the Built-In Flash Compensating for the Flash Exposure Reducing Red-Eye Slow Synchro Flash and Glass 2nd Curtain Sync Chapter 8 Assignments	155 156 158 158 161 163 164 167 168 170 170 171
Shooting When the Lights Get Low Poring Over the Picture Raising the ISO: The Simple Solution Stabilizing the Situation Focusing in Low Light Shooting Long Exposures Using the Built-In Flash Compensating for the Flash Exposure Reducing Red-Eye Slow Synchro Flash and Glass 2nd Curtain Sync Chapter 8 Assignments CHAPTER 9: CREATIVE COMPOSITIONS	155 156 158 158 161 163 164 167 168 170 170 171 172

Angles	181
Point of View	181
Patterns	182
Color	182
Contrast	184
Leading Lines	186
Splitting the Frame	186
Frames within Frames	188
Chapter 9 Assignments	189
CHAPTER 10: ADVANCED TECHNIQUES	191
Impress Your Family and Friends	191
Poring Over the Picture	192
Spot Meter for More Exposure Control	194
Avoiding Lens Flare	196
Bracketing Exposures	198
Macro Photography	201
Shadow Correction and Dynamic Range (DR) Correction	202
Shooting with an External Flash	204
The My Menu Setting	210
Chapter 10 Assignments	211
CHAPTER 11: SHOOTING VIDEO	213
Because Everything in Front of the Lens is Moving	213
Shooting Video	214
Locking Focus	216
Locking the Exposure Level	216
Video Shooting Tips	217
Watching Your Videos	218
Chapter 11 Assignments	219
INDEX	220

Introduction

Although compact digital cameras have improved over the years, they still suffer from relatively slow shot-to-shot speeds and small imaging sensors (which often can't produce the quality of a photo shot with a DSLR). Those limitations have frustrated people who want to go the extra steps necessary to get great shots, but who don't want to spend hundreds or thousands of dollars on professional cameras. The Canon PowerShot G12 jumps into that middle area between compacts and DSLRs. Shoot everything in fully automatic mode if you want, and when you're ready to move up to more complexity, advanced features are all there. I've put together a short Q&A to help you get a better understanding of just what you can expect from this book.

Q: IS EVERY CAMERA FEATURE GOING TO BE COVERED?

A: Nope, just the ones I felt you need to know about in order to start taking great photos. The owner's manual is a great resource that covers every feature of your camera. Writing a book that just repeats this information would have been a waste of my time and your money. What I did want to write about was how to harness certain camera features to the benefit of your photography.

Q: SO IF I ALREADY OWN THE MANUAL, WHY DO I NEED THIS BOOK?

A: The manual does a pretty good job of telling you how to use a feature or turn it on in the menus, but it doesn't necessarily tell you *why* and *when* you should use it. If you really want to improve your photography, you need to know the whys and whens to put all those great camera features to use at the right time. The manual is a great resource on the camera's features, so I treat it like a companion to this book.

Q: WHAT CAN I EXPECT TO LEARN FROM THIS BOOK?

A: Hopefully, you will learn how to take great photographs. My goal, and the reason the book is laid out the way it is, is to guide you through the basics of photography as they relate to different situations and scenarios. By using the features of your camera and this book, you will learn about aperture, shutter speed, ISO, depth of field, and many other photographic concepts. You will also find plenty of large full-page photos that include captions, shooting data, and callouts so you can see how all of the photography fundamentals come together to make great images. All the while, you will be learning how your camera works and how to apply its functions and features to your photography.

Q: WHAT ARE THE ASSIGNMENTS ALL ABOUT?

A: At the end of most of the chapters, you will find shooting assignments, where I give you some suggestions as to how you can apply the lessons of the chapter to help reinforce everything you just learned.

Q: SHOULD I READ THE BOOK STRAIGHT THROUGH OR CAN I SKIP AROUND FROM CHAPTER TO CHAPTER?

A: I recommend reading the first four chapters to get the building blocks you need to know about your camera. After that, move around the book as you see fit because those chapters are written to stand on their own as guides to specific types of photography or shooting situations. Or, you can read it straight through. The choice is up to you.

Q: IS THAT IT?

A: One last thought before you dive into the first chapter. Take some time to learn the basics and then put them to use. Photography, like most things, takes time to master and requires practice. It's not the camera but the person using it who makes beautiful photographs. Have fun, make mistakes, and then learn from them. In no time, I'm sure you will transition from a person who takes snapshots to a photographer who makes great shots.

THE G12 GREAT SHOTS COMMUNITY

When I wrote the original edition of this book, which covered the G10 and G11, it was clear that I couldn't possibly populate the book entirely with my own images and still hit a tight deadline (and I couldn't convince Peachpit to fly me in luxury around the world to shoot photos). So we embarked on an experiment. We set up a group on the photo sharing site Flickr (www.flickr.com) where owners of the cameras could add their images to the pool as submissions for possible inclusion in the book. For the G12 we did the same, and solicited images from both groups. We've since changed the focus of the groups from searching for publishable candidates to anyone who has purchased, or is interested in, this book.

http://www.flickr.com/groups/canon_g10g11_from_snapshots_to_greatshots/ http://www.flickr.com/groups/canon_g12_from_snapshots_to_greatshots/

I'm humbled by the interest and awed by the quality of the photos. All the images that appear in these pages were shot either by me or by the Flickr group members listed here. When you find a picture you like, I encourage you to note the photo credit at the end of each figure caption and return to these pages for the Flickr Web address where you can see more of the photographer's work.

You can view a Flickr Gallery that contains all of the book's photos at the following URL:

http://www.flickr.com/photos/g12greatshots/galleries/72157625507585789/

I also want to point out that although we required each photographer to grant us permission to use the work, the copyright remains with the original owner. We're thrilled that so many people contributed a large amount of quality work.

Thomas Baake

www.flickr.com/photos/poyas52/

Jeff Carlson

www.flickr.com/photos/jeffcarlson/

Charlwood Photography

www.flickr.com/photos/charliecharlwood/

Lynette Coates

www.flickr.com/photos/42959385@N08/

Crystal Photo Memories (Robert Keiser)

www.flickr.com/photos/bobusn/

Nick Damiano

www.flickr.com/photos/nickdamiano/

Bob Eddings

www.flickr.com/photos/associatedpixels/

Dean Ducas

www.flickr.com/photos/deanspic/

Scott Edwards

www.flickr.com/photos/smeracing/

Michael Gerpe

www.flickr.com/photos/mgerpe/

Patrick Gervais

www.flickr.com/photos/patrickgervais/

Anthony Goto

www.flickr.com/photos/anthony_goto/

Paul Hunter

www.flickr.com/photos/13896810@N04/

Dave Jenson Photography

www.flickr.com/photos/speednutdave/

Jake Jessey

www.flickr.com/photos/jakej/

ivlphoto.com

www.flickr.com/photos/jvlphoto/

Thespina Kyriakides

www.flickr.com/photos/40625411@N02/

Rich Legg

www.flickr.com/photos/richlegg/

John Wayne Lucia III

www.flickr.com/photos/studioseiko/

Jeff Lynch

www.flickr.com/photos/jefflynchphoto/

Jan Messersmith

www.flickr.com/photos/boogieswithfish/

Manolo Millan

www.flickr.com/photos/subexpuesto/

Ryan Paul (www.phenotyp.com)

www.flickr.com/photos/phenotyp/

Paul Perton

www.flickr.com/photos/paulperton/

Oscar Sainz

www.flickr.com/photos/o-royksopp/

Evan Spellman/Earth Light Photography

www.flickr.com/photos/evanspellman/

Morag Stark

www.flickr.com/photos/32349577@N00/

Chris Thomas

www.flickr.com/photos/expatwelsh/

Hiroyuki Uchiyama (a.k.a. innermt)

www.flickr.com/photos/innermt/

Anneliese Voigt

www.flickr.com/photos/lizzies_photos/

Caroline Ward

www.flickr.com/photos/cfward/

James Williams

www.flickr.com/photos/focal-plane/

Deak Wooten

www.flickr.com/photos/dcwooten/

Nicole S. Young

www.flickr.com/photos/nicolesy/

Wan-Ting Zhao

www.flickr.com/photos/wan ting92/

The PowerShot G12 Top Ten List

TEN TIPS TO MAKE YOUR SHOOTING MORE PRODUCTIVE RIGHT OUT OF THE BOX

With your new Canon PowerShot G12 in your hands, you're probably anxious to jump right in and start cranking off exposures. What you really should be doing, though, is sitting down with the instruction manual to learn how to use all of the camera's features...but what fun is that?

Of course, this behavior usually leads to frustration in the end—there are always issues that would have been easily addressed if you had known about them before you started shooting. Maybe if you had a Top Ten list of things to know, you could be more productive without having to spend countless hours with the manual. So this is where we begin.

The following list will get you up and running without suffering many of the "gotchas" that come from not being at least somewhat familiar with your new camera. Here are the top ten things you should know before you start taking pictures with your Canon G12.

PORING OVER THE CAMERA

CAMERA FRONT

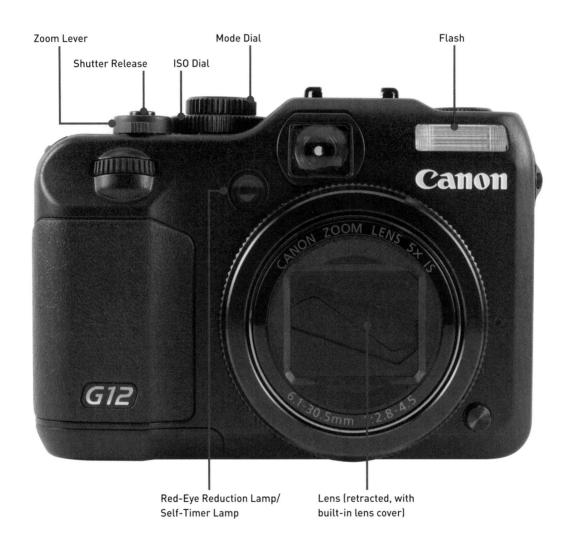

CAMERA BACK

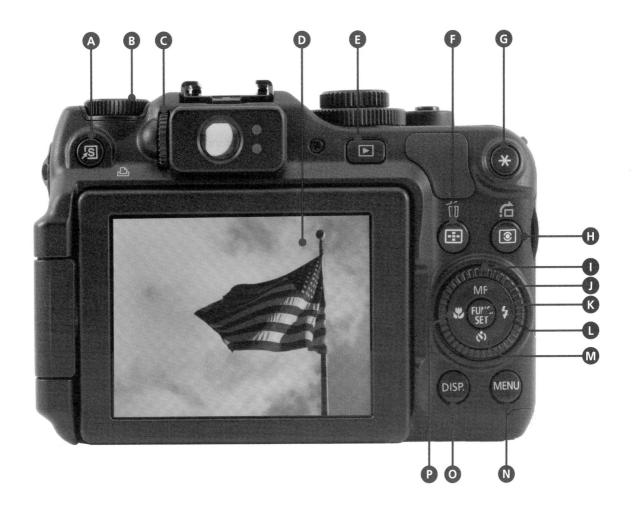

- A Shortcut
- B Exposure Compensation Dial
- C Diopter Adjustment Dial
- D LCD
- E Image Review
- F AF Frame Selector

- G ★ AE/AF Lock
- H Metering Light
- Control Dial
- J Manual Focus/Up
- K Function/Set

- L Flash Control/Right
- M Self-Timer/Down
- N Menu
- 0 Display
- P Macro/Left

PORING OVER THE CAMERA

CAMERA TOP

1. CHARGE YOUR BATTERY

This will be one of the hardest things for you to do because you really want to start shooting, but a little patience will pay off later.

When you first open your camera and slide the battery into the battery slot, you will be pleased to find that there is probably juice in the battery and you can start shooting right away. What you should really be doing is getting out the battery charger and giving that power-cell a full charge. Not only will this give you more time to shoot once you start, it will start the battery off on the right foot. No matter what claims the manufacturers make about battery life and charging memory, you'll likely get better life and performance from your batteries when you charge them fully and then use them right down to the point where they have nothing left to give. To check your battery level, insert it into the camera, turn on the camera, and look for the battery indicator at the top left of the LCD (Figure 1.1).

FIGURE 1.1
The LCD shows how much charge is left on your battery.

KEEPING A BACKUP BATTERY

A second battery is a great accessory that you should consider purchasing. Nothing stinks more than being out in the field and having your camera die. Keeping a fully charged battery in your bag will always give you the confidence that you can keep on shooting without fail. Not only is this a great strategy to extend your shooting time, but it also helps to lengthen the life of your batteries by alternating between them. No matter what the manufacturers say, batteries do have a life and using them half as much will only lengthen their usefulness.

While you're at it, consider buying a second battery charger, too. A quick search online pulls up third-party chargers that cost much less than the official Canon model.

2. KEEP A BACKUP MEMORY CARD

True story: I grabbed my camera, went to the beach, and just when my daughter was doing something especially cute, I discovered I had left the camera's memory card in the card reader attached to my computer.

If you turn your camera on without a memory card installed, you'll see a "No memory card" message at the top of the LCD. Furthermore, if you press the shutter button to take a picture, you'll get another message ("Cannot record!") on the LCD in combination with an audible signal—six chirps—to get your attention.

Cards are relatively inexpensive, so consider not only picking up one or two spares, but also storing them in a convenient place: a wallet, a purse, or a car's glove compartment. I'll discuss memory cards and proper formatting in more depth in Chapter 2.

3. SET YOUR JPEG IMAGE QUALITY

Your G12 has a number of image quality settings to choose from, and depending on your needs, you can adjust them accordingly. Most people shoot with the JPEG option because it allows them to capture a large number of photos on their memory cards. The problem is that unless you understand what JPEG is, you might be degrading the quality of your images without realizing it.

The JPEG format has been around since about 1994 and stands for Joint Photographic Experts Group. JPEG was developed by this group as a method of shrinking the size of digital images down to a smaller size for the purpose of reducing large file sizes while retaining the original image information. (Technically, JPEG isn't even a file format—it's a mathematical equation for reducing image file sizes—but to keep things simple, I'll just refer to it as a file format.) The problem with JPEG is that, in order to reduce a file size, it has to throw away some of the information, a technique referred to as "lossy compression." This is important to understand because, while you can fit more images on your memory card by choosing a lower-quality JPEG setting, you will also be reducing the quality of your image. This quality reduction becomes more apparent as you enlarge your pictures.

The JPEG file format also has one other characteristic: To apply the compression to the image before final storage on your memory card, the camera has to apply all the image processing first. Image processing involves such factors as sharpening, color adjustment, contrast adjustment, noise reduction, and so on. Many photographers

now prefer to use the RAW file format to get greater control over their image processing. (In fact, shooting RAW is one of the main appeals of the G12.) I'll take a closer look at this in Chapter 2, but for now let's just make sure you are using the best-quality JPEG possible.

The G12 has eight quality settings for the JPEG format: two settings each for the Large (L), Medium 1 (M1), Medium 2 (M2), and Small (S) settings. The two settings—Fine and Normal—represent more or less image compression based on your choice. I recommend working with the highest-quality setting possible. After all, the goal is to make big, beautiful photographs, so why cripple the process from the start with lower-quality images?

SETTING THE IMAGE QUALITY

- Press the Function/Set (FUNC./SET) button at the center of the Control dial to bring up the Function menu along the left side of the LCD.
- 2. Use the Down button to navigate to the Image Type setting. If it already reads JPEG in the menu, skip to Step 4.
- 3. Use the Right button to select the JPEG image type.
- 4. Next, use the Down button to navigate to the Quality setting at the bottom of the menu.
- 5. Use the Right button to select the Large (L) setting (A).
- To set the compression amount, press the Display (DISP.) button to bring up the Compression setting options.
- 7. Select the Fine setting (B), then press the Function/Set button.

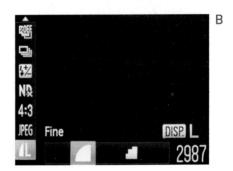

As you will see when scrolling through these settings—by looking at the number at the bottom right on the LCD—the higher the quality, the fewer pictures you will be able to fit on your card. Always try to choose quality over quantity. Your pictures will be the better for it.

The G12 includes one more setting related to image quality: Aspect Ratio, which defines the shape of the frame. Five aspect ratios are available (C). For example, if you plan to shoot HD video with the G12 and want still photos to match the same frame size, choose the 16:9 setting.

That said, I recommend sticking with the default 4:3 aspect ratio, which takes advantage of the full surface of the G12's image sensor. You can always crop to a different size on your computer. Shooting in something like the 1:1 aspect ratio, which is a square, omits areas to the left and right of the frame—you never know, the most interesting part of a shot could happen at the edges, and you'd miss it!

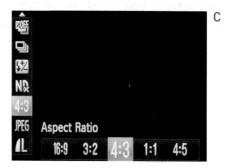

4. AVOID USING THE AUTO ISO SETTING

The ISO setting in your camera allows you to choose the level of sensitivity of the camera sensor to light. The ability to change this sensitivity is one of the biggest advantages to using a digital camera. In the days of film cameras, you had to choose the ISO by film type. This meant that if you wanted to shoot in lower light, you had to replace the film in the camera with one that had a higher ISO. So not only did you have to carry different types of film, but you also had to remove one roll from the camera to replace it with another, even if you hadn't used up the current roll. Now all you have to do is adjust the ISO dial on the top of the camera to select the appropriate ISO.

Having this flexibility is a powerful option, but just as with the Quality setting, the ISO setting has a direct bearing on the quality of the final image. The higher the ISO, the more digital noise the image will contain. Since the goal is to produce high-quality photographs, it is important to get control over all the camera controls and bend them to your will. If you have the ISO set to Auto, this means the camera determines how much light is available and chooses what it believes is the correct ISO setting. Since you want to use the lowest ISO possible, you should always manually select the appropriate ISO.

Which ISO you choose depends on your level of available or ambient light. For sunny days or very bright scenes, use a low ISO such as 80, 100, or 200. As the level of light is reduced, raise the ISO level. Cloudy days or indoor scenes might require you to use ISO 400. Low-light scenes, such as when you are shooting at night, will mean you need to bump that ISO to 1600 or 3200. The thing to remember is to shoot with the lowest setting possible for maximum quality.

NOISE

Noise is the enemy of digital photography, but it has nothing to do with the loudness of your camera operation. It is a term that refers to the electronic artifacts that appear as speckles in your image. They generally appear in darker shadow areas and are a result of the camera trying to amplify the signal to produce visible information. The more the image needs to be amplified—for example, by raising the sensitivity through higher ISOs—the greater the amount of noise there will be.

5. SET YOUR FOCUS

Canon's focus modes will give you a ton of flexibility in your shooting. There is, however, one small problem that is inherent with any focusing system. No matter how intelligent it is, the camera is looking at all the subjects in the scene and determining which is closest to the camera. It then uses this information to determine where the proper focus point should be. It has no way of knowing what your main emphasis is, so it is using a "best guess" system. To eliminate this factor, you should set the camera so that you can ensure that you are focusing on the most important feature in the scene.

The G12 has three AF (autofocus) Frame modes that determine *where* the camera is focusing. For now, you should use the FlexiZone mode, which gives you the most control over where the camera focuses. Once you have become more familiar with the focus system, you can experiment with the other modes.

Additionally, there's a separate Continuous AF setting, in which the camera continually scans the scene and focuses on objects until the shutter is pressed halfway, which locks the focus. This option can help you get the shot, but it can also deplete your battery quickly. When Continuous AF is turned off, the camera will focus only when the shutter is pressed halfway.

SETTING THE FOCUS MODE

- 1. To set the AF frame mode to FlexiZone, press the Menu button and, in the Shooting menu (the one with the camera icon), navigate up to the AF Frame setting, and use the Right button to select FlexiZone (A). Press the Menu button (or press the shutter button halfway) to return to shooting mode.
- 2. To turn off the Continuous AF setting, press the Menu button and, in the same menu, navigate down to the Continuous AF setting. Use the Right button to select Off (B).

The FlexiZone AF Frame mode is designed to let you specify which area of the scene you want to keep in focus. When you're shooting, press the AF Frame Selector but-

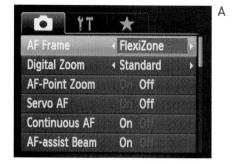

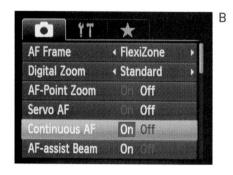

ton (just above and to the left of the Control dial), then use the Left, Right, Up, and Down buttons to move the frame over the area where you want the camera to focus (**Figure 1.2**). (You can also rotate the Control dial to quickly move the frame.) Press the Display button to switch to a smaller frame to specify a tighter focus area; press it again to return to the larger frame.

FIGURE 1.2
Use the directional buttons to move the AF Frame and choose where to focus.

Press the shutter halfway to focus—you will hear a chirp when the camera has locked in and focused on the subject—then press it fully to take the picture. To move the frame back to the center point, press and hold the AF Frame Selector button.

You can also leave the frame in the center, focus on your subject, and then recompose your shot. Place the focus point in the viewfinder on your subject, press the shutter release button halfway until the camera chirps and, without letting up on the shutter button, recompose your shot and then press the shutter button all the way down to make your exposure.

6. SET THE CORRECT WHITE BALANCE

White balance correction is the process of rendering accurate colors in your final image. Most people don't even notice that light has different color characteristics, because the human eye automatically adjusts to different color temperatures—so quickly, in fact, that everything looks correct in a matter of milliseconds.

When color film ruled the world, photographers would select which film to use depending on what their light source was going to be. The most common film was balanced for daylight, but you could also buy film that was color balanced for tungsten light sources. Most other lighting situations had to be handled by using color filters over the lens. This process was necessary so that the photographer's final image would show the correct color balance of a scene.

Your camera has the ability to perform this same process automatically, but you can also choose to override it and set it manually. Luckily, you don't need to have a deep understanding of color temperatures to control your camera's white balance. The choices are pretty simple:

- Auto: The default setting for your camera. It is also the setting used by all of the Scene modes (see Chapter 3).
- Day Light: Most often used for general daylight/sunlit shooting.
- Cloudy: The choice for overcast or very cloudy days. This will eliminate the blue color cast from your images.
- Tungsten: Used for any occasion where you are using regular household-type bulbs for your light source. Tungsten is a very warm light source and will result in a yellow/orange cast if you don't correct for it.
- **Fluorescent:** Used to get rid of the green-blue cast that can result from using regular fluorescent lights as your dominant light source.
- Fluorescent H: Used for fluorescent lights that are balanced for daylight.
- Flash: Used whenever you're using the built-in flash or using a flash on the hot shoe. You should select this white balance to adjust for the slightly cooler light that comes from using a flash. (The hot shoe is the small bracket located on the

- top of your camera, which rests just above the eyepiece. This bracket is used for attaching a more powerful flash to the camera.)
- Underwater: This will reduce the blue color cast that comes from shooting underwater. (Note: A waterproof case for your G12 is sold separately.)
- Custom1 and Custom2: Indicates that you are using a customized white balance that is adjusted for a particular light source. To set the custom white balance, point the center box at something white and press the Display button. You can then select that Custom setting to shoot using that white balance value.

SETTING THE WHITE BALANCE

- 1. Select one of the Creative shooting modes, such as P (you can't select the white balance when using any of the Automatic modes).
- 2. Press the Function/Set button in the middle of the Control dial to bring up the Function menu. Navigate to the White Balance setting (at the top of the menu).
- 3. Use the Left and Right buttons or the Control dial to select the proper white balance for your shooting situation.
- 4. Press the Function/Set button to lock in your selection.
- 5. Check the LCD to ensure that the proper white balance is selected. You can see right on the display how changes to the setting affect the color in your image.

The G12 takes the white balance control a step further by letting you make a manual adjustment that applies to all the presets. If you prefer a cooler image or want to correct for a color cast, for example, you can adjust the white balance range to be more blue, no matter which setting you choose (including Auto).

ADJUSTING THE WHITE BALANCE

- 1. Choose any of the white balance presets using the steps outlined above.
- 2. Rotate the Front dial to adjust the white balance point toward B (blue) or A (amber).
- 3. For finer adjustment, press the Display button.
- 4. Rotate the Front dial to adjust between B and A, and rotate the Control dial to adjust between G (green) and M (magenta). You can also press the arrow buttons to position the white balance point in the adjustment field. To reset your changes, press the Menu button.
- **5.** Press the Display button to exit the screen.

7. ADJUST THE VIEWFINDER DIOPTER

If you use the viewfinder on your G12, everything may not appear in crisp focus. To remedy this, use the Diopter Adjustment Dial, located to the left of the viewfinder, to adjust for your vision (Figure 1.3). There is no "correct" setting for this adjustment so you will have to dial it in yourself. Simply look through the viewfinder (if you normally wear glasses, leave them on) and adjust the dial until everything looks sharp. It's a small thing, but it can make a big difference when you use the viewfinder.

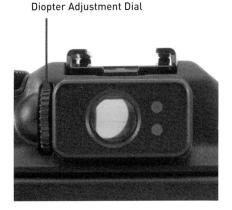

FIGURE 1.3
Adjust the focus of the viewfinder.

8. KNOW HOW TO OVERRIDE AUTO FOCUS

As good as the Canon autofocus system is, there are times when it just isn't doing the job for you. Often you'd like to compose a scene and specify where the actual point of focus should be. This can be especially true when you are using the camera on a tripod, where you can't pre-focus and then recompose before shooting (as discussed earlier). To take care of this problem, switch to manual focus by pressing the MF button (Figure 1.4).

A large "MF" appears in the center of the LCD, and a bar showing a distance display appears along the right side of the screen. Using the Control dial, adjust the focus as necessary—using the distance display as a rough guide—and take your picture.

I'll cover manual focus in more detail in later chapters.

FIGURE 1.4
Press the MF button to manually focus.

9. REVIEW YOUR SHOTS

One of the greatest features of a digital camera is its ability to give instant feedback. By reviewing your images on the camera's LCD screen, you can instantly tell whether you got your shot. This visual feedback allows you to make adjustments on the fly and make certain that all of your adjustments are correct before moving on.

When you first press the shutter release button, your camera quickly processes the shot and then displays the image on the LCD display. The default setting for that display is only two seconds. Personally, I don't find this to be nearly enough time to take in all the visual feedback that I might want. Instead of using this "quick glance" method, change your display time to the Hold setting. This will keep the image up on the display until you decide that you are ready to move on to your next shot. (Note that this option will drain your batteries a little faster than the default setting.)

CHANGING THE REVIEW TIME SETTING

- Press the Menu button and, in the Shooting menu, navigate to the Review setting.
- 2. Use the Right button to select the Hold option (or choose an increment, up to 10 seconds).
- 3. Press the Menu button again to return to the shooting mode.

When reviewing your images in Playback mode (by pressing the Playback button), four display modes give you different amounts of information. The default view displays only your image.

For more visual feedback, press the Display button to scroll through the other display options. Press it once to see the photo's Quality setting, the image number that you are currently viewing ("3/207" would mean that you're looking at the third image of 207 total images) and its file name, the time and date of the shot, and the camera's battery level (Figure 1.5).

Pressing the button a second time results in a huge amount of information being

FIGURE 1.5
The basic shot information.

displayed along with the image. You will now be able to see the following items in your display: shutter speed, aperture, exposure compensation, image name, image thumbnail, histogram, shooting mode, ISO, white balance setting, quality setting, size of the image in megabytes and pixels, image number, date, and time (Figure 1.6). This display also shows "blinkies," or areas that are blown out with pure white (see Chapter 4 for more information).

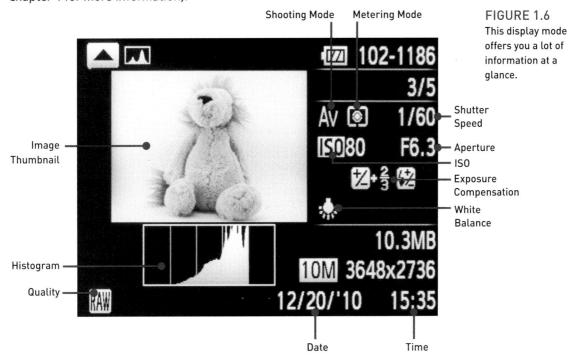

You probably won't want to use this display option as your default review mode, but if you are trying to figure out what settings you used or if you want to consult the histogram (see the sidebar "The Value of the Histogram," just ahead), you now have all this great information available.

The Focus Check display shows a magnified area of the image, allowing you to confirm that you've achieved sharp focus in your image (Figure 1.7).

Pressing the shutter release or Menu button results in closing the image display. To get your image back up on the LCD screen, simply press the Playback button on the back of the camera.

FIGURE 1.7
The fourth display option shows you the Focus Check display.

THE VALUE OF THE HISTOGRAM

Simply put, histograms are two-dimensional representations of your images in graph form. The G12 offers a *luminance* histogram when you're shooting (press the Display button to view it), which is valuable when evaluating your exposures. In **Figure 1.8**, you see what looks like a mountain range. The graph represents the entire tonal range that your camera can capture, from the whitest whites to the blackest blacks. The left side represents black, all the way to the right side, which represents white. The heights of the peaks represent the number of pixels that contain those luminance levels (a tall peak in the middle means your image contains a large amount of medium-bright pixels). Looking at this figure, it is hard to determine where all of the ranges of light and dark areas are and how much of each there are. Looking at the histogram, you can see that the largest peak of the graph is in the middle and trails off as it reaches the edges. In most cases, you would look for this type of histogram, indicating that you captured the entire range of tones, from dark to light, in your image. Knowing that is fine, but here is where the information really gets useful.

When you see a histogram that has a spike or peak riding up the far left or right side of the graph, it means that you are clipping detail from your image. In essence, you are trying to record values that are either too dark or too light for your sensor to accurately record. This is usually an indication of over- or underexposure. It also means you need to correct your exposure so that important details will not record as solid black or white pixels (which is what

happens when clipping occurs). There are times, however, when some clipping is acceptable. If you're photographing a scene where the sun will be in the frame, you can expect some clipping because the sun is just too bright to hold any detail. Likewise, if you are shooting something that has true blacks in it—think coal in a mineshaft at midnight—there are most certainly going to be some true blacks with no detail in your shot. The main goal is to ensure that you aren't clipping any "important" visual information, and that is achieved by keeping an eye on your histogram.

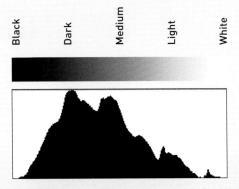

FIGURE 1.8
This is a typical histogram, where the dark to light tones run from left to right. The black-to-white gradient above the graph demonstrates where the tones lie on the graph and would not appear above your camera histogram display.

Take a look at **Figure 1.9**. The histogram displayed on the image shows a heavy skew toward the left with almost no part of the mountain touching the right side. This is a good example of what an underexposed image histogram looks like. Now look at **Figure 1.10** and compare the histogram for the image that was correctly exposed. Notice that even though there are distinct peaks on the graph, there is a more even distribution across the entire histogram.

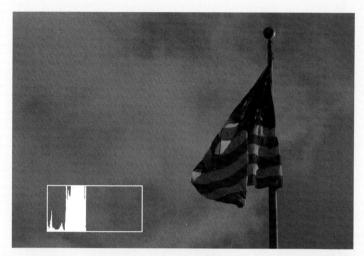

FIGURE 1.9
This image is about two stops under-exposed. Notice the histogram is skewed to the left.

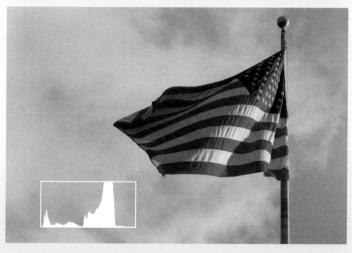

FIGURE 1.10
This histogram
reflects an image
with better exposure.

10. HOLD YOUR CAMERA FOR PROPER SHOOTING

You might think this is really dumb, but take a few seconds to read this over and make sure that you are giving yourself the best chance for great images. Many people hold their cameras in a fashion that is either unstable or just plain uncomfortable-looking. Learning the correct way to hold your camera now will result in better images later. The purpose of practicing correct shooting form is to provide the most stable platform possible for your camera (besides using a tripod, of course).

The basics of properly holding the camera begin with grasping the camera body with the right hand. You will quickly find that most of the important camera controls are within easy reach of your thumb and forefinger. Keeping the camera as close to you as possible will help stabilize it—and while you will usually use the LCD screen (as opposed to the viewfinder) to frame and focus your shots, there are still a couple of things you can do to reduce self-induced "camera shake": support the camera with your left hand, and draw your elbows as closely to your body as you can. This helps stabilize your shooting position.

DELETING IMAGES

Deleting or erasing images is a fairly simple process that is covered on page 28 of the manual. To quickly get you on your way, simply press the Playback button and spin the Control dial until you find the picture you want to delete. Then press the Image Erase button—the one that looks like a trashcan—just above and to the left of the Control dial. Select Erase, and then press the Set button (Figure 1.11).

Caution: Once you have deleted an image, it is gone for good. Make sure you don't want it before you drop it in the trash.

FIGURE 1.11
Some pictures you know are destined for the trash bin.

Chapter 1 Assignments

Begin your shooting assignments by setting up and using all of the elements of the Top Ten list. Even though we have yet to cover the Creative shooting modes, you should set your camera to the P (Program) mode on the Mode dial. This will allow you to interact with the various settings and menus that have been covered thus far.

Basic camera setup

Charge your battery to 100% to get it started on a life of dependable service. Next, using your newfound knowledge, set up your camera to address Image Quality.

Selecting the proper white balance

Take your camera outside during daylight and photograph the same scene using different white balance settings. Pay close attention to how each setting affects the overall color cast of your images. Next, move inside and repeat the exercise while shooting in a tungsten lighting environment. Finally, find a fluorescent light source and repeat one more time.

Focusing with FlexiZone

Set your AF frame mode to FlexiZone. Also, change your camera setting so that you are focusing by pressing the shutter halfway—turning Continuous AF off. Practice focusing on a subject and then recomposing before actually taking the picture, and also practice putting the focus frame over your subject and focusing. Try doing this with subjects at varying distances.

Evaluating your pictures with the LCD

Set up your image display properties and then review some of your previous assignment images using the different display modes. Review your shooting information for each image, and take a look at the histograms to see how the content of your photo affects the shape of the histograms.

Discovering the manual focus mode

Change your focus mode from auto to manual focus, and practice using the Control dial to lock the focus. Get familiar with how to use manual focus to achieve sharp images.

Get a grip: proper camera holding

This final assignment is something that you should practice every time you shoot: proper grip and stance for shooting with your camera. Use the described technique and then shoot a series of images. Try comparing it with improper techniques (camera raised above your head with one hand, standing on a wire and juggling chainsaws while shooting, and the like) to compare the stability of the grip and stance.

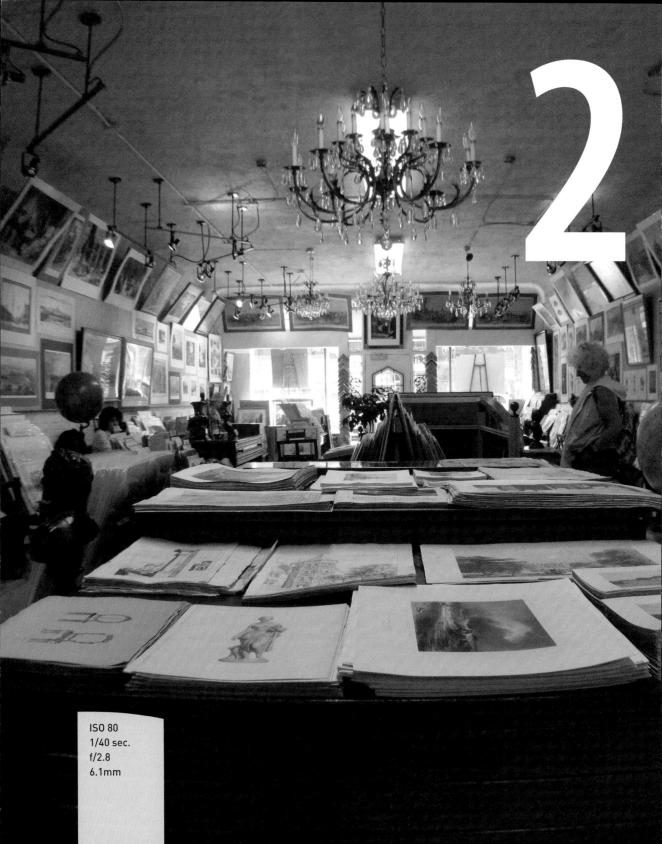

First Things First

A FEW THINGS TO KNOW AND DO BEFORE YOU BEGIN TAKING PICTURES

Now that I've covered the top ten tasks to get you up and shooting, it's time to take care of some other important details. You must become familiar with certain features of your camera before you can take full advantage of it. So to get things moving, let's start off with something that you will definitely need before you can take a single picture: a memory card.

PORING OVER THE PICTURE

Once you begin to think like a photographer, I guarantee you'll pay much more attention to light. I'm always drawn to contrasts such as those found in this photo from Thomas Baake: bright color against dark clouds, the way a sunbreak can invigorate anything.

The dark clouds add — contrast and brighten the already stunning colors of the building.

The overall exposure reduces glare from the bright sunlight, minimizing blown-out areas and keeping the cream walls from becoming white.

CHOOSING THE RIGHT MEMORY CARD

Memory cards are the digital film that stores all the shots you take until you move the image files to a computer. The cards come in different shapes and sizes, and they are critical for capturing all your photos. It is important not to skimp when it comes to selecting your memory cards. The G12 uses Secure Digital (SD) memory cards (Figure 2.1).

If you've been using a point-and-shoot camera, chances are you may already own a Secure Digital (SD) media card. Which brand of card you use is completely up to you, but here is some advice about choosing your memory card:

FIGURE 2.1

Make sure you select an SD card that has enough capacity to handle your photography needs.

- Size matters, at least in memory cards. At 10 megapixels, the camera requires a lot
 of storage space, especially if you shoot in the RAW or RAW + JPEG mode (more
 on this later in the chapter) or shoot video. You should definitely consider using a
 card with a storage capacity of at least 4 GB.
- Consider buying high-capacity SDHC or SDXC cards. These cards are generally
 much faster, both when writing images to the card as well as when transferring
 them to your computer. If you are planning on using the Continuous shooting
 mode (see Chapter 5) for capturing fast action, you can gain a boost in performance just by using an SDHC card with a Class rating of at least 4 or 6. The higher
 the class rating, the faster the write speed. Having a fast card also benefits your
 video capture by keeping the flow of video frames moving quickly to your card.
- Buy more than one card. If you have already purchased a memory card, consider
 getting another. Nothing is worse than almost filling your card and then having to
 either erase shots or choose a lower-quality image format so that you can keep on
 shooting. With the cost of memory cards what it is, keeping a spare (or two) just
 makes good sense.

FORMATTING YOUR MEMORY CARD

Now that you have your card, let's talk about formatting. When you purchase any new SD card, you can start shooting right away—and probably everything will work as it should. However, what you should do first is format the card in the camera. This process allows the camera to initialize the card so it records images to its specifications, just as a computer hard drive must be formatted. The card may work in the camera without being formatted, but chances of failure down the road are much higher.

As a general practice, I always format new cards, or cards that have been used in different cameras. I also reformat cards after I have downloaded my images and want to start a new shooting session. Note that you should always format your card in the camera, not your computer. Using the computer could render the card useless. You should also pay attention to the manufacturer's recommendations in respect to moisture, humidity, and proper handling procedures. It sounds cliché, but when it comes to protecting your images, every little bit helps.

Formatting the memory card is not equivalent to erasing all of its data, however. The truth is that when the camera formats the card, it's resetting the file management information. Your camera will simply write the new image data over the previous data. Think of it as removing the table of contents from a book and replacing it with a blank page. All of the contents are still there, but you wouldn't know it by looking at the empty table of contents. The camera will see the card as completely empty so you won't be losing any space, even if you have previously filled the card with images. Why explain all this detail? This technique makes it possible to recover photos, using third-party software, in the event you accidentally format a card.

FORMATTING YOUR MEMORY CARD

- 1. Insert your memory card into the camera if it's not already there.
- 2. Press the Menu button and navigate to the setup menu screen (the second tab from the left).
- 3. Press the Down button to highlight the Format option (A) and press Set.
- 4. The default selection for the Format screen is Cancel, just in case you didn't really want to format the card. Press the Right button to highlight OK (B).
- 5. Press the Set button to format the card.

Note that when you perform the card formatting, you can select Low Level Format, which performs a more intensive formatting of the card. The camera formats all of

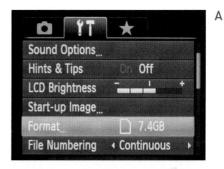

the recordable sectors on the card, a process that takes much longer than a normal formatting and does not need to be performed every time you format. You only

need to do this if you see a slowdown in card performance. To enable the Low Level Format option, follow the directions on the previous page, but highlight the Low Level Format option and press the Right button (which puts a checkmark next to the option) before starting the format process (Figure 2.2).

USING THE RIGHT FORMAT: RAW VS. JPEG

FIGURE 2.2 Choose Low Level Format to format all sectors of a memory card.

When shooting with your G12, you have a choice of two image formats that your camera will use to store the pictures on the memory card. JPEG is probably the format most familiar to anyone who has been using a digital camera.

As I mentioned in Chapter 1, JPEG is not actually an image format. It is a compression standard, and compression is where things go bad. When you have your camera set to JPEG—whether it is the large, medium, or small sizes—you are telling the camera to process the image and then throw away enough image data to make it shrink into a smaller space. In doing so, you give up subtle image details that you can never get back in post-processing. That is an awfully simplified statement, but still fairly accurate.

There is nothing wrong with JPEG if you are taking casual shots. JPEG files are ready to use, right out of the camera. Why go through the process of adjusting RAW images of the kids opening presents when you're just going to email them to Grandma? However, if you care about having complete creative control over all of your image data—as opposed to what a compression algorithm thinks is important—JPEG may entail too many compromises.

SO WHAT DOES RAW HAVE TO OFFER?

First and foremost, RAW images are not compressed. (Some cameras have a compressed RAW format, but it is *lossless* compression, which means there is no loss of actual image data.) Note that RAW image files require you to perform post-processing on your photographs. This is not only necessary; it's the reason most photographers use it.

RAW images have a greater dynamic range than JPEG-processed images. You can recover image detail in the highlights and shadows that just aren't available in JPEG-processed images.

There is also more color information in a RAW image, because it is a 14-bit image; that means it contains more color information than a JPEG, which is almost always an 8-bit image. More color information means more to work with and smoother changes between tones—kind of like the difference between performing surgery with a scalpel as opposed to a butcher's knife. They'll both get the job done, but one will do less damage.

Regarding sharpening, a RAW image offers more control because you are the one who is applying the sharpening according to the effect you want to achieve. Once again, JPEG processing applies a standard amount of sharpening that you cannot change after the fact. Once it is done, it's done.

Finally, and most importantly, a RAW file is your negative. No matter what you do to it, you won't change it unless you save your file in a different format. This means you can come back to that RAW file later and try different processing settings to achieve differing results and never harm the original image. By comparison, if you make a change to your JPEG and accidentally save the file, guess what? You have a new original file, and you will never get back to that first image. That alone should make you sit up and take notice.

IMAGE RESOLUTION

When discussing digital cameras, image resolution is often used to describe pixel resolution, or the number of pixels used to make an image. This can be displayed as a dimension such as 3648 x 2736. This is the physical number of pixels in width and height of the image sensor. Resolution can also be referred to in megapixels (MP) such as 10 MP. This number represents the number of total pixels on the sensor and is commonly used to describe the amount of image data that a digital camera can capture.

ADVICE FOR NEW RAW SHOOTERS

Don't give up on shooting RAW just because it means more work. Hey, if it takes up more space on your card, buy bigger cards or more smaller ones. Will it take more time to download? Yes, but good things come to those who wait. Don't worry about needing to purchase expensive software to work with your RAW files; you already own a program that will allow you to work with your RAW files. Canon's Digital Photo Professional software comes bundled in the box with your camera and gives you the ability to work directly on the RAW files and then output the enhanced results.

Now, after trying my best to convince you to shoot in RAW, my recommendation going forward is to shoot in JPEG mode while you are using this book. (Some shooting modes record only JPEG files, in fact; see Chapter 3.) This will allow you to quickly review your images and study the effects of future lessons. Once you're comfortable with all of the camera features, you should switch to shooting in RAW mode so that you can start gaining more creative control over your image processing. After all, you took the photograph—shouldn't you be the one to decide how it looks in the end?

SELECTING RAW + JPEG

Your camera has the added benefit of being able to write two files for each picture you take, one in RAW and one in JPEG. This can be useful if you need a quick version to email but want a higher-quality version for more advanced processing.

Note that using both formats requires more space on the memory card. I recommend you use only one format or the other unless you have a specific need to shoot both.

SETTING RAW + JPEG SHOOTING MODE

- 1. Press the Function/Set button.
- Press the Down button or use the Control dial to highlight the Image Type menu item (which probably appears as JPEG).
- 3. Press the Left or Right button to select the RAW + JPEG option.
- **4.** Press the Function/Set button to lock in your changes.

THE LENS AND FOCAL LENGTHS

The technology and engineering that goes into your camera is a marvel, but it isn't worth a darn if it can't get the light from outside onto the sensor. The G12 includes one built-in lens capable of a multitude of tasks, from focusing on a subject, to metering a scene, to delivering and focusing the light onto the camera sensor.

For most people, however, the first consideration of a lens is its *focal length*, more commonly referred to as *zoom*.

A wide angle lets you include a large scene in the frame (Figure 2.3). It can display a large depth of field, which allows you to keep the foreground and background in sharp focus, making it very useful for landscape photography. It also works well in tight spaces, such as indoors, where there isn't much elbow room available (Figure 2.4).

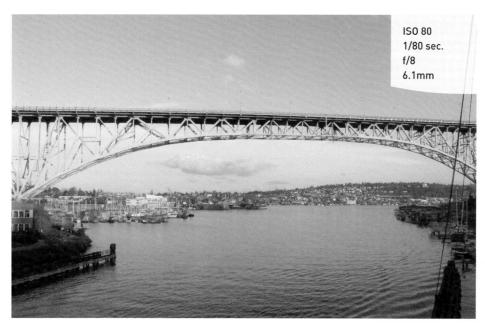

FIGURE 2.3
The 6.1mm zoom
setting provides
a wide view of the
scene but little
detail of distant
objects. [Photo:
Jeff Carlson]

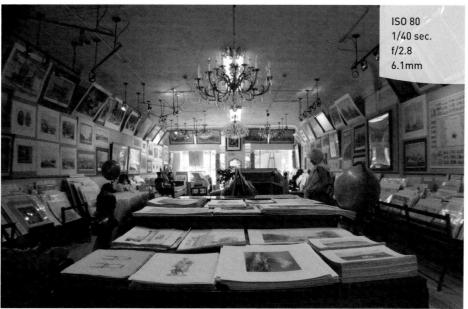

FIGURE 2.4
When shooting in tight spaces, such as indoors, a nice wide-angle lens helps capture more of the scene. The photographer also used a third-party wide-angle attachment to further increase the field of view. [Photo: Anneliese Voigt]

The lens in your camera is capable of shooting photos at 6.1mm at the *wide-angle* end, and up to 30.5mm when at its full *telephoto* (zoomed) end; Canon's marketing materials refer to the level of zoom, which is 5x.

35MM EQUIVALENT FOCAL LENGTHS

In digital photography, you'll often see focal lengths expressed as "35mm equivalent." The G12 shoots a 35mm equivalent range of 28mm to 140mm—but what does that mean? Without wading into the field of optics, here's a simplified explanation. Traditionally, a photo exposed on film using a 35mm lens delivered a "normal" image, which was close to what your eye perceives. The image sensors in most digital cameras are physically smaller than the frame of film exposed in old cameras, so the area of data recorded by a digital camera is smaller than the area of light that the lens is actually seeing. This narrower field of view creates the same effect as zooming in, which is sometimes referred as the $crop\ factor$. The crop factor for the G12 is roughly 4.6: the 6.1mm view is about what you'd see if you used a 28mm lens on a film camera (6.1 x 4.6 = 28.06).

The middle range of the zoom (Figure 2.5) is useful for photographing people and architecture, and for most other general photographic needs (Figure 2.6).

FIGURE 2.5
The middle of the zoom range gets you closer to your subject. Compare this to Figure 2.3, shot from the same location. [Photo: Jeff Carlson]

FIGURE 2.6
The middle range
of the zoom worked
well in this image.
[Photo: Lynette
Coates]

The upper part of the focal length range is referred to as *telephoto*. You can zoom in and get more detail on distant objects, but the angle of view is greatly reduced (Figure 2.7). A tight zoom dramatically focuses your attention, however (Figure 2.8).

You will also find that you can achieve a much narrower depth of field. However, you may also notice something called distance compression, which means objects at different distances appear to be much closer together than they really are.

One sacrifice that is made when shooting telephoto is in aperture. When zoomed all the way in, the lens is capable of a minimum aperture of f/4.5 (compared to f/2.8 at the wide angle), which is the middle of the camera's possible aperture range. That means it cannot work in lower light levels without the assistance of image stabilization, a tripod, or higher ISO settings. (We'll discuss all this in more detail in later chapters.)

USING THE ZOOM CONTROL

- 1. With the camera on in any of the shooting modes, press the Zoom lever to the right (clockwise) to zoom in (telephoto). Press the lever to the left (counterclockwise) to zoom out.
- 2. Use the lever to fine-tune the amount of zoom you want.

FIGURE 2.7 30.5mm is the 612's highest optical zoom. This shot was taken from the same vantage point as Figure 2.3. [Photo: Jeff Carlson]

FIGURE 2.8
The camera's
maximum telephoto highlights
the vibrant colors
of the Chin Swee
Temple against
the dark and
cloudy sky. [Photo:
Thomas Baake]

DIGITAL ZOOM

The G12 is capable of a 20x zoom, or an impressive 560mm! However, there's a catch: any focal length above 140mm on these cameras is accomplished by using *digital zoom*. The camera's processor makes a sophisticated guess about how to enlarge the scene to appear zoomed-in. To accommodate for the lack of optical information, the processor interpolates the difference by filling in pixels.

In the past, my gut reaction would have been: "Turn it off now!" After all, I presume your aim in purchasing a G12 is to create great shots, not ones that are fuzzy due to interpolation. But, at the risk of having my photographic license revoked, I have to say that the digitally zoomed images on these cameras are...not bad. I wouldn't rely on the feature all the time, but if the choice is to get the shot with digital zoom or not get a shot at all, then the result can be acceptable (Figure 2.9).

FIGURE 2.9
Digital zoom lets
you get even closer
to the subject, but
at the expense of
some sharpness.
The detail at right
is reproduced at
100% its original
size. [Photo:
Jeff Carlson]

ENABLING DIGITAL ZOOM

- 1. Press the Menu button and make sure you're viewing the shooting menu.
- 2. Press the Down button or rotate the Control dial to highlight the Digital Zoom option. (Note that the option is inaccessible if you're shooting in RAW or at an aspect ratio other than 3:4.)
- **3.** Press the Left or Right button to choose one of the following three options:
 - **Standard:** This option enables digital zoom to get telephoto shots that are closer than the optical zoom.
 - 1.4x: Instead of switching from optical to digital zoom, the camera applies a "digital tele-converter" to the entire zoom range. The image is magnified 1.4 times normal, and "1.4x" appears onscreen.

- 2.3x: The image is magnified 2.3 times normal using the digital tele-converter and "2.3x" appears onscreen.
- 4. Press the Menu button to apply the change.

The camera also incorporates what Canon calls Safety Zoom: If you're shooting at a smaller JPEG image size, the amount of image deterioration due to interpolation isn't noticeable. For example, you can get a clean image at 11x zoom when shooting at the M2 size (1600 x 1200 pixels). The zoom indicator or digital tele-converter number changes from white to blue to indicate that you'll see image deterioration; within the Safety Zoom range, the number becomes yellow.

Since I still prefer optical zoom over digital zoom, here are the steps to turn off the feature. In most cases, zoom with your feet instead: get physically closer to the subject.

TURNING OFF DIGITAL ZOOM

- 1. Press the Menu button and make sure you're viewing the shooting menu.
- 2. Press the Down button or rotate the Control dial to highlight the Digital Zoom option.
- 3. Press the Right or Left button until Off is visible.
- 4. Press the Menu button to accept the setting.

WHAT IS EXPOSURE?

In order for you to get the most out of this book, I need to briefly discuss the principles of exposure. Without this basic knowledge, it will be difficult for you to move forward in improving your photography. Granted, I could write an entire book on exposure and the photographic process—and many people have—but for our purposes I'll just cover some of the basics. This will give you the essential tools to make educated decisions in determining how best to photograph a subject.

Exposure is the process whereby the light reflecting off a subject passes through an opening in the camera lens for a defined period of time onto the camera sensor. The combination of the lens opening, shutter speed, and sensor sensitivity is used to achieve a proper exposure value (EV) for the scene. The EV is the sum of these components necessary to properly expose a scene.

The relationship between these factors is sometimes referred to as the "Exposure Triangle," the corners of which are made up of the following:

- **ISO:** Determines the sensitivity of the camera sensor. ISO stands for the International Organization for Standardization, but the acronym is used as a term to describe the sensitivity of the camera sensor to light. The higher the sensitivity, the less light is required for a good exposure. These values are a carryover from the days of traditional color and black and white films.
- **Aperture:** Also referred to as the f-stop, this determines how much light passes through the lens at once.
- Shutter Speed: Controls the length of time that light is allowed to hit the sensor.

Here's how it works. The camera sensor has a level of sensitivity that is determined by the ISO setting. To get a proper exposure—not too much, not too little—the lens needs to adjust the aperture diaphragm (the size of the lens opening) to control the volume of light entering the camera. Then the shutter is opened for a relatively short period of time to allow the light to hit the sensor long enough for it to record on the sensor.

ISO numbers for the G12 start at 80 and then double in sensitivity as you double the number; so, 200 is twice as sensitive as 100. The camera can be set to use 1/2- or 1/3-stop increments, but for ISO just remember that the base numbers double: 100, 200, 400, 800, and so on. There is also a wide variety of shutter speeds that you can use. The speeds on the camera range from as long as 15 seconds to as short as 1/4000 of a second. Typically, you will be working with a shutter speed range from around 1/30 of a second to about 1/2000, but these numbers will change depending on your circumstances and the effect that you are trying to achieve.

When it comes to exposure, a change to any one of these factors requires changing one or more of the other two. This is referred to as a reciprocal change. If you let more light in the lens by choosing a larger aperture opening, you will need to shorten the amount of time the shutter is open. If the shutter is allowed to stay open for a longer period of time, the aperture needs to be smaller to restrict the amount of light coming in.

HOW IS EXPOSURE CALCULATED?

We now know about the exposure triangle—ISO, shutter speeds, and aperture—so it's time to put all three together to see how they relate to one another and how you can change them as needed.

STOP

You will hear the term *stop* thrown around all the time in photography. It relates back to the f-stop, which is a term used to describe the aperture opening of your lens. When you need to give some additional exposure, you might say that you are going to "add a stop." This doesn't just equate to the aperture; it could also be used to describe the shutter speed or even the ISO. So when your image is too light or dark or you have too much movement in your subject, you will probably be changing things by a "stop" or two.

When you point your camera at a scene, the light reflecting off your subject enters the lens and is allowed to pass through to the sensor for a period of time as dictated by the shutter speed. The amount and duration of the light needed for a proper exposure depends on how much light is being reflected and how sensitive the sensor is. To figure this out, your camera utilizes a built-in light meter that looks through the lens and measures the amount of light. That level is then calculated against the sensitivity of the ISO setting to come up with an exposure value. Here is the tricky part: There is no single way to achieve a perfect exposure, because the f-stop and shutter speed can be combined in different ways to allow the same amount of exposure. See, I told you it was tricky.

Here is a list of reciprocal settings that would all produce the same exposure result. Let's use a traditional "sunny 16" rule, which states that, when using f/16 on a sunny day, you can use a shutter speed that is roughly equal to the ISO setting to achieve a proper exposure. For simplification purposes, we will use an ISO of 100. (I've included f-stops higher than f/8 to demonstrate the point, even though the G12 is capable of only f/8.)

RECIPROCAL EXPOSURES: ISO 100

F-STOP	2.8	4	5.6	8	11	16	22
SHUTTER SPEED	1/4000	1/2000	1/1000	1/500	1/250	1/125	1/60

If you were to use any one of these combinations, they would each have the same result in terms of the exposure (i.e., how much light hits the camera's sensor). Also take note that every time we cut the f-stop in half, we reciprocated by doubling our shutter speed. (If you're wondering why f/8 is half of f/5.6, it's because those numbers are actually fractions based on the opening of the lens in relation to its focal

length. That's an evasive way of saying that a lot of math goes into figuring out just what the total area of a lens opening is, so you just have to take it on faith that f/8 is half of f/5.6.) A good way to remember which opening is larger is to think of your camera lens as a pipe that controls the flow of water. If you had one pipe that was 1/2" in diameter (f/2) and one that was 1/8" (f/8), which would allow more water to flow through? It would be the 1/2" pipe. The same idea works here with the camera f-stops; f/2.8 is a larger opening than f/4 or f/8 or f/16.

Now that we know this, we can start using this information to make intelligent choices in terms of shutter speed and f-stop. Let's bring in the third element by changing our ISO by one stop, from 100 to 200.

RECIPROCAL EXPOSURES: ISO 200

F-STOP	2.8	4	5.6	8	11	16	22
SHUTTER SPEED	_	1/4000	1/2000	1/1000	1/500	1/250	1/125

Notice that, since we doubled the sensitivity of the sensor, we now require half as much exposure as before. We have also reduced our maximum aperture from f/2.8 to f/4 because the camera can't use a shutter speed that is faster than 1/4000 of a second.

So why not just use the exposure setting of f/8 at 1/1000 of a second? Why bother with all of these reciprocal values when this one setting will give us a properly exposed image? The answer is that the f-stop and shutter speed also control two other important aspects of our image: motion and depth of field.

MOTION AND DEPTH OF FIELD

Distinct characteristics are related to changes in aperture and shutter speed. Shutter speed controls the length of time the light strikes the sensor; consequently, it also controls the blurriness (or lack of blurriness) of the image. The less time light hits the sensor, the less time your subjects have to move around and become blurry. This can let you impose some control, like freezing the motion of a fast-moving subject (Figure 2.10) or blurring subjects to give the feel of energy and motion (Figure 2.11).

The aperture controls the amount of light that comes through the lens, but it also determines what areas of the image will be in focus. This is referred to as depth of field, and it is an extremely valuable creative tool.

FIGURE 2.10 A fast shutter speed and high ISO froze the action mid-swing. [Photo: Jeff Carlson]

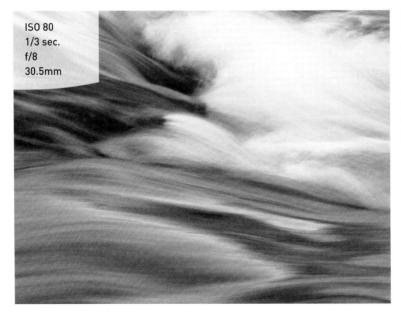

FIGURE 2.11
The slower
shutter speed,
combined with the
camera's neutral
density filter, shows
the flow of water
across the rocks.
[Photo: Jeff Lynch]

The smaller the opening (the larger the number, such as f/8), the greater the sharpness of objects from near to far (**Figure 2.12**). A large opening (or small number, like f/2.8) means more blurring of objects at distances other than your subject (**Figure 2.13**).

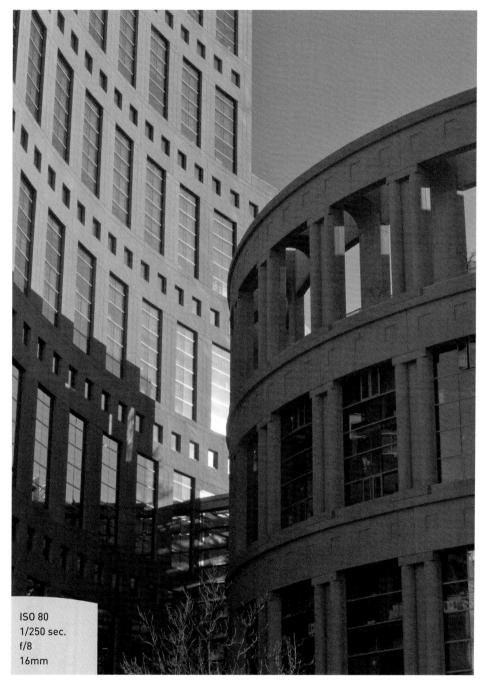

FIGURE 2.12
By using a small aperture, the area of sharp focus extends from a point that is near the camera all the way out to distant objects. [Photo: Jeff Carlson]

FIGURE 2.13 Isolating a subject is accomplished by using a large aperture, which produces a narrow area of sharp focus. [Photo: Jeff Carlson]

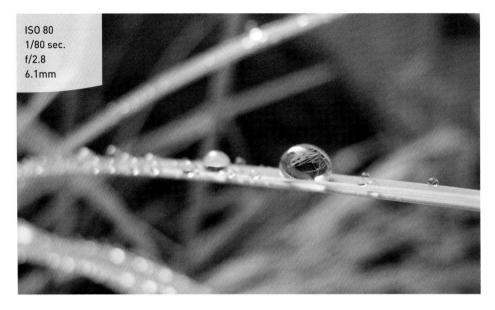

As we further explore the features of the camera, you will learn not only how to utilize the elements of exposure to capture properly exposed photographs, but also how you can make adjustments to emphasize your subject. It is the manipulation of these elements—motion and focus—that will take your images to the next level.

LIMITED APERTURE RANGE

If you're accustomed to using a DSLR, you may be scoffing at the f/8 aperture limit of the G12. In that realm, f/8 falls in the middle of the scale (peek at the tables a few pages back to get an idea). However, the G12 doesn't have the luxury of swapping lenses like a DSLR. To keep the camera compact and use a single built-in lens, a broader aperture range was sacrificed. That said, the camera does a good job of maintaining sharpness from near to far using f-stops as low as f/4 or f/5.6—settings that represent the wide-open end for many DSLR lenses.

Chapter 2 Assignments

Formatting your card

Even if you have already begun using your camera, make sure you are familiar with formatting the SD card. If you haven't done so already, follow the directions given earlier in the chapter and format as described (make sure you save any images that you may have already taken). Then perform the format function every time you have downloaded or saved your images or use a new card.

Exploring your image formats

I want you to become familiar with all of the camera features before using the RAW format, but take a little time to explore the format menu so you can see what options are available.

Exploring the lens

Spend a little time shooting with all of the different focal lengths, from the widest to the longest. See just how much of an angle you can cover with the widest setting. How much magnification will you be able to get from the telephoto setting? Try shooting the same subject with a variety of focal lengths to note the differences in how the subject looks, and also the relationship between the subject and the other elements in the photo.

5

ISO 400 1/640 sec. f/8 30.5mm

The Automatic Modes

GET SHOOTING WITH THE AUTOMATIC CAMERA MODES

Although quite advanced compared to other cameras, the G12 is still a point-and-shoot camera at heart. Canon created several modes tailored to common types of photos, such as portraits, landscapes, low-light situations, and moving subjects. The cameras also include specialized modes to shoot fireworks, snow scenes, and even underwater and aquarium photos. The idea is that even if you don't know (or don't care) about settings such as shutter speed, aperture, or white balance, you can let the camera use its smarts to take care of the technical details while you enjoy taking the shot.

Most of the Automatic modes are accessed via the SCN (also known as the Special Scene Mode, or just Scene mode) setting on the Mode dial. The G12 also includes two extra modes: Low Light and Quick Shot. Let's take a look at the different modes and how and when to use them.

Photo: Jeff Carlson 43

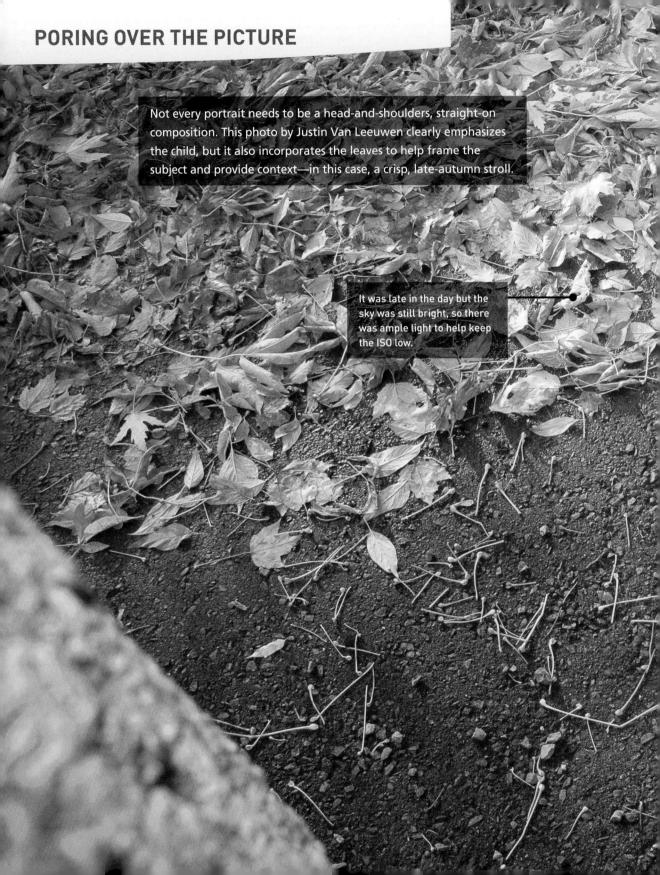

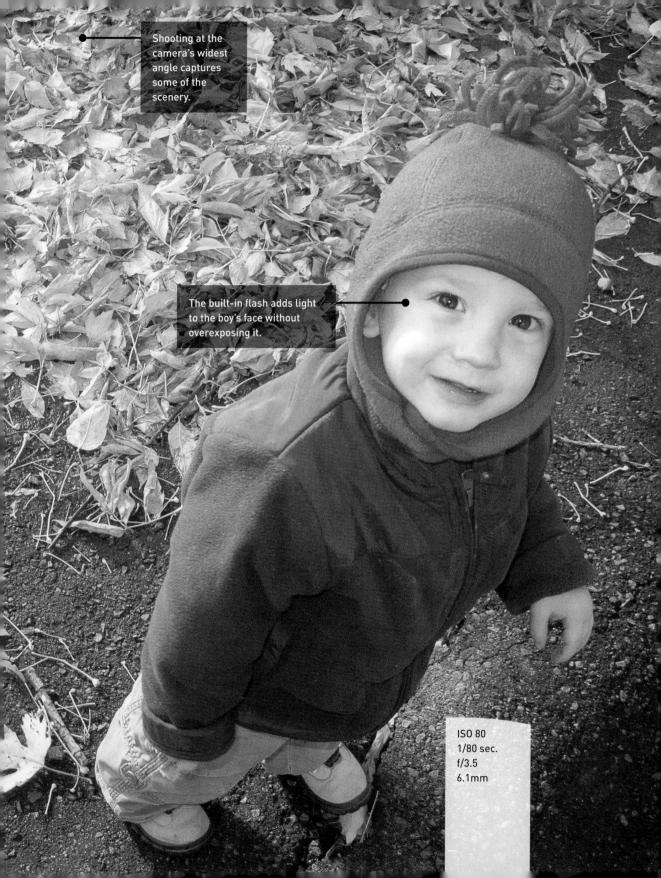

AUTO MODE

Auto mode is all about (mostly) thought-free photography. There is little to nothing for you to do in this mode except point and shoot. Your biggest concern when using Auto mode is focusing. The camera utilizes the

automatic focusing modes to achieve the best possible focus for your picture. Press the shutter button down halfway while looking at the LCD, and you will see the autofocus frame light up over the subject. Now just press the shutter button the rest of the way to take the photo. It's just that easy (**Figure 3.1**). The camera takes care of all your exposure decisions, including when to use flash. (In fact, most other functions are disabled.)

The G12 offers a bit more information about how it's going to handle a shot when using the Auto mode. An icon appears at the upper-right corner of the screen indicating the type of scene it has detected.

Let's face it: This is the lazy person's mode. But sometimes it's nice to be lazy and click away without giving thought to anything but preserving a memory. There are times, though, when you will want to start using your camera's advanced features to improve your shots.

FIGURE 3.1
Auto works great
when you just
want to snap some
shots and don't
want to think
too much. This
picture was taken
during a stroll
near my office in
Seattle. [Photo:
Jeff Carlson]

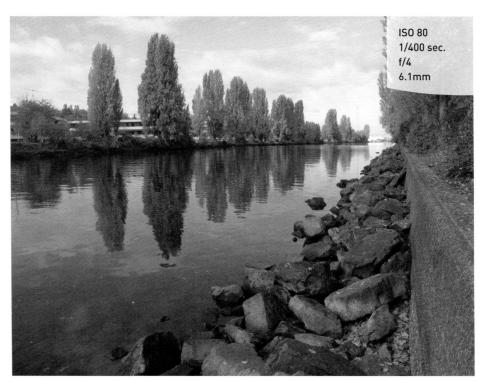

AUTO TRACKING MODE

The Auto mode has a feature you may have missed while skimming the user manual. When you press the Metering Light button (above and to the right of the Control dial), the G12's Tracking mode is enabled. Move the camera so the selection rectangle is over an object you want to keep in focus and press the shutter button halfway—a blue rectangle tracks with that object, even when you move the camera or the object moves. Press the shutter button fully to take the shot.

SCENE MODES

One problem with Auto mode is that it has no idea what type of subject you are photographing and therefore attempts to make a best-guess reading of each situation. Many Scene modes are optimized for many of the shooting scenarios you're likely to encounter, and some apply in-camera effects that would be difficult or time-consuming to replicate on a computer later.

Even if you're planning to shoot most often using the camera's advanced modes (see Chapter 4), the Scene modes can be a helpful training tool. Shoot a few shots using the Sports preset, for example, and note the shutter speed, aperture, and ISO settings that the camera chose. Then, fine-tune your own settings using the Scene values as a baseline.

USING THE SCENE MODES

- 1. Set the Mode dial to the SCN setting.
- 2. Press the Function/Set button. The Scene modes are selected at the top of the menu.
- 3. Rotate the Control dial until your chosen scene icon appears.
- 4. Press the Function/Set button to choose the scene.

PORTRAIT

Shooting portraits is a perfect example of a common scene (Figure 3.2). This mode emphasizes skin tones and makes them a little softer to improve the skin's look, avoiding the harsh, greenish cast that can occur under some types of lighting.

Portrait mode is a great choice for shots like this one. Positioning the subject to the side of the frame makes the shot stand out among portrait photos. [Photo: jvlphoto.com]

LANDSCAPE

As you might have guessed, the Landscape scene has been optimized for shooting landscape images. The camera does its best to boost the greens and blues in the image (Figure 3.3). This makes sense, since the typical landscape would be outdoors where grass, trees, and skies should look more colorful. This mode also increases the sharpness that is applied during processing and utilizes the lowest ISO settings possible in order to keep digital noise to a minimum.

KIDS & PETS

It's hard to get any more specific than this. Kids and pets have a habit of not always posing for the shot you want...or the shot you think you might get...if only they'd...just...stop...moving...for a moment. The Kids & Pets mode uses a fast shutter speed, wide aperture, and high ISO to freeze the action of these moving targets.

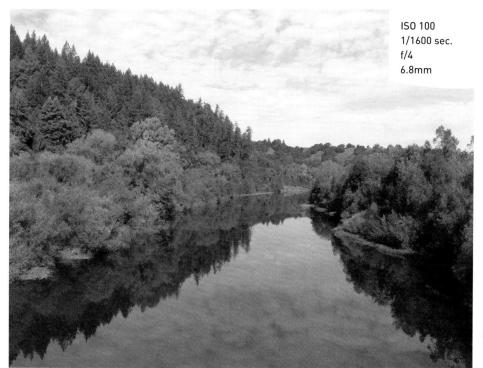

FIGURE 3.3
This type of scene
just calls out for the
Landscape mode.
The vegetation and
sky were given
more saturation,
and a medium
aperture was used
for greater depth
of field. [Photo:
Deak Wooten]

SPORTS

While this is called the Sports scene, you can use it for any moving subject that you are photographing. The mode is built on the principles of sports photography: continuous focusing and fast shutter speeds (Figure 3.4). To handle these requirements, the camera sets the drive mode to Continuous AF shooting and the ISO to Auto. Overall, these are sound settings that will capture most moving subjects well. We will take an in-depth look at all these features, like Continuous drive mode, in Chapter 5.

You can, however, run the risk of too much digital noise in your picture if the camera decides you need a very high ISO (such as 1600). Also, when using the Sports scene, you will need to frame your subject in the middle of the viewfinder so the center focus point is on them.

FIGURE 3.4 This is the type of shot that was made for Sports mode, where action-freezing shutter speeds and continuous focusing capture the moment. [Photo: Rick Lewis]

SMART SHUTTER

Most of the Scene modes are easy to figure out from their names, but what's so smart about Smart Shutter? It's designed for getting good shots of people, especially when you're shooting pictures of yourself in a group of people. Smart Shutter has three modes, accessible by pressing the Display button:

- Smile: When you look at the camera and smile, a shot is taken—you don't need to press the shutter release button at all.
- Wink Self-Timer: As you frame your subjects, the G12 detects one person's face. Press the shutter release button. The camera waits for that person to wink, then counts down a couple of seconds before taking the shot. (If it doesn't detect a wink, the shot fires after 15 seconds.) You may need to wink with both eyes to trigger the shutter.
- Face Self-Timer: Press the shutter release button and then look directly into the camera to start the self-timer countdown.

For each mode, you can set the camera to shoot up to 10 successive shots by pressing the up or down button.

SUPER VIVID, POSTER EFFECT, NOSTALGIC, AND FISH-EYE

These four Scene modes replicate looks that you can achieve using post-processing software such as Adobe Photoshop Elements, iPhoto, or other programs. The advantage to using them while shooting is that you don't need to spend time applying the effects later. The

disadvantage is that you're stuck with the effect for the shot. Personally, I'd prefer to do the processing later in software using a "normal" shot where I have more control.

COLOR ACCENT & COLOR SWAP

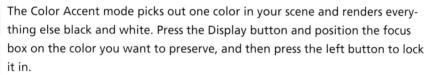

Color Swap works in a similar fashion, only in addition to setting a target color, you then point at a different color in your scene and press the Right button to set the replacement hue. Anything blue, for example, could appear red.

Again, however, I'd much rather do these adjustments in software later.

HDR

HDR, or High Dynamic Range, is a method of combining several shots at different exposures to bring out more detail than you could normally get

with just one shot. For example, you could use HDR to shoot a scene where a person in the foreground might otherwise be put into silhouette by a bright sky in the background. HDR used to be possible only in software, but now the HDR Scene mode does the work in-camera.

For best results, mount the G12 on a tripod or other stationary surface, then press the shutter release button. The camera takes three shots and then combines them into one HDR image. It's best to turn off the image stabilizer (IS) when using this mode; that sounds counterintuitive, but the camera could overcompensate and produce a blurry shot.

If you want more control over HDR images than what the Scene mode offers, see Chapter 7.

MINIATURE EFFECT

The Miniature Effect mode pulls off a neat trick: By selectively blurring areas of an image, the effect makes objects in the center look like miniature toys

(Figure 3.5). Another term for this effect is tilt-shift, which is accomplished on DSLRs using expensive lenses with selective focus controls.

With the mode enabled, press the Display button to adjust how the focus is centered. Press Set to change the highlight rectangle from horizontal to vertical (or vice versa). Then, use the zoom control to make the area larger or smaller.

FIGURE 3.5 The Miniature Effect mode uses a tilt-shift effect to concentrate focus on one area, which makes otherwise normal scenes appear as if they're miniatures. [Photo: Jeff Carlsonl

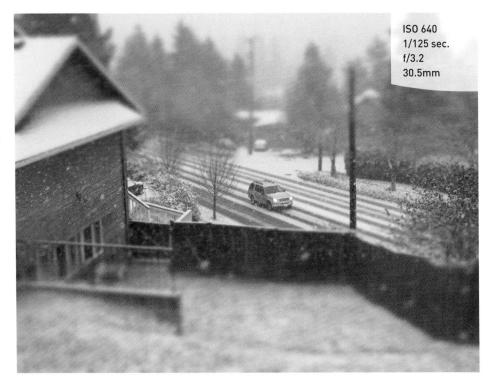

BEACH AND SNOW

Shooting at the beach or in the snow, while representing opposite extremes of temperature, share a trait that's problematic to digital cameras: The environments are often very bright from light reflecting off sand or snow, which can confuse a camera's light meter. These modes compensate for the brightness.

UNDERWATER

Fishy environments feature the opposite trait of the Beach and Snow modes. Often underlit and exhibiting blue-green color casts, underwater and aquarium shots can easily turn muddy. The Underwater mode reduces the blue-green coloring and enhance the other colors. (And for today's obvious public service announcement, Canon wants you to know that it's highly recommended that you put your G12 in a waterproof enclosure before submerging it.)

FOLIAGE

I never paid as much attention to trees and flowers as I do now that I carry a camera everywhere. The Foliage scene boosts colors to make them more vivid, a welcome enhancement in the autumn or spring especially (Figure 3.6).

FIGURE 3.6
The Foliage scene
brings out the color
in flowers, leaves,
and other natural
subjects. [Photo:
Jeff Carlson]

FIREWORKS

With only a few opportunities each year to take photos of fireworks (unless you live at a Disney theme park), it seems odd that Canon would include a scene dedicated to the nighttime explosions. However, fireworks are tricky to photograph well. The Fireworks scene features long exposures and a narrow aperture to emphasize the bright colors against a dark sky (Figure 3.7).

FIGURE 3.7 Fireworks can be notoriously tricky to capture. [Photo: John Wayne Lucia III]

LOW LIGHT MODE

You can't always count on having great light when you want to take a picture. Shooting indoors is difficult, and shooting indoors under very low light is even worse. The G12 includes a Low Light mode that aims

to improve scenes like this by using a wide aperture and a high ISO (Figure 3.8).

The feature comes with a price, however. The G12 may significantly increase the ISO—beyond 3200, even, the highest setting on the ISO dial—which can lead to more image noise than you may find acceptable. You do have some control over ISO, though: Press the Function/Set button, make sure the ISO setting at the top of the menu

is selected, and use the Control dial to choose an ISO level from 320 up to 12800. This mode also reduces the photo size to the M setting (1824 by 1368 pixels). See Chapter 8 for more techniques on how to pull detail out of dimly lit environments.

FIGURE 3.8
The Low Light
mode is designed
to capture dark
situations, especially when you
don't want to use
the flash, such as
during this music
performance.
[Photo: Crystal
Photo Memories]

QUICK SHOT MODE

When you want more control than what Auto mode offers but still want the camera to do most of the work, turn to the Quick Shot mode. It uses the LCD only for displaying settings, not a preview of what the camera sees, so more of the camera's processor resources can work on getting the shot (you'll need to use the viewfinder to frame the shot). The camera continually focuses on faces it detects or whatever object occupies the center of the frame. However, remember that doing so drains the battery faster.

You can specify a handful of settings: ISO, white balance, image format and quality (including RAW, which isn't available to the Auto and most Scene modes), aspect ratio, single or continuous shooting, shot timer, flash, and the amount of flash power used. Follow these steps to capture photos in the Quick Shot mode.

SHOOTING IN QUICK SHOT MODE

- 1. Rotate the Mode dial to the Quick Shot icon. The Quick Shot settings appear (A).
- 2. To change any of the settings, press the Function/Set button.
- 3. Use the navigation buttons or the Control dial to select a setting to change, then turn the Front dial to adjust the setting's value (B). Change the ISO and exposure compensation using the respective dials on the top of the camera.
- **4.** Look through the viewfinder to frame the shot.
- 5. Press the shutter button halfway to view the camera's chosen shutter speed and aperture, and then press the button all the way to capture the photo.

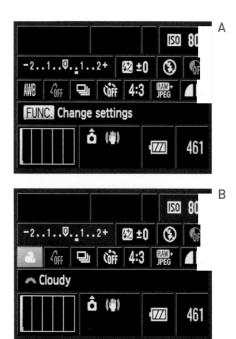

WHY YOU WILL RARELY WANT TO USE THE AUTOMATIC MODES

With so many easy-to-use camera modes, why would anyone ever want to use anything else? After all, a point-and-shoot camera is specifically designed to do most of the work for you, and there will be plenty of times when you don't want to ponder shutter speed, and you just want to capture a good, spur-of-the-moment photo.

However, the G12 isn't an ordinary point-and-shoot camera. It's specifically designed to offer more control over your shooting. Control is the number one reason for using a more advanced point-and-shoot camera. The ability to control every aspect of your photography opens up creative avenues that just aren't available using the Automatic modes. Let's look at what we are giving up.

- ISO: Most of the Automatic modes stick with the default Auto ISO setting, regardless of how you've configured the ISO speed dial. This will undoubtedly lead to unwanted digital noise in your images when the ISO begins to reach up into the higher settings.
- **Prefabricated effects:** When using the automatic Scene modes, most attributes for fine-tuning your images are not available; you need to accept what the camera offers or switch to a different shooting method.
- RAW format: Even if you plan to shoot in RAW, the automatic settings don't allow it. In fact, the Low Light mode even knocks the image resolution down to the M setting.
- White balance: Except for the Quick Shot mode, no choice is available for white balance. You are simply stuck with the Auto setting. This isn't necessarily a bad thing, but your camera doesn't always get it right. And when you use the Automatic modes, there is just no way to change it.
- Autofocus: Some of the modes, such as the Scene modes, automatically focus on
 what the camera deems worthy. There is no way to change these. And if you can't
 manually select a focus area, you must constantly recompose your image.

Another thing you will find when using any of the Automatic modes is that the options in the main camera menu have been reduced to just a few user-friendly choices. These aren't the only restrictions to using the Automatic modes, but they should be enough to make you want to explore the Creative side of the dial.

Chapter 3 Assignments

These assignments will have you shooting in the various Automatic modes so you can experience the advantages and disadvantages of using them in your daily photography.

Shooting in Auto mode

It's time to give up complete control and just concentrate on what you see in the viewfinder or the LCD preview. Set your camera to Auto and practice shooting in a variety of conditions, both indoors and outside. Take notice of the camera settings when you are reviewing your pictures.

Checking out Portrait mode

Grab your favorite photogenic person, switch to the Scene mode, and start shooting in the Portrait mode. Try switching between Auto and the Portrait mode while photographing the same person in the same setting. You should see a difference in the skin tones and overall softness of the image.

Capturing the scenery with the Landscape mode

Take your camera outside for some landscape work. First, find a nice scene and then, with your lens set to its widest zoom, take some pictures using the Landscape mode. Then, switch back to Auto so that you can compare the settings used for each image as well as the changes to colors and sharpness.

Stopping the action with the Sports mode

This assignment will require that you find a subject in motion. That could be the traffic in front of your home or your child at play (but not your child playing in traffic!). The only real requirement is that the subject be moving. This will be your opportunity to test out the Sports mode. There isn't a lot to worry about here. Just point and shoot. Try shooting a few frames one at a time and then go ahead and hold down the shutter button and shoot a burst of about five or six frames. It will help if your subject is in good available light to start with so that the camera won't be forced to use high ISOs.

Peer into the dark with Low Light mode

While you're outside, or inside with few lights on, switch to the Low Light mode and capture a few shots, then do the same in the Auto mode to see how differently the camera responds to each situation.

The Creative Modes

TAKING YOUR PHOTOGRAPHY TO THE NEXT LEVEL

Once upon a time, long before digital cameras and program modes, there was manual mode. In those days it wasn't called "manual mode" because there were no other modes. It was just photography. If a photographer didn't have a handle on the basics of aperture and shutter speed, she'd produce a lot of discarded film. Now, thanks to the powerful computer in your camera, many of the decisions about how to balance those two factors are computed in milliseconds—but only if you choose. The other side of the Mode dial contains the Creative shooting modes, which offer the greatest amount of control over your photography. You can let the camera figure out the values automatically but with input from you; set the aperture manually and let the camera figure out shutter speed, or vice versa; or go back to the old ways and dial in your settings manually. Whatever your choice, it's essential that you understand not only how to control these modes, but also why you are controlling them. So let's move that Mode dial to the first of our Creative modes: Program mode.

61

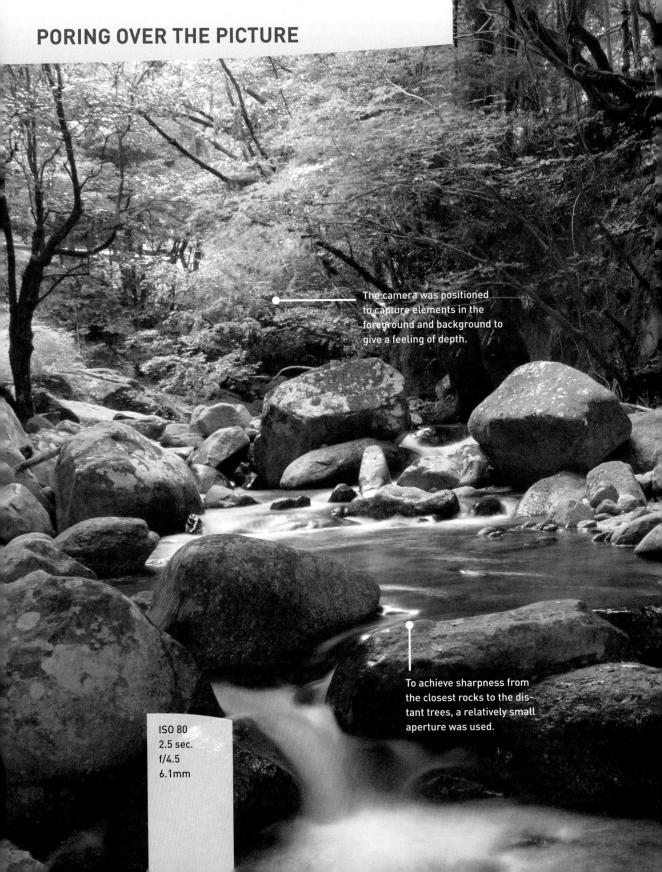

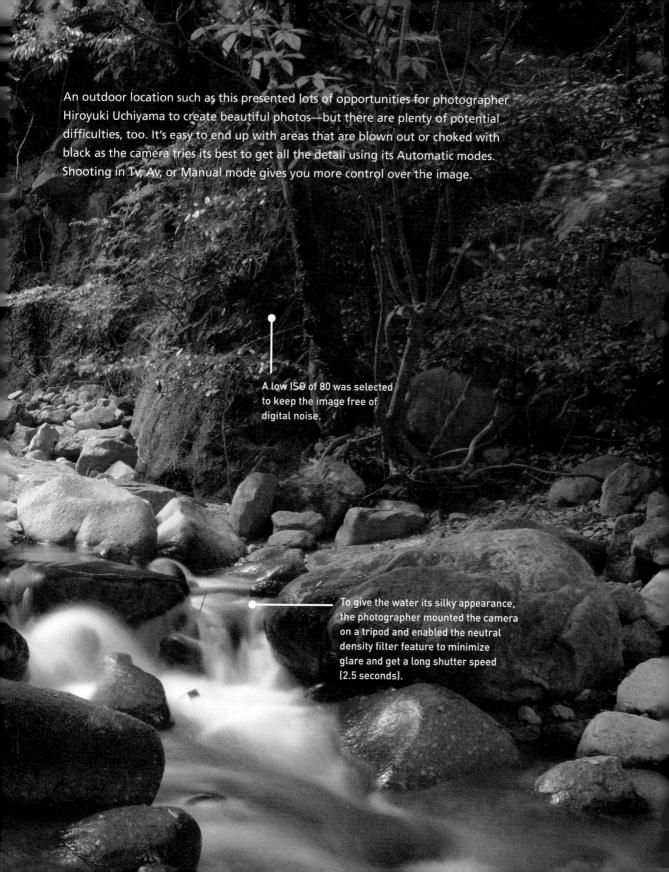

P: PROGRAM MODE

There's a reason Program mode is only one click away from the Automatic modes: With respect to aperture and shutter speed, the camera is doing most of the thinking for you. So, if that is the case, why even bother with

Program mode? It doesn't give as much control over the image-making process as the other Creative modes, but there are occasions when it comes in handy, such as shooting in widely changing lighting conditions, or when you're willing to give up ultimate control of the scene in the greater service of getting the shot. Think of a picnic outdoors in a partial shade/sun environment. I want great-looking pictures, but I'm not looking for anything to hang in a museum. If that's the scenario, why choose Program over one of the Automatic modes? Because it still offers choices and control that none of those modes can deliver.

WHEN TO USE PROGRAM (P) MODE INSTEAD OF THE AUTOMATIC MODES

- When shooting in a casual environment where quick adjustments are needed
- When you want control over the ISO
- If you want to make corrections to the white balance
- · If you want to shoot in RAW

Let's go back to our picnic scenario. As I said, the light is moving from deep shadow to bright sunlight, which means the camera is trying to balance three photo factors (ISO, aperture, and shutter speed) to make a good exposure. From Chapter 1, you know that Auto ISO is just not a consideration, so we're not using that setting on the ISO dial (right?).

Well, in Program mode, you can choose which ISO you would like the camera to base its exposure on. The lower the ISO number, the better the quality of the photographs, but the less light-sensitive the camera becomes. It's a balancing act with the main goal always being to keep the ISO as low as possible—too low an ISO, and you get camera shake in images from a long shutter speed; and too high an ISO means you have an unacceptable amount of digital noise. For our purposes, let's go ahead and select ISO 400 to provide enough sensitivity for those shadows while allowing the camera to use shutter speeds that are fast enough to stop motion.

Let's set up the camera for Program mode and see how we can make all this come together.

SETTING UP AND SHOOTING IN PROGRAM MODE

- 1. Turn your camera on and turn the Mode dial to P.
- 2. Select your ISO by rotating the ISO dial (see the sidebar, "Starting Points for ISO Selection").
- 3. Point the camera at your subject and activate the camera meter by pressing the shutter button halfway.
- 4. View the exposure information at the bottom of the LCD.
- **5.** Start clicking. As you shoot, feel free to adjust the ISO to compensate: If the photos are coming out blurry, increase the ISO to raise the shutter speed; if the image looks good, try dropping the ISO setting and see if you can keep the quality while reducing the digital noise.

The downside to shooting in Program mode is that you're relying on the camera to pick what it believes are suitable exposure values using its internal meter. Sometimes it doesn't know what it's looking at and how you want those values applied (Figure 4.1 and Figure 4.2). That's when it's time to start adjusting the settings by hand.

STARTING POINTS FOR ISO SELECTION

There is a lot of discussion concerning ISO in this and other chapters, but it might be helpful if you know where your starting points should be for your ISO settings. The first thing you should always try to do is use the lowest possible ISO setting. That being said, here are good starting points for your ISO settings:

- 80 or 100: Bright sunny day
- 200: Hazy or outdoor shade on a sunny day
- 400: Indoor lighting at night or cloudy conditions outside
- · 800: Late-night, low-light conditions or sporting arenas at night

These are just suggestions, and your ISO selection will depend on a number of factors that will be discussed later in the book. You might have to push your ISO even higher as needed, but at least now you know where to start.

FIGURE 4.1 (left) The camera settings are affected by the flat sky as well as the color of the paint on the front of the building.

FIGURE 4.2 (right) By recomposing slightly, the light meter focused on the wall, resulting in a change of exposure. [Photos: Jeff Carlson]

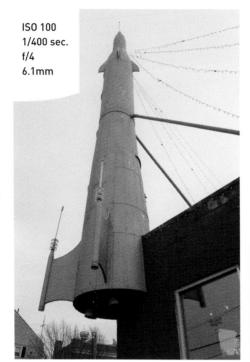

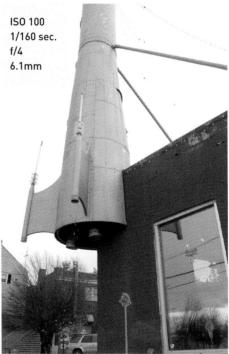

TV: SHUTTER PRIORITY MODE

Tv mode is what photographers commonly refer to as Shutter Priority mode. If you dig deep in your manual, you will actually see that Tv stands for Time Value. I'm not sure who came up with this term, but I can tell you

it wasn't a photographer. I don't ever recall thinking, "Hey, this would be a great situation to use the Time Value mode." However, you don't need to know why it is called Tv mode; the important thing is to know why and when to use it.

Just as with Program mode, Tv mode gives us more freedom to control certain aspects of our photography. In this case, we are talking about shutter speed, which determines how long you expose your camera's sensor to light. The longer it remains open, the more light the sensor gathers. The shutter speed also contributes greatly to how sharp your photographs are. Because a slower shutter speed means that light from your subject is hitting the sensor for a longer period of time, any movement by you (camera shake) or your subject shows up in your photos as blur.

SHUTTER SPEEDS

A *slow* shutter speed refers to leaving the shutter open for a long period of time—like 1/30 of a second or less. A *fast* shutter speed means that the shutter is open for a very short period of time—like 1/250 of a second or more.

WHEN TO USE SHUTTER PRIORITY (TV) MODE

- When you want to create that silky-looking water in a waterfall (Figure 4.3)
- When you want to use a long exposure to gather light over a long period of time (Figure 4.4); you'll learn more in Chapter 8
- When working with fast-moving subjects where you want to freeze the action (Figure 4.5); Chapter 5 covers this in detail
- When you want to emphasize movement in your subject with motion blur

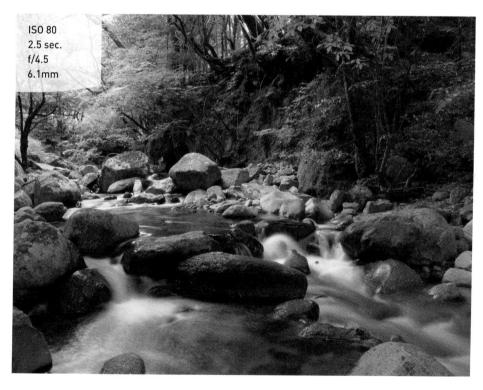

FIGURE 4.3 Increasing the length of the exposure time gives flowing water a silky look. [Photo: Hiroyuki Uchiyama]

FIGURE 4.4
A long exposure
makes this amusement park ride look
like a completely
different structure.
[Photo: Patrick
Gervais]

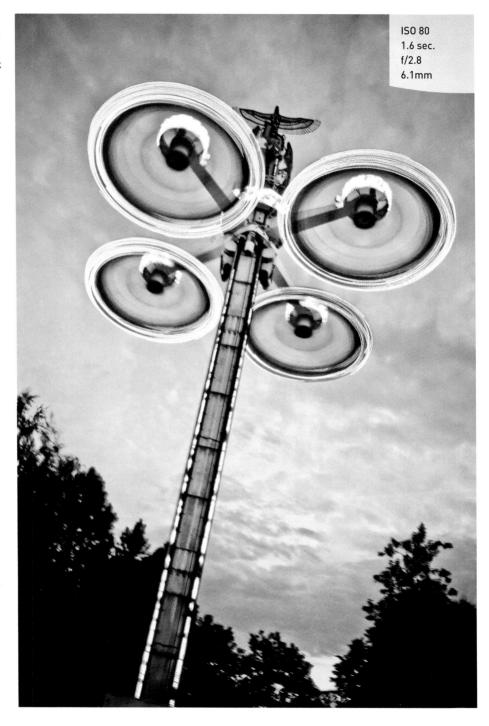

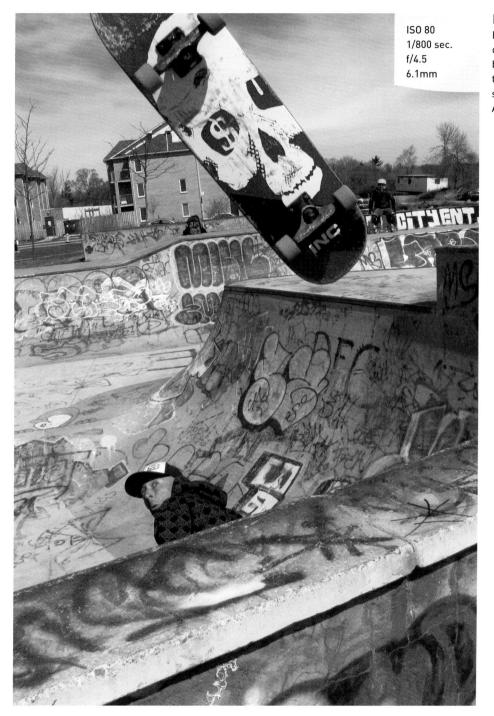

FIGURE 4.5 Even the fastest of subjects can be frozen with the right shutter speed. [Photo: Anneliese Voigt]

As you can see, the subject of your photo usually determines whether or not you will use Tv mode. It's important that you be able to visualize the result of using a particular shutter speed. The great thing about shooting with digital cameras is that you get instant feedback by checking your shot on the LCD screen. But what if your subject won't give you a do-over? Such is often the case when shooting sporting events. It's not like you can go ask the quarterback to throw that touchdown pass again because your last shot was blurry from a slow shutter speed. This is why it's important to know what those speeds represent in terms of their capabilities to stop the action and deliver a blur-free shot.

First, let's examine just how much control you have over the shutter speeds. The G12 has a shutter speed range from 1/4000 of a second all the way down to 15 seconds. With that much latitude, you should have enough control to capture almost any subject. The other thing to think about is that Tv mode is considered a "semi-automatic" mode—you control the shutter speed and the camera chooses a corresponding aperture to achieve a well-exposed image. This is important because there will be times that you want to use a particular shutter speed, but the lens won't be able to accommodate your request.

For example, you might encounter this problem when shooting in low-light situations. Suppose you're shooting a fast-moving subject that blurs at a shutter speed slower than 1/125 of a second. The lens's largest aperture is f/2.8, which might not provide enough available light for the shot and result in an underexposed photo. In that case, that aperture display on the LCD appears orange, and the yellow light near the viewfinder blinks to warn you.

Another case in which you might run into this situation is when you are shooting moving water. To get that look of silky, flowing water, it's usually necessary to use a shutter speed of at least 1/15 of a second. If your waterfall is in full sunlight, you may get that blinking aperture display once again, because the lens you are using only closes down to f/8 at its smallest opening. In this instance, your camera is warning that you will be overexposing your image. There are workarounds for these problems, which we will discuss later (see Chapter 7), but it is important to know that there can be limitations when using Tv mode.

SETTING UP AND SHOOTING IN TV MODE

- 1. Turn your camera on and turn the Mode dial to Tv.
- 2. Select your ISO by rotating the ISO dial.
- Rotate the Front dial to choose a shutter speed, which appears at the bottom of the LCD. Roll the dial to the right for faster shutter speeds and to the left for slower speeds.

- **4.** Point the camera at your subject and then activate the camera meter by pressing the shutter button halfway to preview the exposure.
- 5. Release the button and adjust the Front dial to change the setting.
- 6. Press the shutter button fully when you're ready to shoot.

AV: APERTURE PRIORITY MODE

You wouldn't know it from its name, but Av mode is one of the most useful and popular of the Creative modes. Av stands for Aperture Value and, like Time Value, it's another term that you'll never hear a photogra-

pher toss around. The mode, however, is one of my personal favorites, and I believe that it will quickly become one of yours as well. Av, more commonly referred to as Aperture Priority mode, is also deemed a semi-automatic mode because it allows you to once again control one factor of exposure while the camera adjusts for the other.

Why is this one of my favorite modes? It's because the aperture of your lens dictates depth of field. Controlling depth of field lets you direct attention to what's important in your image by specifying how much area in your image is sharp. If you want to isolate a subject from the background, such as when shooting a portrait, a large aperture keeps the focus (literally) on your subject and makes both the foreground and background blurry. If you want to keep the entire scene sharply focused, such as with a landscape scene, then using a small aperture will render the greatest amount of depth of field possible.

WHEN TO USE APERTURE PRIORITY (AV) MODE

- When shooting macro, or close-up, photography (Figure 4.6)
- When shooting portraits or wildlife (Figure 4.7)
- When shooting architectural photography, which often benefits from a large depth of field (Figure 4.8)
- When shooting most landscape photography (see Chapter 7)

FIGURE 4.6 Aperture priority helps keep the foreground image in focus in macro photos. [Photo: Lynette Coates]

FIGURE 4.7 A large aperture created a blurry background so all the emphasis was left on the subject. [Photo: Anneliese Voigt]

FIGURE 4.8
Using the camera's smallest available aperture provides a large depth of field. [Photo: Jeff Carlson]

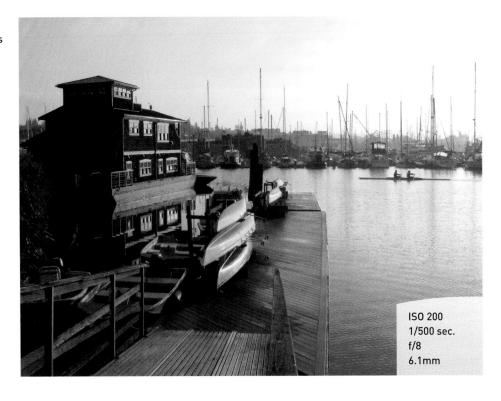

F-STOPS AND APERTURE

As discussed earlier, when referring to the aperture value, you will find it described as an *f-stop*. The f-stop is one of those old photography terms that, technically, relates to the focal length of the lens (e.g., 200mm) divided by the effective aperture diameter. These measurements are defined as "stops" and work incrementally with your shutter speed to determine proper exposure. Older camera lenses used one-stop increments to assist in exposure adjustments, such as 1.4, 2, 2.8, 4, 5.6, 8, 11, 16, and 22. Each stop represents about half the amount of light entering the lens iris as the larger stop before it. Today, all adjustments to this setting are performed via the camera's electronics. The stops are also now typically divided into 1/3-stop increments to allow much finer adjustments to exposures.

So we have established that Aperture Priority (Av) mode is highly useful in controlling the depth of field in your image. But it's also pivotal in determining the limits of available light that you can shoot in. The larger the maximum aperture, the less light you need in order to achieve an acceptably sharp image. You will recall that, when in Tv mode, there is a limit at which you can handhold your camera without introducing movement or hand shake, which causes blurriness in the final picture. A larger aperture lets in more light at once, which means that you can use a faster shutter speed.

On the other hand, bright scenes require the use of a small aperture (such as f/8), especially if you want to use a slower shutter speed. That small opening reduces the amount of incoming light, and this reduction of light requires that the shutter stay open longer.

SETTING UP AND SHOOTING IN AV MODE

- 1. Turn your camera on and turn the Mode dial to Av.
- 2. Select your ISO by rotating the ISO dial.
- 3. Rotate the Front dial to choose an aperture setting, which appears at the bottom of the LCD. Roll the dial to the right for a smaller aperture (higher f-stop number) and to the left for a larger aperture (smaller f-stop number).
- 4. Point the camera at your subject and then activate the camera meter by pressing the shutter button halfway to preview the exposure. As with the Shutter Priority mode, the orange light by the viewfinder will blink if the image is underexposed or overexposed.
- 5. Release the button and adjust the Front dial to change the setting.
- 6. Press the shutter button fully when you're ready to shoot.

M: MANUAL MODE

Let's face it—if you want to learn the effects of aperture and shutter speed on your photography, there is no better way to learn than by dialing in these settings yourself. However, today, with the advancement

of camera technology, many new photographers never give this mode a second thought. That's a shame, as not only is it an excellent way to learn your photography basics, but it's also an essential tool to have in your photographic bag of tricks.

In Manual (M) mode, the camera meter gives you a reading of the scene. It's your job to set both the f-stop (aperture) and the shutter speed to achieve a correct exposure. If you need a faster shutter speed, you will have to make the reciprocal change to your f-stop. This can be challenging at first, but after a while you will have a complete understanding of how each change affects your exposure, which will, in turn, improve the way you use the other modes.

WHEN TO USE MANUAL (M) MODE

- When learning how each exposure element interacts with the others (Figure 4.9)
- When shooting silhouetted subjects, which requires overriding the camera's meter readings (Figure 4.10)
- When your environment is fooling your light meter and you need to maintain a certain exposure setting

SETTING UP AND SHOOTING IN MANUAL MODE

- 1. Turn your camera on and turn the Mode dial to M.
- 2. Select your ISO by rotating the ISO dial.
- 3. Rotate the Front dial to choose a shutter speed, which appears at the bottom of the LCD. The exposure information is displayed by a scale with marks that run from –2 to +2 stops. A proper exposure (according to the camera meter) will line up with the arrow mark in the middle. As the indicator moves down, it is a sign that you will be underexposing (there is not enough light on the sensor to provide adequate exposure). If the indicator is above the middle mark, you will be providing more exposure than the camera meter calls for (overexposure).
- 4. Rotate the Control dial to choose an aperture value, keeping the light meter in mind as you change the f-stop.
- 5. Point the camera at your subject and then press the shutter button halfway to preview the exposure. As with the Tv and Av modes, the orange light by the viewfinder will blink if the image is underexposed or overexposed.
- **6.** Release the button and adjust the Front dial or Control dial to change the setting.
- 7. Press the shutter button fully when you're ready to shoot.

FIGURE 4.9
Beaches and
snow are always a
challenge for light
meters. Instead
of fighting the
light meter, switch
to Manual mode
and dial in a good
exposure yourself.
[Photo: Michael
Gerpe]

FIGURE 4.10
Although the meter can do a pretty good job of exposing for the sky, you can use the Manual mode to make creative adjustments, such as pushing the skyline elements into complete black silhouette. [Photo: Dean Ducas]

HOW I SHOOT: A CLOSER LOOK AT THE CAMERA SETTINGS I USE

Whether it's isolating my subject with a large aperture or trying to maximize the overall sharpness of a sweeping landscape, I always keep an eye on my aperture setting. If I do have a need to control the action, I use Shutter Priority. If I'm trying to create a soft waterfall effect, I can depend on Tv to provide a long shutter speed. When trying to grab a shot of my toddler, I definitely need the fast shutter speeds that will freeze the action. While the other camera modes have their place, I think you will find yourself using the Av and Tv modes for 90 percent of your shooting.

The other concern I have when I'm setting up my camera is just how low I can keep my ISO. I raise the ISO only as a last resort because each increase in sensitivity is an opportunity for more digital noise to enter my image.

To make quick changes while I shoot, I often use the Exposure Compensation feature (covered in Chapter 7) so that I can make small over- and underexposure changes. This is different than changing the aperture or shutter; it is more like fooling the camera meter into thinking the scene is brighter or darker than it actually is.

One of the reasons I change my exposure is to make corrections when I see the "blinkies" while looking at my images on the LCD, which indicate that part of my image has been overexposed to the point that I no longer have any detail in the highlights. The only unfortunate thing about this feature is that it doesn't work with the full-screen preview mode. You have to set your camera display to the Histogram display mode (see Chapter 1) to see the Highlight Alert (Figure 4.11).

FIGURE 4.11 You can only see the Highlight Alert ("blinkies") when in the Histogram display mode.

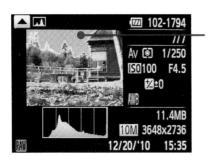

The flashing area is alerting me that the sky is overexposed and will lose detail.

As you work your way through the coming chapters, you will see other tips and tricks I use in my daily photography, but the most important tip I can give is to understand the features of your camera so that you can leverage the technology in a knowledgeable way. This will result in better photographs.

Chapter 4 Assignments

The information covered in this chapter defines how you work with your camera from this point on. Granted, there may be times when you just want to grab some quick pictures and will take advantage of the Automatic modes, but to get serious with your photography, you should learn the Creative modes.

Starting off with Program mode

Set your camera on Program mode and start shooting. While shooting, make sure that you keep an eye on your ISO.

Learning to control time with the Tv mode

Find some moving subjects and then set your camera to Tv mode. Have someone ride their bike back and forth or even just photograph cars as they go by. Start with a slow shutter speed of around 1/30 of a second and then start shooting with faster and faster shutter speeds. Keep shooting until you can freeze the action. Now find something that isn't moving, like a flower, and work your shutter speed from something fast like 1/500 of a second down to about 1/4 of a second. The point is to see how well you can handhold your camera before you start introducing hand shake into the image.

Controlling depth of field with the Av mode

The name of the game with Av mode is depth of field. Set up three items an equal distance from you. I would use chess pieces or something similar. Now focus on the middle item and set your camera to the largest aperture of f/2.8 (remember, large aperture means a small number). Now, while still focusing on the middle subject, start shooting with ever-smaller apertures until you are at the smallest f-stop, f/8. Try doing this exercise with the lens zoomed out at the widest and then the most telephoto setting. Now move up to subjects that are farther away, like telephone poles, and shoot them in the same way. The idea is to get a feel for how each aperture setting affects your depth of field.

Giving and taking with Manual mode

Go outside on a sunny day and, using the camera in Manual mode, set your ISO to 100, your shutter speed to 1/2000 of a second, and your aperture to f/4. Now press your shutter release button to get a meter reading. You should be pretty close to that zero mark. If not, make small adjustments to one of your settings until it hits that mark. Now is where the fun begins. Start moving your shutter speed slower, to 1/500, and then set your aperture to f/8. Now go the other way. Set your aperture on f/5.6 and your shutter speed to 1/1000. Now review your images. If all went well, all the exposures should look the same. This is because you balanced the light with reciprocal changes to the aperture and shutter speed. Now try moving the shutter speed without changing the aperture. Just make 1/3-stop changes (1/800 to 1/640 to 1/500 to 1/400), and then review your images to see what a 1/3 stop of overexposure looks like. Then do the same thing going in the opposite way. It's hard to know if you want to over- or underexpose a scene until you have actually done it and seen the results.

Moving Target

SHOOTING ACTION, STOPPING MOTION, AND MORE

Now that you have learned about the Creative modes, it's time to put your newfound knowledge to good use. Whether you're shooting the action at a sporting event or a child on a merry-go-round, you'll learn techniques that will help you bring out the best in your photography when your subject is in motion.

The number one thing to know when trying to capture a moving target is that speed is king! I'm not talking about how fast your subject is moving, but rather how fast your shutter is opening and closing. Shutter speed is the key to freezing a moment in time—but also to conveying movement. It's all in how you turn the dial. There are also some other considerations for taking your shot to the next level, which we'll explore in this chapter.

Photo: Dean Ducas

PORING OVER THE PICTURE

I'm willing to bet that a large reason you bought a G12 was to have it with you to capture moments as they happen. Often those events occur quickly, so you need to be ready to shoot them as they unfold. Here, Oscar Sainz grabs a quick slice of late-afternoon action without ending up with blurry motion trails.

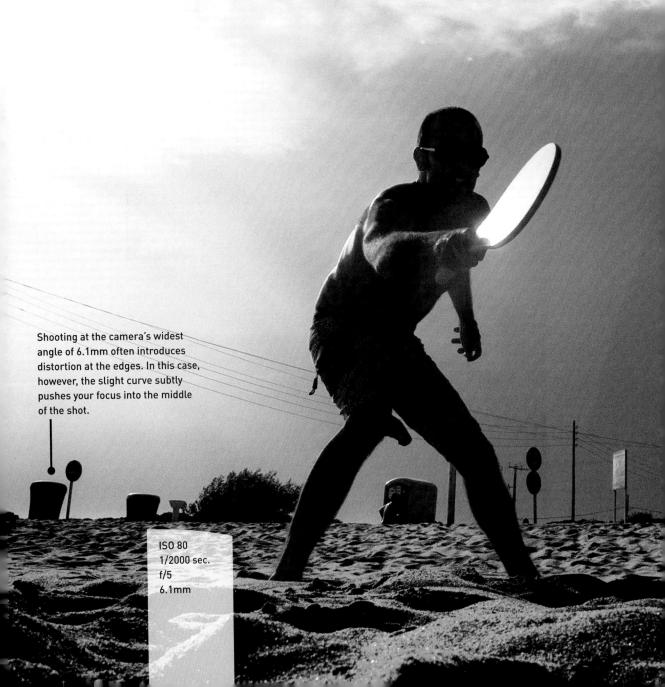

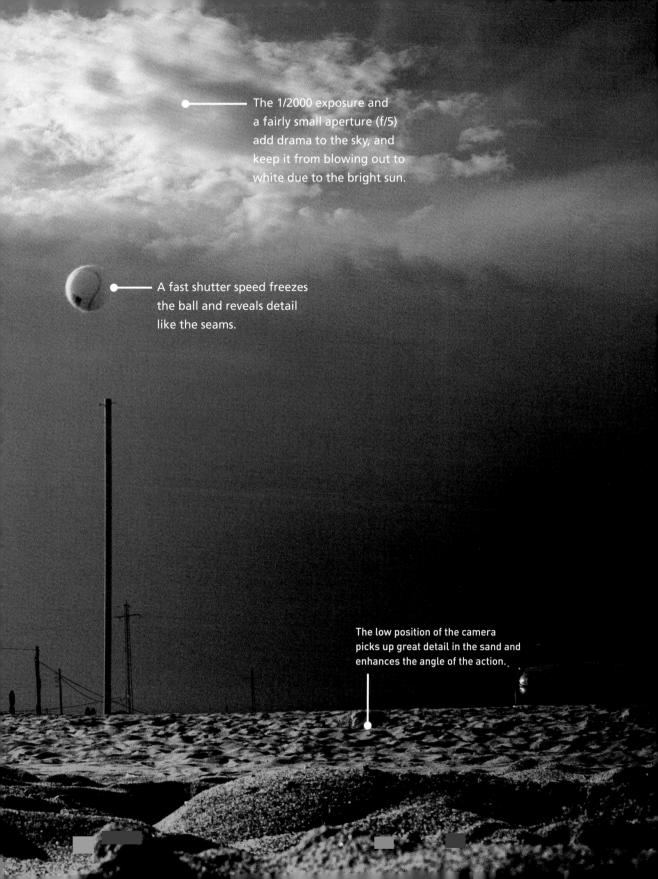

STOP RIGHT THERE!

Shutter speed is the main tool in the photographer's arsenal for capturing great action shots. The ability to freeze a moment in time often makes the difference between a good shot and a great one. To take advantage of this concept, you should have a good grasp of the relationship between shutter speed and movement. When you press the shutter release button, your camera goes into action by activating the sensor for a predetermined length of time. The longer you leave your shutter open, the more your subject moves across the frame, so common sense dictates that the first thing to consider is just how fast your subject is moving.

Typically, you will be working in fractions of a second. How many fractions depends on several factors. Subject movement, while simple in concept, is actually based on three factors. The first is the direction of travel. Is the subject moving across your field of view (left to right) or traveling toward or away from you? The second consideration is the actual speed at which the subject is moving. There is a big difference between a moving sports car and a child on a bicycle. Finally, the distance from you to the subject has a direct bearing on how fast the action seems to be taking place. Let's take a brief look at each of these factors to see how they might affect your shooting.

DIRECTION OF TRAVEL

Typically, the first thing that people think about when taking an action shot is how fast the subject is moving, but in reality the first consideration should be the direction of travel. Where you are positioned in relation to the subject's direction of travel is critically important in selecting the proper shutter speed. When you open your shutter, the lens gathers light from your subject and records it on the camera sensor. If the subject is moving across your viewfinder, you need a faster shutter speed to keep that lateral movement from being recorded as a streak across your image. Subjects that are moving perpendicular to your shooting location do not move across your viewfinder and appear to be more stationary. This allows you to use a slightly slower shutter speed. A subject that is moving in a diagonal direction—both across the frame and toward or away from you—requires a shutter speed between the two.

SUBJECT SPEED

Once the angle of motion has been determined, you can then assess the speed at which the subject is traveling. The faster your subject moves, the faster your shutter speed needs to be in order to "freeze" that subject (**Figure 5.1**). A person walking across your frame might only require a shutter speed of 1/60 of a second, whereas a cyclist traveling in the same direction would call for 1/500 of a second. That same

cyclist traveling toward you at the same rate of speed, rather than across the frame, might only require a shutter speed of 1/125 of a second. You can start to see how the relationship of speed and direction comes into play in your decision-making process.

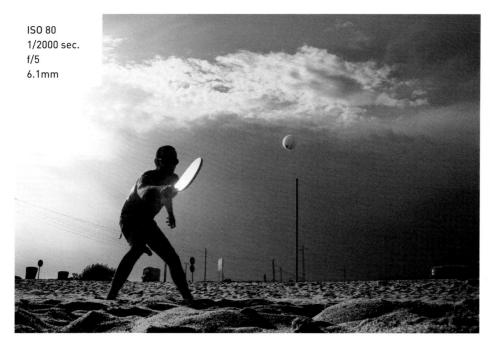

FIGURE 5.1 A fast-moving subject that is crossing your path will require a faster shutter speed. [Photo: Oscar Sainz]

SUBJECT-TO-CAMERA DISTANCE

So now you know both the direction and the speed of your subject. The final factor to address is the distance between you and the action. Picture yourself looking at a highway full of cars from up in a tall building a quarter of a mile from the road. As you stare down at the traffic moving along at 55 miles per hour, the cars and trucks seem to be slowly moving along the roadway.

Now picture yourself standing in the median of that same road as the same traffic flies by at the same rate of speed. Although the traffic is moving at the same speed, the shorter distance between you and the traffic makes the cars look like they are moving much faster. This is because your field of view is much narrower; therefore, the subjects are not going to present themselves within the frame for the same length of time. The concept of distance applies to the length of your lens as well. If your lens is at a wide-angle setting, you can probably get away with a slower shutter speed than if you were zoomed in, which puts you in the heart of the action. It all has to do with your field of view. That telephoto zoom gets you "closer" to the action—and the closer you are, the faster your subject moves across your viewfinder.

USING SHUTTER PRIORITY (TV) MODE TO STOP MOTION

As we covered in the last chapter, Tv mode gives you control over shutter speed, while handing over aperture selection to the camera. The ability to concentrate on just one exposure factor helps you quickly make changes on the fly while staying glued to your camera's LCD and your subject.

There are a couple of things to consider when using Tv mode, both of which have to do with the amount of light that is available when shooting. Although you have control over which shutter speed you select in Tv mode, the range of available shutter speeds depends largely on how well your subject is lit.

Typically, when shooting fast-paced action or trying to capture something that happens quickly, you will be working with very fast shutter speeds (**Figure 5.2**). This means your lens will probably be set to its largest aperture. Although the G12 offers a maximum aperture of f/2.8, that applies only when shooting at the lens's widest setting. As you zoom, the largest aperture available to you reduces; the largest aperture you can expect when fully zoomed is f/4.5. If the available light is not sufficient for the shutter speed selected, you'll need to raise the ISO of the camera to balance the exposure.

Let's say you're shooting a baseball game at night, and you want to get some great action shots. You set your camera to Tv mode and, after testing out some shutter speeds, determine that you need to shoot at 1/500 of a second to freeze the action on the field. When you press the shutter button halfway, you notice that the f-stop readout is blinking at f/4.5. This is your camera's way of telling you that the lens has now reached its maximum aperture, and any pictures you shoot are going to be underexposed at the currently selected shutter speed. You could slow your shutter speed down until the aperture reading stops blinking, but then you would get images with too much motion blur.

The alternative is to raise your ISO to a level that is fast enough for a proper exposure. The key here is to always use the lowest ISO you can get away with. That might mean ISO 80 in bright sunny conditions or ISO 1600 for an indoor or night situation. Just remember that the higher the ISO, the greater the amount of noise in your image. (This is the reason you see professional sports photographers using those mammoth lenses perched atop a monopod: They could use a smaller lens, but to get those very large apertures they need a huge piece of glass on the front of the lens. The larger the glass on the front of the lens, the more light it gathers, and the larger the aperture for shooting. For the working pro, the large aperture translates into low ISO—and thus low noise—fast shutter speeds, and razor-sharp action.)

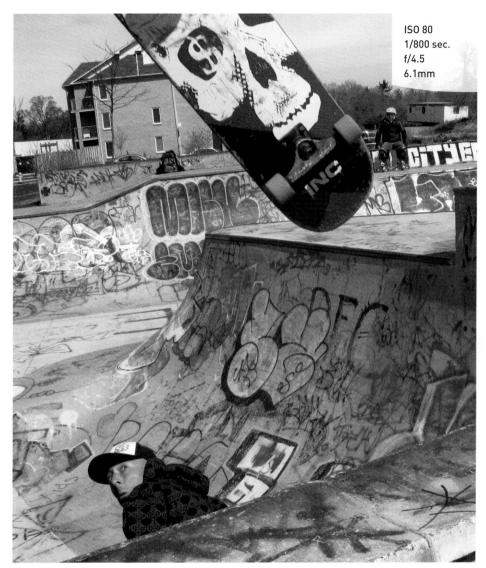

FIGURE 5.2 Here's an enlarged detail of a photo we saw in Chapter 4. The fast shutter speed captures the skateboard mid-air with very little blurring. (Increasing the ISO may have frozen it completely.) Also note that the f/4.5 aperture the middle of the camera's range-keeps the background elements in focus, too. [Photo: Anneliese Voigt]

ADJUSTING YOUR ISO AS YOU SHOOT

- 1. Press the shutter button halfway and check for the blinking aperture readout in the bottom portion of the LCD.
- 2. If it is blinking, adjust the ISO dial to the next highest value.
- 3. Lightly press the shutter button and check to see if the aperture is still blinking.
- 4. If it's not blinking, shoot away. If it is, repeat steps 2 and 3 until it is set correctly.

USING APERTURE PRIORITY (AV) MODE TO ISOLATE YOUR SUBJECT

One of the benefits of working in Tv mode with fast shutter speeds is that, more often than not, you will be shooting with the largest aperture available. Shooting with a large aperture allows you to use faster shutter speeds, but it also narrows your depth of field.

To isolate your subject in order to focus your viewer's attention on it, a larger aperture is required. The larger aperture reduces the foreground and background sharpness: The larger the aperture, the more blurred they will be.

The reason I bring this up here is that when you are shooting most sporting events, the idea is to isolate your main subject by having it in focus while the rest of the image has some amount of blur. This sharp focus draws your viewer right to the subject. Studies have shown that the eye is drawn to sharp areas before moving on to the blurry areas. Also, depending on what your subject matter is, there can be a tendency to get distracted by a busy background if everything in the photo is equally sharp. Without a narrow depth of field, it might be difficult for the viewer to establish exactly what the main subject is in your picture.

As we established in Chapter 4, Av mode is the key to controlling aperture and, in turn, depth of field. So how do you know when you should use Av mode as opposed to Tv mode? It's not a simple answer, but your LCD screen can help you make this determination. The best scenario for using Av mode is a brightly lit scene where maximum apertures will still give you plenty of shutter speed to stop the action.

Let's say that you are shooting a soccer game in the midday sun. If you have determined that you need something between 1/500 and 1/1250 of a second for stopping the action, you could set your camera to a high shutter speed in Tv mode and just start shooting. But you also want to be using an aperture of, say, f/4.5 to get that narrow depth of field. Here's the problem: If you set your camera to Tv and select 1/1000 of a second as a nice compromise, you might get that desired f/stop—but you might not. As the meter is trained on your moving subject, the light levels could rise or fall, which might actually change that desired f-stop to something higher, like f/5.6 or even f/8. Now the depth of field is extended, and you will no longer get that nice isolation and separation that you wanted.

To rectify this, switch the camera to Av mode and select f/4.5 as your aperture. Now, as you begin shooting, the camera holds that aperture and makes exposure adjustments with the shutter speed (**Figure 5.3**). As I said before, this works well when you have lots of light—enough light so that you can have a high-enough shutter speed without introducing motion blur.

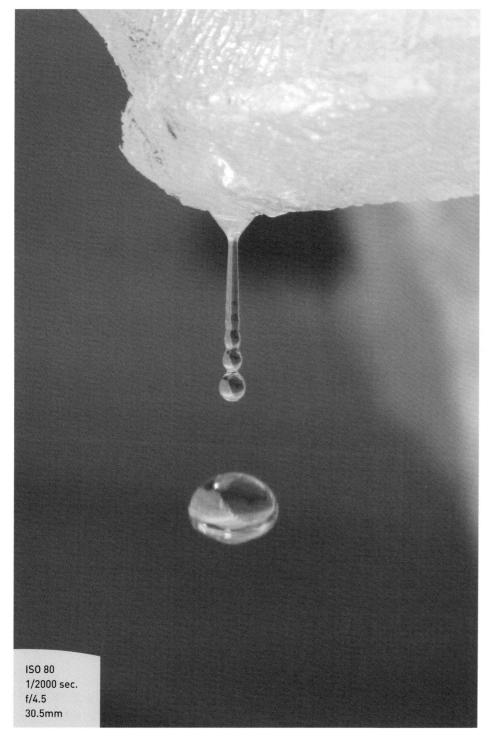

FIGURE 5.3 Several factors contribute to the appearance of this photo: A high shutter speed catches the droplet just as it's separating; a tight zoom frames the shot and helps to provide a shallow depth of field with the focus on the droplet's stem; and a relatively wide aperture (the widest possible at that zoom level) enhances the depth of field and provides enough light that the photographer didn't need to increase the ISO. [Photo: Dean Ducas]

MANUAL FOCUS FOR ANTICIPATED ACTION

While I utilize the automatic focus modes for the majority of my shooting, there are times when I like to fall back on manual focus. If I know when and where the action will occur, I want to capture the subject as it crosses a certain plane of focus. This is useful in sports like motocross or track and field events, where the subjects are on a defined track, or when you're setting up a fast-moving shot. By pre-focusing the camera, all I have to do is wait for the subject to approach my point of focus and then start firing the camera.

ZOOM IN TO BE SURE

When reviewing your shots on the LCD, don't be fooled by the display. The smaller your image is, the sharper it will look. To ensure that you are getting sharp, blur-free images, make sure that you zoom in on your LCD display.

To zoom in on your images, press the Image Review button located above the LCD display and then turn the Zoom lever clockwise to zoom (**Figure 5.4**). Continue turning the lever to increase the zoom ratio.

To zoom back out, simply turn the Zoom lever counterclockwise.

Another option is to enable the Focus Check review feature, which displays a smaller preview of your full image but also includes a zoomed-in portion; move the Zoom lever to quickly increase the size of the portion to check the image's focus (see Chapter 1).

 $\label{eq:figure} FIGURE~5.4$ Zooming in on your image helps you confirm that the image is really sharp.

SAFETY SHIFT

The G12 includes a feature that injects a little automation into the Tv and Av modes if you choose to enable it. (Press the Menu button, scroll down to Safety Shift, and use the Right button to turn it On.) Regardless of what mode you choose, Safety Shift adjusts the shutter speed or aperture to achieve a balanced exposure. So, for example, if you're shooting at 1/400 but the environment is too dark even at the largest aperture, the camera knocks the shutter speed down to 1/60 (or whatever value works). To be honest, the only reason I can surmise for why you'd want to use Safety Shift instead of switching over to Program (P) mode is to be able to get shots that unexpectedly veer into darker situations (such as patches of dark shadows in an otherwise sunny day) without constantly adjusting your shutter speed or aperture. I'd rather maintain control over shutter speed or aperture and take my chances with a higher ISO to avoid a blurry shot.

KEEP THEM IN FOCUS WITH SERVO AF

With the exposure issue handled for the moment, let's move on to an area that is equally important: focusing. As you learned in Chapter 1, a few autofocus options are available to you. We disabled the Continuous autofocus feature to preserve battery life, but the capability to let the camera work to keep a shot in focus is definitely helpful when shooting action. The alternative is to engage Servo AF mode, which offers continuous focus, but only when the shutter button is pressed halfway down; normally, half-pressing the shutter button locks focus. When using Servo AF mode, the AF Frame appears as a blue outline. You can also press the AF Frame Selector button to reposition the frame and specify where to concentrate the focus.

SELECTING SERVO AF MODE

- 1. While you're using one of the Creative modes, press the Menu button.
- Press the Down button to highlight Servo AF.
- **3.** Press the Left or Right button to switch Servo AF to On.
- 4. Press the Menu button to exit.

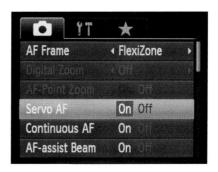

KEEPING UP WITH CONTINUOUS DRIVE MODE

Getting great focus is one thing, but capturing the best moment on the sensor can be difficult if you are shooting just one frame at a time. In the world of sports, and in life in general, things move pretty fast. If you blink, you might miss it. The same can be said for shooting in the Single Shot drive mode.

The drive mode determines how fast your camera will take pictures. The Single Shot drive mode is for taking one photograph at a time. With every full press of the shutter, the camera will take a single image. The Continuous mode allows for a more rapid capture rate. Think of it like a machine gun. In Continuous mode, the camera continues to take pictures as long as the shutter release button is held down (or until the buffer fills up).

The Continuous—or "burst"—mode lets you capture a series of images at up to 2 frames per second. Admittedly, that's not terribly impressive when you're shooting fast action, especially compared to the output that DSLRs can produce (anywhere from 3 to 12 or more frames per second). However, that's still faster than shooting in Single Shot mode when you take into consideration the time it takes to write the image to the memory card and prepare for the next shot. See **Figure 5.5**.

FIGURE 5.5
Use the Continuous
drive mode to
capture sequences
or make sure
you're getting the
action. [Photos:
Jeff Carlson]

The G12 also features two other Continuous shooting modes: Continuous Shooting AF engages the autofocus while firing off shots to try to keep each shot sharp; the regular Continuous mode locks focus when you press the shutter button halfway. Continuous Shooting LV replaces its AF counterpart when you've set a manual focus point. The shots-per-second rate is reduced to 0.7 and 0.8 images per second, respectively, for these two modes, since they're performing other processing tasks.

SETTING UP THE CONTINUOUS DRIVE MODE

- 1. Press the Function/Set button.
- 2. Press the Down button until you select the Drive Mode icon.
- Press the Left or Right button, or rotate the Control dial, to choose a mode.
 The icon that looks like stacked-up little rectangles is the Continuous mode.
- **4.** Press the Function/Set button to lock in your change.

To shoot, just press the shutter button and hold until the desired number of frames has been captured.

Your camera has an internal memory, called a "buffer," where images are stored while they are being processed prior to being moved to your memory card. Depending on the image format you are using, the buffer might fill up, and the camera will stop shooting until space is made in the buffer for new images. If this happens, you will see the word "Busy" appear on the LCD panel. The camera readout in the viewfinder tells you how many frames you have available.

A SENSE OF MOTION

Shooting action isn't always about freezing the action. There are times when you want to convey a sense of motion so the viewer can get a feel for the movement and flow of an event. Two techniques you can use to achieve this effect are panning and motion blur.

PANNING

Panning has been used for decades to capture the speed of a moving object as it moves across the frame. Panning is achieved by following your subject across your frame, moving your camera along with the subject, and using a slower-than-normal shutter speed so that the background (and sometimes even a bit of the subject) has a sideways blur, but the main portion of your subject is sharp and blur-free (Figure 5.6). It doesn't work well for subjects that are moving toward or away from you. The key to a great panning shot is selecting the right shutter speed: Too fast and you won't get the desired blurring of the background; too slow and the subject will have too much blur and will not be recognizable. Practice the technique until you can achieve a smooth motion with your camera that follows along with your subject. The other thing to remember when panning is to follow through even after the shutter has closed. This will keep the motion smooth and give you better images.

FIGURE 5.6
Following the subject as it moves across the field of view allows for a slower shutter speed and adds a sense of motion.
[Photo: Thespina Kyriakides]

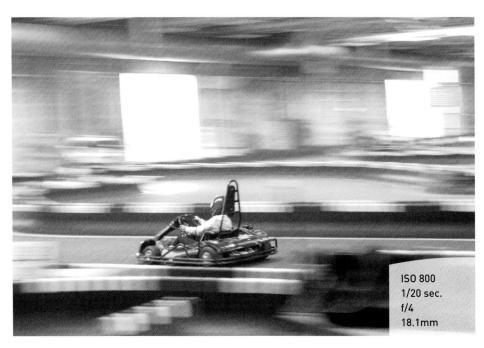

MOTION BLUR

Another way to let the viewer in on the feel of the action is to intentionally include some blur in the image. This isn't accidental blur from choosing the wrong shutter speed. This blur is more exaggerated, and it tells a story. In **Figure 5.7**, a fast shutter speed would have resulted in cars obscuring the building. As it's a night shot, you probably wouldn't see much detail, either. The long shutter speed brings out the stationary lights on the buildings and makes the passing vehicles blurs of light.

Just as in panning, there is no preordained shutter speed to use for this effect. It's a matter of trial and error until you have a look that conveys the action. The key to this technique is the correct shutter speed combined with keeping the camera still during the exposure. You are trying to capture the motion of the subject, not the photographer or the camera, so use a good shooting stance or even a tripod.

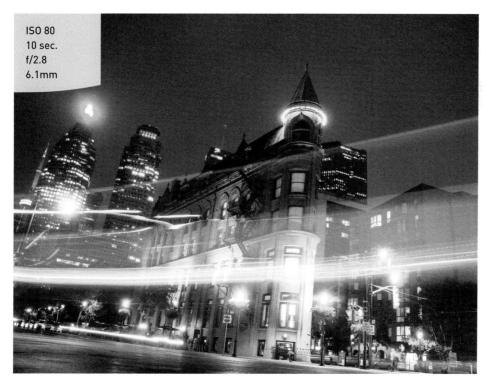

FIGURE 5.7
A long shutter
speed blurs the
passing cars into
light streaks, while
also giving the
building a warm
glow. [Photo:
Anneliese Voigt]

TIPS FOR SHOOTING ACTION

GIVE THEM SOMEWHERE TO GO

Whether you are shooting something as simple as your child's soccer match or as complex as the wild motion of a bucking bronco, where you place the subject in the frame is equally important as how well you expose the image. A poorly composed shot can completely ruin a great moment by not holding the viewer's attention.

The one mistake I see many times in action photography is that the photographer doesn't use the frame properly. If you are dealing with a subject that is moving horizontally across your field of view, give the subject somewhere to go by placing them to the side of the frame, with their motion leading toward the middle of the frame (Figure 5.8). This offsetting of the subject will introduce a sense of direction and anticipation for the viewer. Unless you're going to completely fill the image with the action, try to avoid placing your subject in the middle of the frame.

FIGURE 5.8
Try to leave space in front of your subject to lead the action in a direction. [Photo: Scott Edwards]

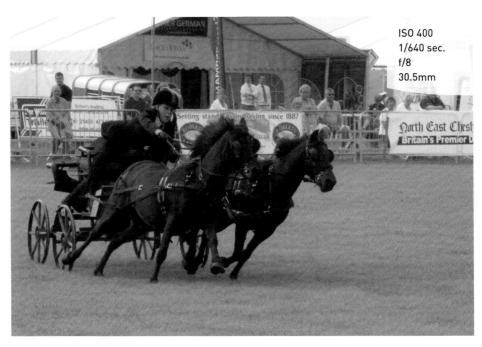

GET IN FRONT OF THE ACTION

When shooting action, show the action coming toward you. Don't shoot the action going away from you. People want to see faces.

Faces convey the action, the drive, the sense of urgency, and the emotion of the moment. So if you are shooting action involving people, always position yourself so that the action is either coming at you or is at least perpendicular to your position.

PUT YOUR CAMERA IN A DIFFERENT PLACE

Changing your vantage point is a great way of finding new angles. Shooting from a low position with the lens at a wide-angle setting might let you incorporate some foreground to give depth to the image. Shooting from farther away while zoomed in will compress the elements in a scene and allow you to crop in tighter on the action. Don't be afraid to experiment and try new things. The image in **Figure 5.9** is a great example of using the compact size of the camera to one's advantage.

FIGURE 5.9 Taking a photo of the road would be fine, as would using a long shutter speed to blur the scenery as the motorcycle sped past it. Instead, the photographer caught the reflection of the road, the scenery, some sun flare, and the bike in his helmet's visor. (The black color of the camera also nicely blends in with the shadows of the bike, so at first glance you don't notice it in the shot.) [Photo: Dean Ducas]

Chapter 5 Assignments

The mechanics of motion

For this first assignment, you need to find some action. Explore the relationship between the speed of an object and its direction of travel. Use the same shutter speed to record your subject moving toward you and across your view. Try using the same shutter speed for both to compare the difference made by the direction of travel.

Wide vs. telephoto

Just as with the first assignment, photograph a subject moving in different directions, but this time, switch between the wide-angle and telephoto positions of the lens. Check out how the telephoto setting will require faster shutter speeds than its wide-angle setting.

Getting a feel for focusing modes

Switch the focusing control to Servo AF mode, find a moving subject, and become familiar with the way the mode works compared to the normal AF setting.

Anticipating the spot using manual focus

For this assignment, you will need to find a subject that you know will cross a specific line that you can pre-focus on. A street with moderate traffic works well for this. Focus on a spot on the street that the cars will travel across and switch to manual focus. To do this right, you need to set the drive mode on the camera to the Continuous mode. Now, when a car approaches the spot, start shooting. Try shooting in three- or four-frame bursts.

Following the action

Panning is a great way to show motion. To begin, find a subject that will move across your path at a steady speed and practice following it in your viewfinder from side to side. Now, with the camera in Tv mode, set your shutter speed to 1/30 of a second and the focus mode to Servo AF. Now pan along with the subject and shoot as it moves across your view. Experiment with different shutter speeds and focal lengths. Panning is one of those skills that takes some time to get a feel for, so try it with different types of subjects moving at different speeds.

Feeling the movement

Instead of panning with the motion, use a stationary camera position and adjust the shutter speed until you get a blurred effect that gives the sense of motion while still enabling you to identify the subject. There is a big difference between a slightly blurred photo that looks like you just picked the wrong shutter speed and one that looks intentional for the purpose of showing motion. Just like panning, it will take some experimentation to find just the right shutter speed to achieve the desired effect.

Say Cheese!

SETTINGS AND FEATURES TO MAKE GREAT PORTRAITS

Taking pictures of people is one of the great joys of photography. You will experience a great sense of accomplishment when you capture the spirit and personality of someone in a photograph. At the same time, you have a great responsibility because the person in front of the camera is depending on you to make them look good. You can't always change how someone looks, but you can control the way you photograph that individual. In this chapter, we will explore some camera features and techniques that can help you create great portraits.

PORING OVER THE PICTURE

We tend to think of "portraits" as unimaginative, straight-ahead, head-and-torso shots. And of course you're welcome to capture those images (sometimes, you may not have a choice). But with camera in hand, there are plenty of techniques you can use to get great, creative portraits like this one by photographer Manolo Millan.

A medium aperture – combined with a long focal length helped blur the background.

Zooming way in let the photographer crop tightly without getting directly in the subject's face.

Holding the camera vertically creates a more natural frame for her face.

Shooting in a shady location helped soften the light and reduced harsh shadows. ISO 200 1/125 sec. f/4.5 30.5mm

AUTOMATIC PORTRAIT MODE

In Chapter 3, we reviewed the automatic Scene (SCN) modes. One of them, the Portrait mode, is dedicated to shooting portraits. While this is not my preferred camera setting, it is a great jumping-off point for those who are just starting out. The key to using this scene is to understand what is going on with the camera so that when you venture further into portrait photography, you can expand on the settings and get the most from your camera and, more importantly, your subject.

Whether you are photographing an individual or a group, the emphasis should always be on the subject. Portrait mode utilizes a larger aperture setting to keep the depth of field very narrow, which means the background will appear blurred or out of focus. You can accentuate this effect by zooming in and also by keeping a pretty close distance to your subject. If you shoot from too far away, the narrow depth of field will not be as effective.

The G12 offers a few other features meant to help when photographing people. The Smart Shutter mode can look for a smile, a wink, or the presence of a face before taking the picture (see Chapter 3). And, of course, face detection helps keep people in focus, as described later in this chapter.

USING APERTURE PRIORITY MODE

If you took a poll of portrait photographers to see which shooting mode was most often used for portraits, the answer would certainly be Aperture Priority (Av) mode. Selecting the right aperture is important for placing the most critically sharp area of the photo on your subject, while simultaneously blurring all of the distracting background clutter (Figure 6.1). Not only will a large aperture give the narrowest depth of field; it will also allow you to shoot in lower light levels at lower ISO settings.

This isn't to say you're stuck shooting everything at a wide angle in order to stick to the widest aperture (remember, the maximum aperture decreases when you zoom). A good place to begin is f/5.6. This will give you enough depth of field to keep the entire face in focus, while providing enough blur to eliminate distractions in the background. This isn't a hard-and-fast setting; it's just a good, all-around number to start with. You can change your aperture depending on the zoom level you're using and on the amount of blur you want for your foreground and background elements.

FIGURE 6.1
Who says a portrait subject has to be human? No matter whose eyes are peeping back at you, shooting at a large aperture blurs distracting background details. [Photo: Wan-Ting Zhao]

METERING MODES FOR PORTRAITS

For most portrait situations, the Evaluative metering mode works well. (For more on how metering works, see the "Metering Basics" sidebar.) This mode measures light values from all portions of the viewfinder and then establishes a proper exposure for the scene. The only problem that you might encounter when using this metering mode is when you have very light or dark backgrounds in your portrait shots.

In these instances, the meter might be fooled into using the wrong exposure information because it will try to lighten or darken the entire scene based on the prominence of dark or light areas (Figure 6.2). You can deal with this in one of two ways. Use the Exposure Compensation feature, covered in Chapter 7, to dial in adjustments for over- and underexposure. Or, you can change the metering mode from Evaluative to Spot metering. The Spot metering mode uses only the center area of the viewfinder to get its exposure information (Figure 6.3). This mode is also great to use when the subject is strongly backlit.

FIGURE 6.2 (left) The light background color fooled the meter into choosing a slightly underexposed setting for the photo.

FIGURE 6.3 (right) When I switched to the Spot metering mode, I was able to specify the woman as the metering target, which made the camera adjust the aperture. [Photos: Jeff Carlson]

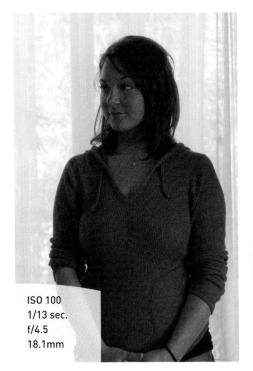

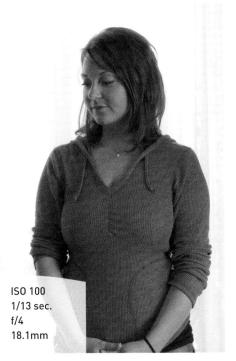

METERING BASICS

You camera has multiple metering modes, but the way they work is very similar. A light meter measures the amount of light being reflected off your subject and then renders a suggested exposure value based on the brightness of the subject and the ISO setting of the sensor. To establish this value, the meter averages all of the brightness values to come up with a middle tone, sometimes referred to as 18 percent gray. The exposure value is then rendered based on this middle gray value. This means that a white wall would be underexposed and a black wall would be overexposed in an effort to make each one appear gray. To assist with special lighting situations, the G12 has three metering modes: Evaluative (Figure 6.4), which uses the entire frame; Center-Weighted Average (Figure 6.5), which looks at the entire frame but places most of the exposure emphasis on the center of the frame; and Spot (Figure 6.6), which takes specific readings from small areas (often used with a gray card).

FIGURE 6.4 The Evaluative metering mode uses the entire frame.

FIGURE 6.5
The Center-Weighted metering mode looks at the entire frame but emphasizes the center of it.

FIGURE 6.6
The Spot metering mode uses a very small area of the frame.

SETTING YOUR METERING MODE TO SPOT METERING

- 1. Press the Metering Light button, located at the upper right of the Control dial.
- 2. Use the Control dial to scroll through the metering modes until you find the symbol for Spot metering mode.
- **3.** Press the Metering Light button to return to shooting mode.

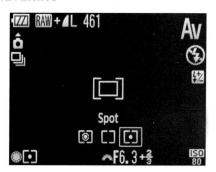

USING THE AE LOCK FEATURE

AE (Auto Exposure) Lock lets you use the exposure setting from any portion of the scene that you think is appropriate and then lock that setting in regardless of how the scene looks when you recompose. An example of this would be when you're shooting a photograph of someone and a large amount of blue sky appears in the picture. Normally, the meter might be fooled by all that bright sky and try to reduce the exposure. Using AE Lock, you can establish the correct metering by zooming in on the subject (or even pointing the camera toward the ground), taking the meter reading and locking it in with AE Lock, and then recomposing and taking your photo with the locked-in exposure.

SHOOTING WITH THE AE LOCK FEATURE

- 1. While composing your shot, place the center focus point on an area that produces the exposure you want.
- 2. Press the AE Lock button. A star (*) appears in your viewfinder, letting you know that the exposure has been locked.
- 3. Recompose your shot.
- 4. The "lock" affords some leeway: Turn the Control dial to make minor adjustments to the exposure settings. When you're ready, take the shot.

FOCUSING: THE EYES HAVE IT

It has been said that the eyes are the windows to the soul, and nothing could be truer when you are taking a photograph of someone (**Figure 6.7**). You could have the perfect composition and exposure, but if the eyes aren't sharp the entire image suffers. The G12 offers a few techniques for helping to nail down that focus point. (The camera can also identify faces, a feature that is covered in "Detect Faces," later in this chapter.)

ADJUSTING THE AF FRAME

The AF Frame normally sits in the center of the LCD, but as I discussed in Chapter 1, you can move it around the scene to specify a different area of focus. (Press the AF Frame Selector button and then use the navigation buttons or the Control dial to position it onscreen.) If your subject is patient and relatively still, make the frame smaller by pressing the Display button in order to get a more specific focus on one of the person's eyes.

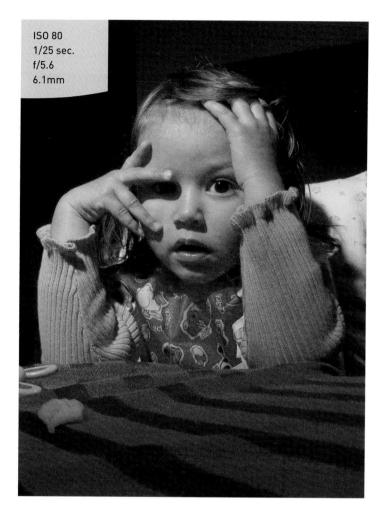

FIGURE 6.7
When photographing people, you should almost always place the emphasis on the eyes. [Photo: Dave Jenson Photography]

MAGNIFYING THE FOCAL POINT

To give you a better idea of whether the AF Frame area is in focus, enable the AF-Point Zoom feature. When you hold the shutter button halfway, you'll see an enlarged view of the focus area in the middle of the screen. (If you don't see the zoomed-in preview, it means the camera can't achieve focus.)

ENABLING AF-POINT ZOOM

- 1. Press the Menu button.
- 2. Press the Down button to select AF-Point Zoom.
- 3. Turn the Control dial to choose On. Press Menu to return to the shooting mode.

BLACK AND WHITE PORTRAITS

Ages ago, I accidentally bought a roll of black and white film and loaded it into my camera without realizing it. Although it produced some nice images (one of which is still a favorite of mine), there was no way I could get color versions of those shots.

With digital photography, everything is color by default. The G12 has a My Colors setting (available from the Function menu) to let you shoot exposures in black and white—or sepia, or several other color variations.

However, I don't recommend them for the same reason I smacked my forehead after getting that roll of film developed. The image sensor is throwing away the color data in favor of applying the effect, and you can't get it back. (Some DSLRs, like Canon's Rebel Tli/500D, let you capture a "monochrome" image with

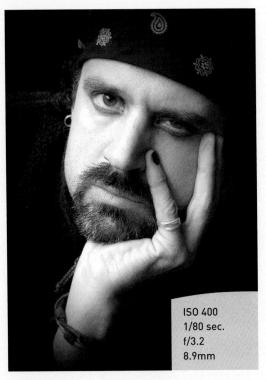

FIGURE 6.8
Black and white portraits can be striking, but it's best to handle them on the computer instead of using the camera's My Colors feature. [Photo: Nicole S. Young]

plenty of control over the black and white attributes and still retain the color version when shooting in RAW mode. However, the My Colors feature of the G12 works only with JPEG-formatted photos.)

This, of course, doesn't mean you have to abandon black and white photography, which can be striking, especially for portraits (**Figure 6.8**). Canon's Picture Photo Professional and even the most basic photo software on your computer include a feature for making color images monochrome. So you're really not missing much by ignoring this feature.

DETECT FACES

Face detection in digital cameras has been around for a few years, but it still seems like magic the first time you use it. When you turn on Face Detection focusing, the camera does an amazing thing: It zeroes in on any face and places a box around it (Figure 6.9). When you press the shutter button halfway, the camera focuses on the face.

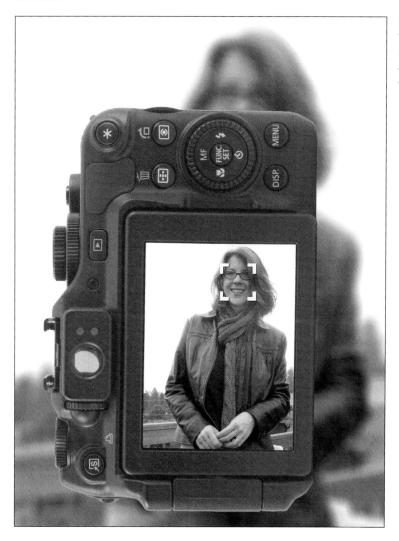

FIGURE 6.9
The Face AiAF
mode can lock on
a subject's face for
easy focusing.

SETTING UP FACE DETECTION FOCUSING

- 1. Press the Menu button.
- **2.** Press the Down button to highlight the AF Frame option.
- Press the Right or Left button and choose Face AiAF (Artificial intelligence Auto Focus).
- 4. Press the Menu button to exit the menu mode.

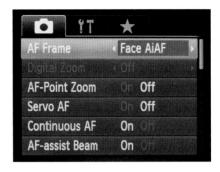

SHOOTING WITH FACE DETECTION

- 1. Point your camera at a person and watch as the frame appears over their face. If more than one person is in the scene, the camera identifies up to three faces at a time; a white box indicates the camera's choice for the main subject, while gray boxes indicate other faces.
- 2. Press the shutter button halfway to view up to nine detected faces.
- 3. Press the shutter button fully to take the photograph.

CHOOSING ONE PERSON USING FACE SELECT

- 1. Press the AF Frame Selector button to enter Face Select mode. The camera focuses on just one face, identified by an orange box. (This mode works only if faces are detected.)
- 2. Press the AF Frame Selector button again to select a different face.
- 3. If you want to exit Face Select mode, press the AF Frame Selector button until the screen reads Face Detect: Off. Otherwise, press the shutter button fully to take the photograph.

TRACKING A PERSON TO MAINTAIN FOCUS

- 1. In the camera's menu, set the AF Frame option to Tracking AF.
- 2. Move the camera so the center target is on the person (or any object) on which you want to focus.
- 3. Press the AF Frame Selector button to enable tracking and reframe the shot. Then press the shutter button to take the photo.

USE FILL FLASH FOR REDUCING SHADOWS

A common problem when taking pictures of people outside, especially during the midday hours, is that the overhead sun can create dark shadows under the eyes and chin. You could have your subject turn his or her face to the sun, but that's usually considered cruel and unusual punishment. So how can you have your subject's back to the sun and still get a decent exposure of the face? Try turning on your flash to fill in the shadows. This also works well when you are photographing someone with a ball cap or someone who has a bright scene behind them. The fill flash helps lighten the subject so they don't appear in shadow, while providing a really nice catchlight in the eyes (Figure 6.10).

FIGURE 6.10
A little fill flash
helps balance your
exposure, gets light
into your subject's
eyes, and lets you
keep the color
of the sky in the
background from
blowing out. [Photo:
Nick Damiano]

CATCHLIGHT

A *catchlight* is that little sparkle that adds life to the eyes. When you are photographing a person with a light source in front of them, you will usually get a reflection of that light in the eye, be it your flash, the sun, or something else brightly reflecting in the eye. The light is reflected off the surface of the eyes as bright highlights and serves to bring attention to the eyes.

The key to using the flash as a fill is to not use it on full power. If you do, the camera will try to balance the flash with the daylight, and you will get a very flat and featureless face.

ADJUSTING HILL FLASH POWER

- 1. Press the Function/Set button.
- 2. Use the Down button to highlight the +/- (Flash) icon (fifth from the top).
- 3. Turn the Control dial (or use the Left or Right button) to select the desired amount of flash compensation.
- **4.** Press the Function/Set button again to accept the setting.

One problem that can quickly surface when using the on-camera flash is red-eye. Not to worry, though—we will talk about that in Chapter 8.

TIPS FOR SHOOTING BETTER PORTRAITS

Before we get to the assignments for this chapter, I thought it might be a good idea to leave you with a few extra pointers on shooting portraits that don't necessarily have anything specific to do with your camera. There are entire books that cover things like portrait lighting, posing, and so on. But here are a few pointers that will make your people pics look a lot better.

GO WIDE FOR ENVIRONMENTAL PORTRAITS

Your subject's environment can be of great significance to the story you want to tell. This might mean using a smaller aperture to get more detail in the background or foreground. Once again, by using Av mode, you can set your aperture to a higher f-stop, such as f/8, and include the important details of the scene that surrounds your subject.

Using the widest angle (6.1mm) can also assist in getting more depth of field as well as showing the surrounding area. The wide angle requires less stopping down of the aperture to achieve an acceptable depth of field. This is due to the fact that the lens is covering a greater area, so the depth of field appears to cover a greater percentage of the scene.

A wider lens setting might also be necessary to relay more information about the scenery (Figure 6.11). Select a zoom level that is wide enough to tell the story but not so wide that you distort the subject; the lens on your camera avoids distortion pretty well, but it can become exaggerated if you're too close to the subject. There's nothing quite as unflattering as giving someone a big, distorted nose (unless you are going for that sort of look). When shooting a portrait at a wide angle, keep the subject away from the edge of the frame to reduce distortion. As the zoom increases, distortion is reduced.

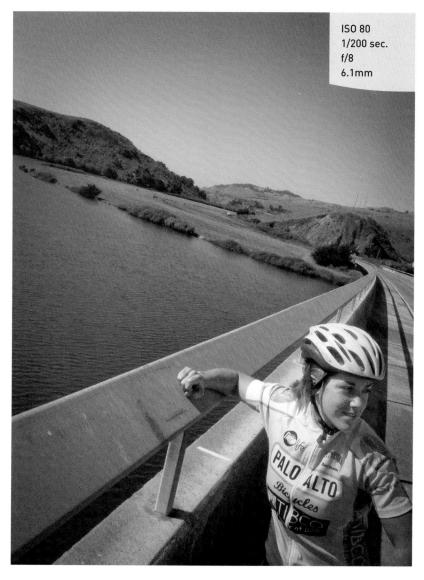

FIGURE 6.11
Here's another
example of defying
expectations: The
subject in your
portrait doesn't need
to occupy the entire
frame. In this case,
the scenery and
angle tell as much
(or more) about the
woman as her outfit
and posture. [Photo:
Anthony Goto]

AVOID THE CENTER OF THE FRAME

This falls under the category of composition. Place your subject to the side of the frame (Figure 6.12)—it just looks more interesting than plunking them smack-dab in the middle.

CHOOSE THE RIGHT FOCAL LENGTH

Choosing the correct zoom can make a huge impact on your portraits. A wide-angle lens can distort features of your subject, which can lead to an unflattering portrait. Selecting a longer focal length can compress your subject's features, which can be more flattering.

PIGURE 6.12
Positioning the subject to one side adds interest and avoids sterile portraits. Also, while a wide angle is normally not advisable for a portrait, here it adds a great sense of play to the shot. [Photo: jvlphoto.com]

USE THE FRAME

Have you ever noticed that most people are taller than they are wide? Turn your camera vertically for a more pleasing composition (Figure 6.13).

FIGURE 6.13
Get in the habit
of turning your
camera to a vertical
position (aptly
named "portrait
orientation") when
shooting portraits.
[Photo: Rich Legg]

SUNBLOCK FOR PORTRAITS

The midday sun can be harsh and can do unflattering things to people's faces. If you can, find a shady spot out of the direct sunlight. You will get softer shadows, smoother skin tones, and better detail (**Figure 6.14**). This holds true for overcast skies as well. Just be sure to adjust your white balance accordingly.

FIGURE 6.14
Shady spots are great because they aren't susceptible to blown-out areas caused by strong sunlight. [Photo: Caroline Ward]

DON'T CUT THEM OFF AT THE KNEES

There is an old rule about photographing people: Never crop the picture at a joint. This means no cropping at the ankles or the knees. If you need to crop at the legs, the proper place to crop is mid-shin or mid-thigh.

KEEP AN EYE ON YOUR BACKGROUND

Sometimes it's so easy to get caught up in taking a great shot that you forget about the smaller details. Try to keep an eye on what is going on behind your subject so they don't end up with things like tree limbs popping out of their heads.

FRAME THE SCENE

Using elements in the scene to create a frame around your subject is a great way to draw the viewer in. You don't have to use a window frame to do this. Just look for elements in the foreground that could be used to force the viewer's eye toward your subject (Figure 6.15).

FIGURE 6.15
I was trying to get an action shot of the spinning merrygo-round, but this image ended up as a happy accident that uses the bars to frame the subject and draw in the viewer's eyes.
[Photo: Jeff Carlson]

ELIMINATE SPACE BETWEEN YOUR SUBJECTS

One of the problems you can encounter when taking portraits of more than one person is that of personal space. What feels like a close distance to the subjects can look impersonal to the viewer. Have your subjects move close together, eliminating any big gaps between them (Figure 6.16).

GIVE THEM A HEALTHY GLOW

Nearly everyone looks better with a warm, healthy glow. Some of the best light of the day happens just a little before sundown, so shoot at that time if you can.

FIGURE 6.16
Getting siblings
close together can
sometimes be a
challenge, but the
results are worth
the effort. [Photo:
Crystal Photo
Memories]

GET DOWN ON THEIR LEVEL

If you want better pictures of children, don't shoot from an adult's eye level. Getting the camera down to the child's level will make your images look more personal (Figure 6.17).

FIGURE 6.17 Sometimes taking photographs of children means lying on the ground, but the end result is a much better image. [Photo: Jeff Carlson]

DON'T BE AFRAID TO GET CLOSE

When you are taking someone's picture, don't be afraid of getting close and filling the frame (Figure 6.18). This doesn't mean you have to shoot from a foot away; try zooming in and capture the details.

FIGURE 6.18
Filling the frame
with the subject's
face can lead to
a much more
intimate portrait.
[Photo: Manolo
Millan]

Chapter 6 Assignments

Depth of field in portraits

Let's start with something simple. Grab your favorite person and start experimenting with using different aperture settings. Shoot wide open at f/2.8 and then really stopped down to f/8. Look at the difference in the depth of field and how it plays an important role in placing the attention on your subject. (Make sure you don't have your subject standing against a backdrop. Give some distance so that there is a good blurring effect of the background at the wide f-stop setting.)

Discovering the qualities of natural light

Pick a nice sunny day and try shooting some portraits in the midday sun. If your subject is willing, have them turn so the sun is in their face. If they are still speaking to you after you've blinded them, have them turn their back to the sun. Try this with and without the fill flash so you can see the difference. Finally, move your subject into a completely shaded spot and take a few more.

Picking the right metering method

Find a very dark or light background and place your subject in front of it. Now take a couple of shots, giving a lot of space around your subject for the background to show. Now switch metering modes and use the AE Lock feature to get a more accurate reading of your subject. Notice the differences in exposure between the metering methods.

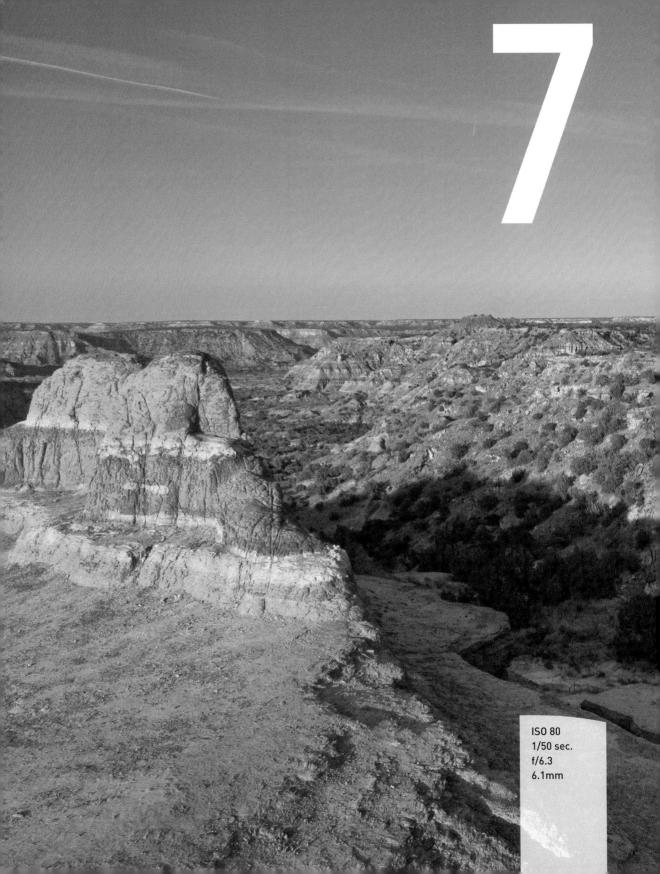

Landscape Photography

TIPS, TOOLS, AND TECHNIQUES TO GET THE MOST OUT OF YOUR LANDSCAPE PHOTOGRAPHY

I'll admit, shooting landscapes kind of scares me. They seem easy: Just take a picture where you can see the horizon, right? Naturally, there's more to capturing a good landscape image than that. You need a combination of location, timing, luck, patience, and not a small amount of stamina—you are working outdoors at the mercy of Mother Nature. But when a landscape photo is done well, you can't take your eyes off it. The end result is a celebration of light, composition, and the world we live in.

In this chapter, we will explore some of the features of the G12 that not only improve the look of your landscape photography, but also make it easier to take great shots. We will also explore some typical scenarios and discuss methods to bring out the best in your work.

Photo: Jeff Lynch 125

PORING OVER THE PICTURE

The secret to shooting great landscapes? Be an early riser. Jan Messersmith captured this vibrant sunrise by being ready with his camera before 6 a.m. The angle of the sun at early morning and late afternoon hours displays colors you won't see at other times during the day.

The lights of the buildings on the left portion of the photo tie in with the orange sunrise on the right.

1S0 80 6 sec. f/5.6 6.1mm

Although the sunrise itself is . happening in the lower-third portion of the image, the cool gradation in the sky draws your eye to the horizon. Shooting near water effectively gives you two sunrises.

SHARP AND IN FOCUS: USING TRIPODS

Throughout the previous chapters we have concentrated on using the camera to create great images. We will continue that trend in this chapter, but there is one additional piece of equipment that is crucial in the world of landscape shooting: the tripod. A tripod is critical for a couple of reasons. The first relates to the time of day that you will be working. For reasons that will be explained later, the best light for most landscape work happens at sunrise and just before sunset. While this is the best time to shoot, it's also kind of dark. That means you'll be working with slow shutter speeds. Slow shutter speeds mean camera shake. Camera shake equals bad photos.

The second reason is also related to the amount of light that you're gathering with your camera. When taking landscape photos, you will usually want to be working with very small apertures, as they give you lots of depth of field (DOF). This also means that, once again, you will be working with slower-than-normal shutter speeds.

Slow shutter = camera shake = bad photos.

Do you see the pattern here? The one tool in your arsenal to truly defeat the camera shake issue and ensure tack-sharp photos is a good tripod (Figure 7.1).

So what should you look for in a tripod? Well, first make sure it's sturdy. Sure, the G12 is a lightweight camera, but a \$10 cheapie tripod is likely to wobble, buckle, or bounce at the slightest provocation (such as wind). Next, check the height of the tripod. Your day will end much better if you haven't bent over for hours framing shots. Finally, think about getting a tripod that utilizes a quick-release head. This usually employs a plate that screws into the bottom of the camera and then quickly snaps into place on the tripod. This will be especially handy if you are going to move between shooting by hand and using the tripod.

TRIPOD STABILITY

Most tripods have a center column that allows the user to extend the height of the camera above the point where the tripod legs join together. This might seem like a great idea, but the reality is that the further you raise that column, the less stable your tripod becomes. Think of a tall building that sways near the top. To get the most solid base for your camera, always try to use it with the center column at its lowest point so that your camera is right at the apex of the tripod legs.

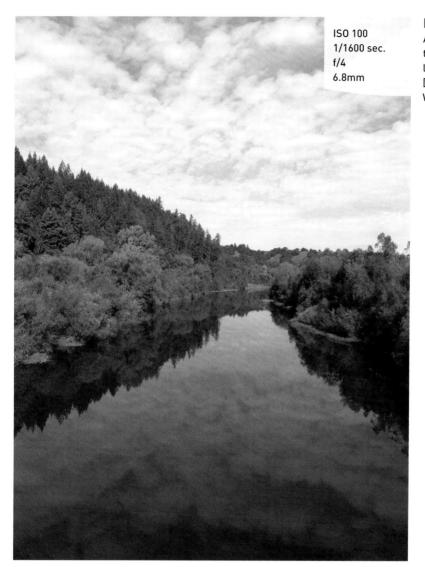

FIGURE 7.1 A sturdy tripod is the key to sharp landscape photos. [Photo: Deak Wooten]

IMAGE STABILIZATION AND TRIPODS DON'T MIX

If you are using the image stabilizer (IS) feature, remember to turn it off when you use a tripod. While trying to minimize camera movement, the image stabilizer can actually *create* movement when the camera is already stable. To turn off the IS feature, press the Menu button, scroll down to the IS Mode item, and set it to Off.

ENABLE THE G12'S BUILT-IN LEVEL

When you want a level horizon but don't have a tripod, look no further than the G12's LCD. A built-in digital level can help straighten your shots. To enable it, go to the Tools menu (the middle tab in the menu screen) and scroll down to Electronic Level. Press the Function/Set button, and choose Calibrate. Exit the menus and, when you're shooting, press the Display button. The level appears at the bottom of the screen. When the "bubble" is in the middle and turns green, you're level. The feature also works in portrait orientation.

SELECTING THE PROPER ISO

When shooting most landscape scenes, the ISO is the one factor that should only be changed as a last resort. While it is easy to select a higher ISO to get a smaller aperture, the noise that it can introduce into your images can be quite harmful (**Figure 7.2**). The noise is not only visible as large grainy artifacts; it can also be multicolored, which

FIGURE 7.2 A high ISO setting created a lot of digital noise in the shadows (left).

When the image is enlarged, the noise is even more apparent (right). [Photos: Jeff Carlson]

further degrades the image quality. Take a look at the image on the left, which was taken with an ISO of 1600. The purpose was to shorten the shutter speed to avoid camera shake in early evening light. The noise level is not only distracting, but also introduces a lot of color.

Now check out another image that was taken at the same time but with a much lower ISO setting (Figure 7.3). As you can see, the noise levels are much lower, which means that my blacks look black, and the texture you're seeing is the wall, not the noise from the camera's sensor.

When shooting landscapes, set your ISO to the lowest possible setting at all times. Between the use of image stabilization (if you are shooting handheld) and a good tripod, there should be few circumstances in which you would need to shoot landscapes with anything above an ISO of 400.

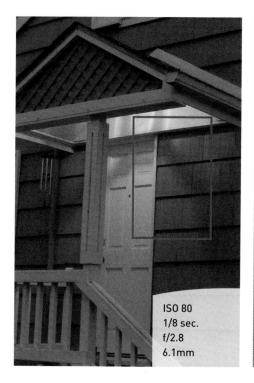

FIGURE 7.3 By lowering the ISO to 80, I was able to avoid the noise and capture a clean image (left).

Zooming in shows that the noise levels for this image are almost nonexistent (right). [Photos: Jeff Carlson]

SELECTING A WHITE BALANCE

This probably seems like a no-brainer. If it's sunny, select Day Light. If it's overcast, choose the Cloudy setting. Those choices wouldn't be wrong for those circumstances, but why limit yourself? Sometimes you can change the mood of the photo by selecting a white balance that doesn't quite fit the light for the scene that you are shooting. Figure 7.4 is an example of a correct white balance. It was late afternoon and the sun was starting to move low in the sky, giving everything that warm afternoon glow. But what if I wanted to make the scene look like it was shot earlier in the day? Simple; I just changed the white balance to Tungsten, a much cooler setting (Figure 7.5).

You can select the most appropriate white balance for your shooting conditions by scrolling through the options in the Function menu; the LCD updates to preview each look as you select it. Even better, you can choose a custom setting that will let you dial in exactly the right look for your image.

CHANGING WHITE BALANCE SETTINGS

- 1. Press the Function/Set button to activate the Function menu. The White Balance control is at the top of the list and automatically highlighted.
- 2. Use the Control dial to select the white balance setting.
- 3. Optionally make finer adjustments using the Front dial (see Chapter 1).
- 4. Press the Function/Set button to lock in your change and resume shooting.

FIGURE 7.4
Using the "proper"
white balance
yields predictable
results. [Photo:
Jeff Carlson]

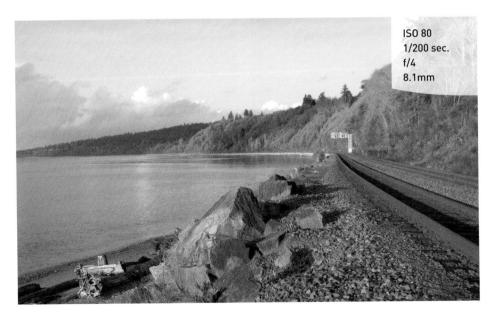

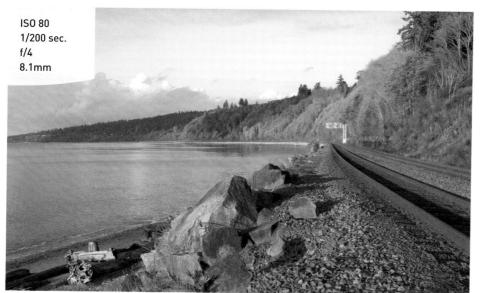

FIGURE 7.5 Changing the white balance to Tungsten gives the impression that the picture was taken at a different time of day. [Photo: Jeff Carlson]

TAMING BRIGHT SKIES WITH EXPOSURE COMPENSATION

Balancing the exposure in scenes that have a wide contrast in tonal ranges can be extremely challenging. The one thing you should try not to do is overexpose your skies to the point of blowing out your highlights (unless, of course, that is the look you are going for). It's one thing to have a clear sky, but it's a completely different and bad thing to have nothing but white space. This usually happens when the camera is trying to gain exposure in the darker areas of the image (**Figure 7.6**).

The one way to tell if you have blown out your highlights is to check the camera's Highlight Alert, or "blinkies," feature (see the "How I Shoot" section in Chapter 4). When you take a shot where the highlights are exposed beyond the point of having any detail, that area will blink in your LCD display. It is up to you to determine if that particular area is important enough to regain detail by altering your exposure. If the answer is yes, then the easiest way to go about it is to use some exposure compensation.

With this feature, you can force your camera to choose an exposure that ranges, in 1/3-stop increments, from two stops over to two stops under the metered exposure (Figure 7.7).

FIGURE 7.6
The building's exposure is fine, but the sky is blown out and the leaves in the foreground are pale. [Photo: Jeff Carlson]

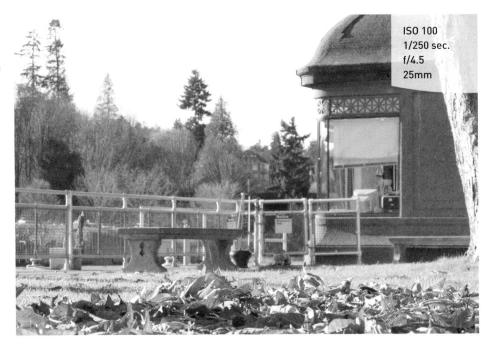

FIGURE 7.7
A compensation
of 1 stop of underexposure brought
back the color of
the sky and detail
in the highlights.
[Photo: Jeff Carlson]

USING EXPOSURE COMPENSATION TO REGAIN DETAIL IN HIGHLIGHTS

- 1. Turn the Exposure Compensation dial counterclockwise one notch to reduce the exposure by a 1/3-stop increment.
- 2. Take a photo and review the result.
- 3. If the blinkies are gone, you are good to go. If not, keep subtracting from your exposure by 1/3 of a stop until you have a good exposure in the highlights.

I generally keep my camera set to -1/3 stop for most of my landscape work unless I am working with a location that is very dark or low-key. That helps avoid blown-out highlights, and often increases the saturation slightly.

HIGH-KEY AND LOW-KEY IMAGES

When you hear someone refer to a subject as being *high-key*, it usually means that the entire image is composed of a very bright subject with very few shadow areas—think snow or beach. It makes sense, then, that a *low-key* subject has very few highlight areas and a predominance of shadow areas. Think of a cityscape at night as an example of a low-key photo.

THE GOLDEN LIGHT

If you ask any professional landscape photographer what their favorite time of day to shoot is, chances are they will tell you it's the hours surrounding daybreak and sunset (Figures 7.8 and 7.9). Light comes from a very low angle to the landscape, which creates shadows and gives depth and character. There is also a quality to the light that seems cleaner and is more colorful than the light you get when shooting at midday. One thing that can dramatically improve any morning or evening shot is the presence of clouds. The sun fills the underside of the clouds with a palette of colors and adds drama to your skies.

FIGURE 7.8
The few minutes
just prior to sunrise
can add great
colors to the sky.
[Photo: Evan
Spellman/Earth
Light Photography]

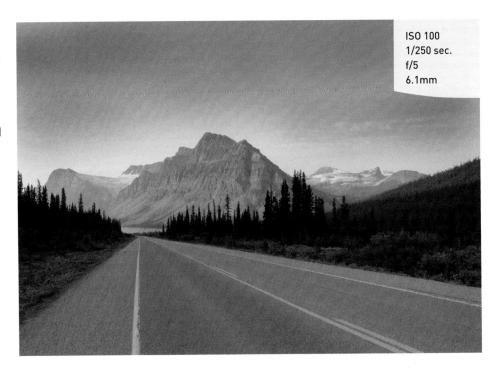

FIGURE 7.9 Late afternoon sun is usually warmer and adds drama and warmth to the clouds. [Photo: Jeff Carlson]

WARM AND COOL COLOR TEMPERATURES

These two terms are used to describe the overall colorcast of an image. Reds and yellows are said to be *warm*, which is usually the look that you get from the late afternoon sun. Blue is usually the predominant color when talking about a *cool* cast.

WHERE TO FOCUS

Large landscape scenes are great fun to photograph, but they can present a problem: Where exactly do you focus when you want everything to be sharp? Since our goal is to create a great landscape photo, we will need to concentrate on how to best create an image that is tack sharp, with a depth of field that renders great focus throughout the scene.

I have already stressed the importance of a good tripod when shooting landscapes. The tripod lets you concentrate on the aperture portion of the exposure without worrying how long your shutter will be open. This is because the tripod provides the stability to handle any shutter speed you might need when shooting at small apertures. Set your camera to Aperture Priority mode and the ISO to 80 for a clean, noise-free image.

However, shooting with the smallest aperture on your lens doesn't necessarily mean that you will get the proper sharpness throughout your image. The real key is knowing where in the scene to focus your lens to maximize the depth of field for your chosen aperture. To do this, you must utilize something called the "hyper focal distance" (HFD) of your lens.

TACK SHARP

Here's one of those terms that photographers like to throw around. *Tack sharp* refers not only to the focus of an image but also the overall sharpness of the image. This usually means that there is excellent depth of field in terms of sharp focus for all elements in the image. It also means that there is no sign of camera shake, which can give soft edges to subjects that should look nice and crisp. To get your images tack sharp, use a small depth of field, don't forget your tripod, use the self-timer to activate the shutter if no cable release is handy, and practice achieving good hyper focal distance when picking your point of focus.

HFD is the point of focus that will give you the greatest acceptable sharpness from a point near your camera all the way out to infinity. If you combine good HFD practice in combination with a small aperture, you will get images that are sharp to infinity.

There are a couple of ways to do this, and the one that is probably the easiest, as you might guess, is the one that is most widely used by working pros. When you have your shot all set up and composed, focus on an object that is about one-third of the distance into your frame (**Figure 7.10**). It is usually pretty close to the proper distance and will render favorable results.

One thing to remember is that as your lens gets wider in focal length, your HFD will be closer to the camera position. This is because the wider the lens, the greater depth of field you can achieve.

FIGURE 7.10
Focusing about a third of the way down the tracks helps to create a nice long depth of field (even with the camera's middle-of-the-road aperture of f/4). [Photo: Paul Hunter]

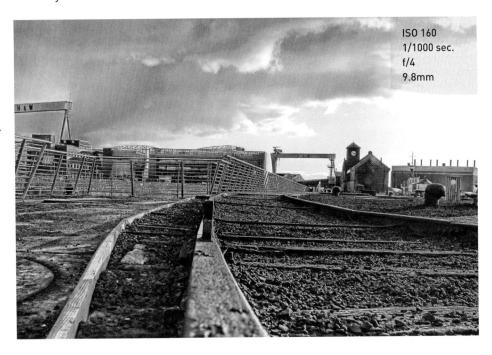

EASIER FOCUSING

There's no denying that the automatic focus features on the G12 are great, but sometimes it pays to turn them off and go manual. This is especially true if you are shooting on a tripod: Once you have your shot composed in the viewfinder and you are ready to focus, chances are the area you want to focus on is not going to be in the AF Frame. Often this is the case when you have a foreground element that is fairly low in the shot. You could position the frame low and then pan the camera down until it rests on your subject, but then you would have to press the shutter button halfway to focus the camera and then try to recompose and lock down the tripod. It's no easy task.

But you can have the best of both worlds by having the camera focus for you, then switching to manual focus to comfortably recompose your shot.

GETTING FOCUSED WHILE USING A TRIPOD

- 1. Set up your shot and find the area that you want to focus on.
- 2. Pan your tripod head so that the AF Frame is on that spot.
- 3. Press the shutter button halfway to focus the camera and then remove your finger from the button.
- 4. Switch the camera to manual focus by pressing the MF button.
- 5. Recompose the image on the tripod and then take the shot.

The camera fires without trying to refocus the lens.

MAKING WATER FLUID

There's nothing quite as satisfying for the landscape shooter as capturing a silky waterfall shot. Creating the smooth-flowing effect is as simple as adjusting your shutter speed to allow the water to be in motion while the shutter is open. The key is to have your camera on a stable platform (such as a tripod) and use a shutter speed that's long enough to work—at least 1/15 of a second or longer (Figure 7.11).

FIGURE 7.11
Waterfalls at long
exposures take on a
completely different
appearance than
when shot at typical
shutter speeds.
[Photo: Jeff Lynch]

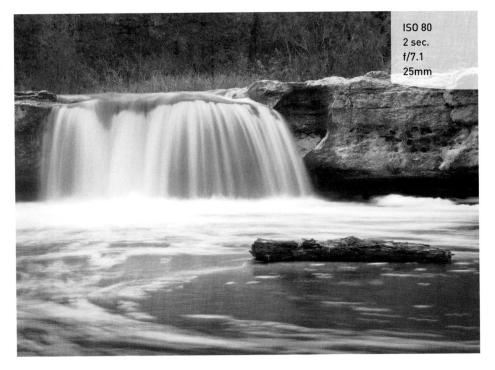

SETTING UP FOR A WATERFALL SHOT

- 1. Attach the camera to your tripod, then compose and focus your shot.
- 2. Make sure the ISO is set to 80.
- 3. Using Av mode, set your aperture to f/8, the smallest opening.
- 4. Press the shutter button halfway so the camera takes a meter reading.
- 5. Check to see if the shutter speed is 1/15 or slower.
- 6. Take a photo and then check the image on the LCD.

If the water is blinking on the LCD, indicating a loss of detail in the highlights, then use the Exposure Compensation dial (as discussed earlier in this chapter) to bring details back into the waterfall.

There is a possibility that you will not be able to have a shutter speed that is long enough to capture a smooth, silky effect, especially if you are shooting in bright daylight conditions. To overcome this obstacle, try enabling the Neutral Density filter. This feature darkens the scene by three stops (1/8 the light intensity), which allows you to use slower shutter speeds during bright conditions. Think of it as sunglasses for your camera lens (Figure 7.12).

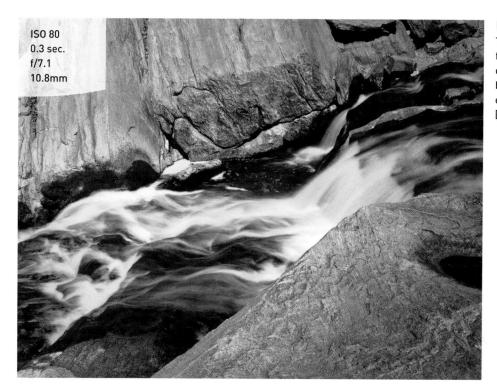

FIGURE 7.12
The Neutral Density
filter prevents
overexposed areas
by darkening the
entire exposure.
[Photo: Jeff Lynch]

ENABLING THE NEUTRAL DENSITY FILTER

- 1. Press the Function/Set button to bring up the Function menu.
- 2. Press the Down button and highlight the ND Filter icon.
- 3. Turn the Control dial or press the Right or Left button to select ND Filter On.
- 4. Press Function/Set again to exit the menu.

DIRECTING THE VIEWER: A WORD ABOUT COMPOSITION

As a photographer, it's your job to lead the viewer through your image. You accomplish this by utilizing the principles of composition, which is the arrangement of elements in the scene that draws the viewer's eye through the image and holds their attention. As the director, you need to understand how people see, and then use that information to focus their attention on the most important elements in your image.

There is a general order at which we look at elements in a photograph. The first is brightness. The eye wants to travel to the brightest object within a scene. So if you have a bright sky, it's probably the first place the eye will travel to. The second order of attention is sharpness. Sharp, detailed elements will get more attention than soft, blurry areas. Finally, the eye will move to vivid colors while leaving the dull, flat colors for last. It is important to know these essentials in order to grab—and keep—the viewer's attention and then direct them through the frame.

In **Figure 7.13**, the eye is drawn to the bright white cloud in the middle of the frame. From there, it is pulled by the vibrant sky down to the reflection in the water, and finally along the sharp grasses of the river bank. The elements within the image all help to keep the eye moving but never leave the frame.

RULE OF THIRDS

There are, in fact, quite a few philosophies concerning composition. The easiest one to begin with is known as the "rule of thirds." Using this principle, you simply divide your LCD into thirds by imagining two horizontal and two vertical lines that divide the frame equally.

If you prefer something more concrete, press the Display button to make a grid overlay the screen. (You can turn the grid off permanently by going to the camera's main menu, selecting Custom Display, and pressing the Function/Set button in the boxes to the right of Grid Lines to make sure neither includes a checkmark.)

The key to using this method of composition is to position your main subject at or near one of the intersecting points.

By placing your subject near these intersecting lines, you are giving the viewer space to move within the frame. The one thing you don't want to do is place your subject smack-dab in the middle of the frame. This is sometimes referred to as "bull's eye" composition, and it requires the right subject matter for it to work. It's not always wrong, but it will usually be less appealing and may not hold the viewer's focus.

Speaking of the middle of the frame, the other general rule of thirds deals with horizon lines. Generally speaking, you should position the horizon one-third of the way up or down in the frame (**Figure 7.14**). Splitting the frame in half by placing your horizon in the middle of the picture is akin to placing the subject in the middle of the frame; it doesn't lend a sense of importance to either the sky or the ground.

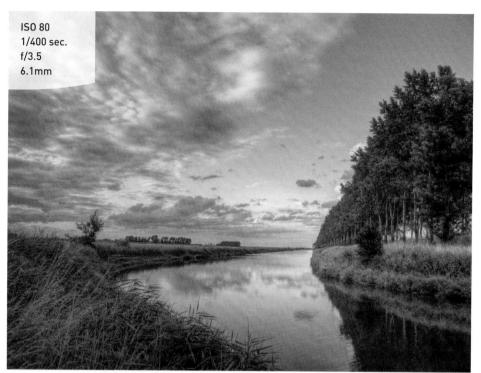

FIGURE 7.13
The composition of
the elements pulls
the viewer's eyes
around the image,
leading from one
element to the
next in a circular
pattern. [Photo:
Chris Thomas]

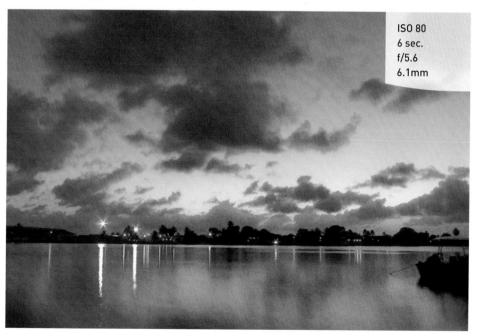

FIGURE 7.14
Placing the
horizon of this
image at the bottom
third of the frame
places emphasis
on the village above
it. [Photo: Jan
Messersmith]

CREATING DEPTH

Because a photograph is a flat, two-dimensional space, you need to create a sense of depth by using the elements in the scene to create a three-dimensional feel. This is accomplished by including different and distinct spaces for the eye to travel: a foreground, middle ground, and background. By using these three spaces, you draw the viewer in and render depth to your image.

Jeff Lynch's photo of sunset at Palo Duro Canyon, shown in **Figure 7.15**, contains a lot of motion for a still landscape. The outcropping in the foreground at left draws your eye, but then the shadow casts your view to the opposite ridge in the middle ground, and the rest of the canyon extends toward the center of the frame.

FIGURE 7.15
The dominant
outcropping and
shadows against
the receding background add to the
feeling of depth in
this image. [Photo:
Jeff Lynch]

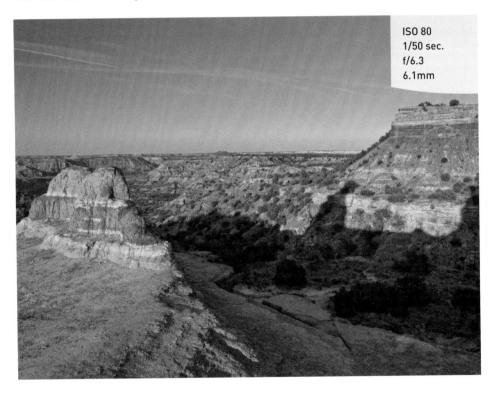

ADVANCED TECHNIQUES TO EXPLORE

For most of this book, I've focused on how to take a great *shot*—one exposure, one image. But shooting digital opens other options that combine several shots into one better photo. The following two sections, covering panoramas and high dynamic range (HDR) images, require you to use image-processing software to complete the photograph. They are, however, important enough that you should know how to correctly shoot for success, should you choose to explore these two popular techniques.

SHOOTING PANORAMAS

If you have ever visited the Grand Canyon, you know just how large and wide open it truly is—so much so that it's difficult to capture its splendor in just one frame. The same can be said for a mountain range, or a cityscape, or any extremely wide vista. Two methods can help you capture the feeling of this type of scene.

THE "FAKE" PANORAMA

The first method is to shoot as wide as you can and then crop out the top and bottom portion of the frame. Panoramic images are generally two or three times wider than a normal image.

CREATING A FAKE PANORAMA

- 1. To create the look of the panorama, zoom out to the camera's widest focal length, 6.1mm.
- 2. Using the guidelines discussed earlier in the chapter, compose and focus your scene, and select the smallest aperture possible.
- 3. Shoot your image. That's all there is to it, from a photography standpoint.
- **4.** Open the image in your favorite image-processing software and crop the extraneous foreground and sky from the image, leaving you with a wide panorama of the scene.

Figure 7.16 isn't a terrible photo, but the amount of sky at the top of the image detracts from the dramatic clouds below. This isn't a problem, though, because it was shot for the purpose of creating a "fake" panorama. Now look at the same image, cropped for panoramic view (**Figure 7.17**). As you can see, it makes a huge difference and gives much higher visual impact by drawing your eyes across the length of the image.

FIGURE 7.16
This is an okay image, but the sky occupying the top half detracts from the clouds. [Photo: Jeff Carlson]

FIGURE 7.17 Cropping adds more visual impact and makes for a more appealing image. [Photo: Jeff Carlson]

THE MULTIPLE-IMAGE PANORAMA

The reason the previous method is sometimes referred to as a "fake" panorama is because it is made with a standard-size frame and then cropped down to a narrow perspective. To shoot a true panorama, you need to combine several frames. Although the camera can't stitch the photos together, it does contain a Stitch Assist mode that aids in lining up the images to be merged together later.

The multiple-image pano has grown in popularity in the past few years; this is principally due to advances in image-processing software. Many software options are available now that will take multiple images, align them, and then "stitch" them into a single panoramic image (Figures 7.18 and 7.19). The real key to shooting a multiple-image pano is to overlap your shots by about 30 percent from one frame to the next. I'll cover the Stitch Assist mode, but I've also included instructions for doing the job manually. Also, it's possible to handhold the camera while capturing your images, but you'll get much better results if you use a tripod.

USING THE STITCH ASSIST MODE

- 1. Mount your camera on your tripod and make sure it is level.
- **2.** Choose a focal length for your lens that is somewhere in the middle of the zoom range (a wide angle can distort the edges, making it harder to stitch together).
- 3. Turn the Mode dial to SCN and then turn the Control dial until you've selected the Stitch Assist scene. (There are actually two Stitch Assist scenes: One helps you shoot left to right, the other helps you shoot right to left.)
- 4. Take the first photo.
- **5.** Carefully pan the camera, using the portion of the previous shot as a guide to align the next shot (see below). When the two images overlap, capture another photo.
- **6.** Repeat steps 4 and 5 until you've captured the entire panorama. Then switch to another mode to exit Stitch Assist.

SHOOTING PROPERLY FOR A MULTIPLE-IMAGE PANORAMA

- 1. Mount your camera on a tripod and make sure it is level.
- 2. Choose a focal length for the lens.
- 3. In Av mode, use a very small aperture for the greatest depth of field. Take a meter reading of a bright part of the scene, and make note of it.
- 4. Now change your camera to Manual mode (M), and dial in the aperture and shutter speed that you obtained in the previous step.

FIGURE 7.18 Here you see the makings of a panorama, with four shots overlapping by about 30 percent from frame to frame. [Photos: Jeff Carlson]

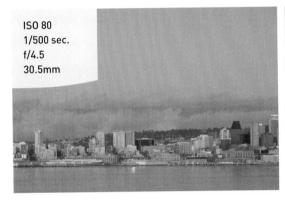

FIGURE 7.19 I used Adobe **Photoshop Elements** to combine the exposures into one large panoramic image. I also cropped and adjusted the color

of the final image.

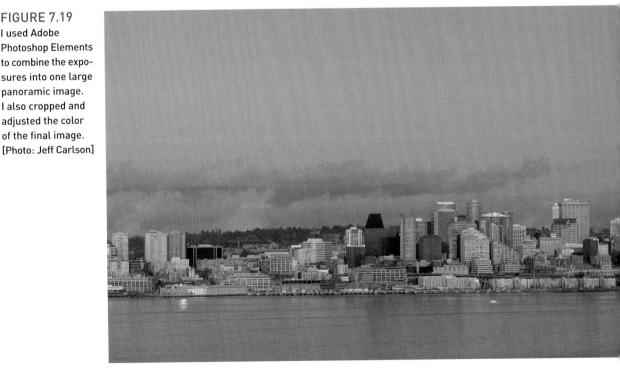

- 5. Switch to manual focus, and then focus your lens for the area of interest. (If you use autofocus, you risk getting different points of focus from image to image, which makes the stitching more difficult for the software.) Or, use the autofocus and remember to set the lens to MF before shooting your images.
- **6.** While carefully panning your camera, shoot your images to cover the entire area of the scene from one end to the other, leaving a 30 percent overlap from one frame to the next.

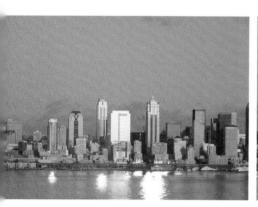

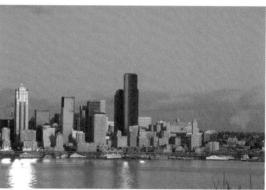

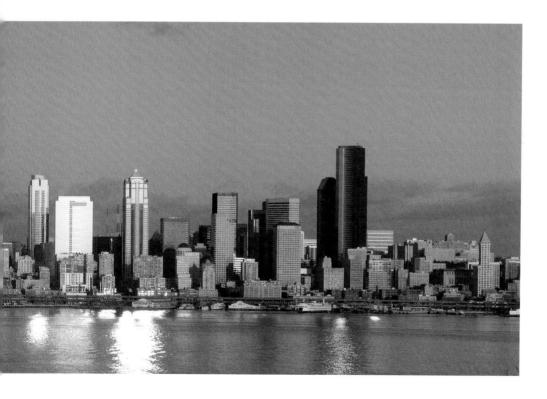

Now that you have your series of overlapping images, you can import them into your image-processing software to stitch them together and create a single image.

SHOOTING HIGH DYNAMIC RANGE (HDR) IMAGES

One of the more recent trends in digital photography is the use of high dynamic range (HDR) to capture the full range of tonal values in your final image. Typically, when you photograph a scene that has a wide range of tones from shadows to highlights, you have to make a decision regarding which tonal values you are going to emphasize, and then adjust your exposure accordingly. This is because your camera has a limited dynamic range, at least as compared to the human eye. HDR photography allows you to capture multiple exposures for the highlights, shadows, and midtones, and then combine them into a single image (Figures 7.20–7.23).

There are two ways to get an HDR image with the G12. Switch to the SCN mode and choose the HDR option. Be sure to stabilize the camera on a tripod or other solid surface and press the shutter button to take the shot. The camera shoots and combines multiple exposures into one HDR shot with a complete range of exposures using a process called "tonemapping."

For more control over the HDR photo's appearance, capture multiple shots at different exposures and use third-party software to process them. I will not be covering the software applications, but I will explore the process of shooting a scene to help you render properly captured images for the HDR process. Note that using a tripod is absolutely necessary for this technique, since you need to have perfect alignment of each image when they are combined.

SORTING YOUR SHOTS FOR THE MULTI-IMAGE PANORAMA

If you shoot more than one series of shots for your panoramas, it can sometimes be difficult to know when one series of images ends and the other begins. Here is a quick tip for separating your images.

Set up your camera using the steps listed here. Now, before you take your first good exposure in the series, hold up one finger in front of the camera and take a shot. Now move your hand away and begin taking your overlapping images. When you have taken your last shot, hold two fingers in front of the camera and take another shot.

Now, when you go to review your images, use the series of shots that falls between the frames with one and two fingers in them. Then just repeat the process for your next panorama series.

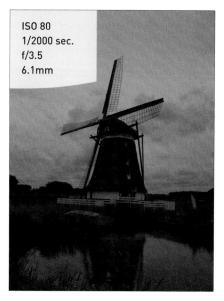

FIGURE 7.20 Underexposing one stop renders more detail in the highlight areas of the sky. [Photo: Chris Thomas]

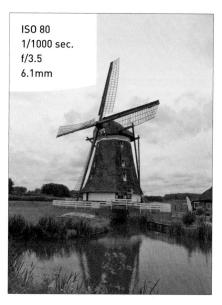

FIGURE 7.21
This is the normal exposure as dictated by the camera meter. [Photo: Chris Thomas]

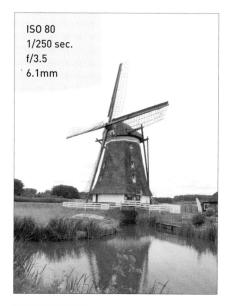

FIGURE 7.22

Overexposing by two stops ensures that the darker areas are exposed to get detail in the shadows. [Photo: Chris Thomas]

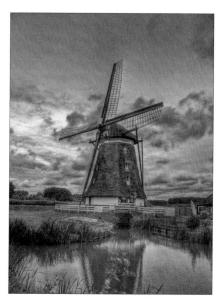

FIGURE 7.23
This is the final HDR image that was rendered from the three other exposures.
[Photo: Chris Thomas]

SETTING UP FOR SHOOTING AN HDR IMAGE

- 1. Set your ISO to 80 to ensure clean, noise-free images.
- 2. Set your program mode to Av. During the shooting process, you will be taking three shots of the same scene, creating an overexposed image, an underexposed image, and a normal exposure. Since the camera is going to be adjusting the exposure, you want it to make changes to the shutter speed, not the aperture, so that your depth of field is consistent.
- 3. Set your camera file format to RAW. This is extremely important because the RAW format contains a much larger range of exposure values than a JPEG file, and the HDR software will need this information.
- 4. Adjust the auto exposure bracket (AEB) mode to shoot three exposures in two-stop increments. To do this, press the Function/Set button and highlight the Bracket setting (third from the top). Next, use the Control dial or press the Right button to select the AEB option (A).
- **5.** Press the Display button to access the exposure control setting.
- 6. Turn the Control dial to the right until the AEB indicators move all the way out to -2 and +2 (B). Press the Set button to lock in your changes.
- 7. Focus the camera using the manual focus method discussed earlier, compose your shot, secure the tripod, and press the shutter button once; the camera fires all three shots automatically.

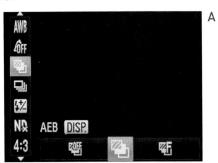

A software program such as Adobe Photoshop or Photomatix Pro can now process your exposure-bracketed images into a single HDR file.

BRACKETING YOUR EXPOSURES

In HDR, *bracketing* is the process of capturing a series of exposures at different stop intervals. You can bracket your exposures even if you aren't going to be using HDR. Sometimes this is helpful when you have a tricky lighting situation and you want to ensure that you have just the right exposure to capture the look you're after. You can bracket in increments as small as a third of a stop. This means that you can capture several images with very subtle exposure variances and then decide later which one is best.

Chapter 7 Assignments

We've covered a lot of ground in this chapter, so it's definitely time to put this knowledge to work in order to get familiar with these new camera settings and techniques.

Comparing depth of field: wide-angle vs. telephoto

Practice using the hyper focal distance of the lens to maximize the depth of field. You can do this by picking a focal length to work with on the lens—try using the longest length. Compose your image and find an object to focus on. Set your aperture to f/8 and take a photo.

Now do the same thing with the zoom at its widest focal length. Use the same aperture and focus point.

Review the images and compare the depth of field when using a wide angle as opposed to a telephoto zoom. Try this again with a large aperture as well.

Applying hyper focal distance to your landscapes

Pick a scene that once again has objects that are near the camera position and something that is clearly defined in the background. Use a small aperture and focus on the object in the foreground; then recompose and take a shot. Without moving the camera position, use the object in the background as your point of focus and take another shot. Finally, find a point that is one-third of the way into the frame from near to far and use that as the focus point. Compare all of the images to see which method delivered the greatest range of depth of field.

Using the rule of thirds

With the grid lines visible, practice shooting while placing your main subject in one of the intersecting line locations. Take some comparison shots with the subject at one of the intersecting locations, and then shoot the same subject in the middle of the frame.

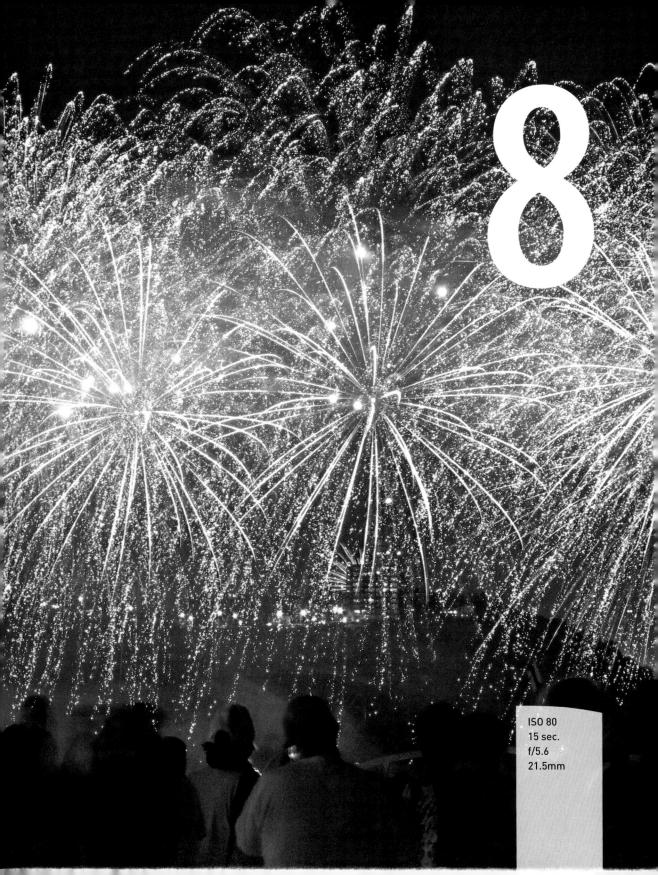

Mood Lighting

SHOOTING WHEN THE LIGHTS GET LOW

There's no reason to put your camera away when the sun goes down. Your G12 has some great features that let you work with available light as well as the built-in flash. In this chapter, we'll explore ways to push your camera's technology to capture great photos in difficult lighting situations. We'll also explore the use of flash and how best to utilize your built-in flash features to improve your photography. But first let's look at working with low-level available light.

PORING OVER THE PICTURE

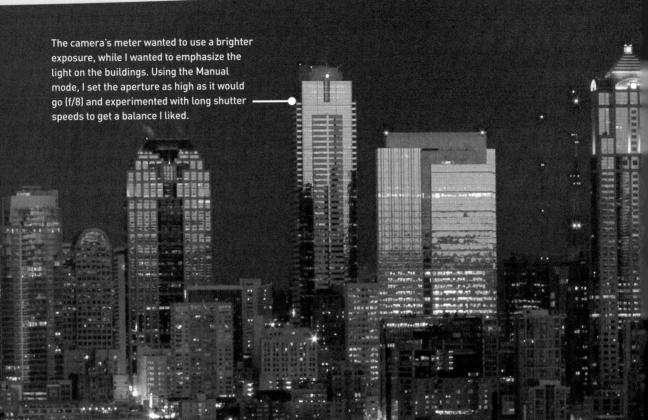

When the sun sets in Seattle, it reflects off the buildings downtown to give them a warm glow, which can be even more dramatic when set against dark clouds. I set up a tripod at Hamilton Viewpoint Park in West Seattle and waited for the sun to go down, snapping dozens of shots with exposure settings all over the map. Not only did this session provide some nice photos, it was also a relaxing way to spend a couple of hours outside.

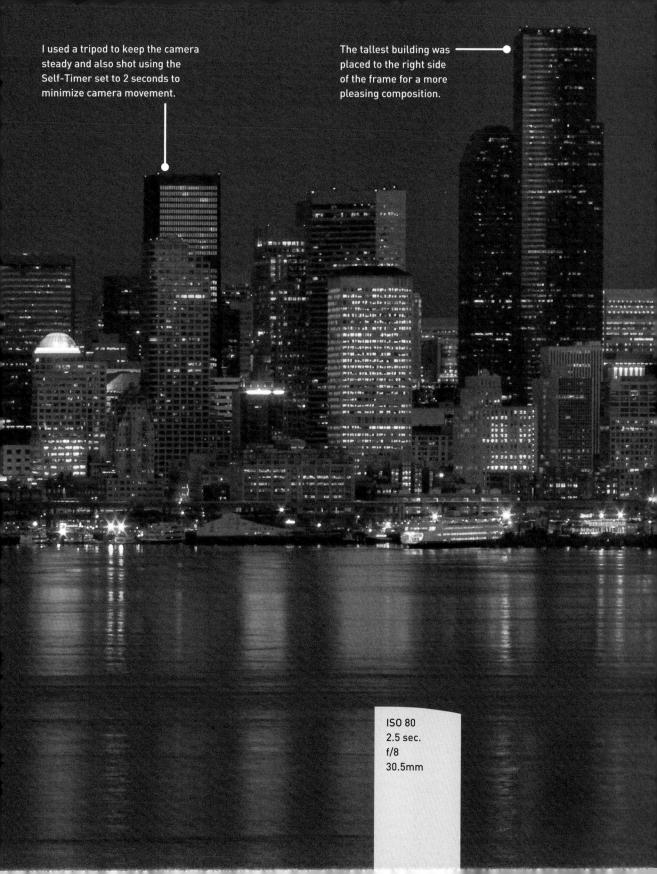

RAISING THE ISO: THE SIMPLE SOLUTION

Let's begin with the obvious ways to keep shooting when the lights get low.

One option is to use the flash, but its limited range (15–20 feet) might not work for the situation. Also, the light from the built-in flash can too often be harsher than what you're looking for. You could be in a setting where flash is prohibited, or at least frowned upon, like at a wedding or in a museum.

What about using a tripod in combination with a long shutter speed? That is also an option, and we'll cover it a little further into the chapter. The problem, though, is that it performs best when subjects aren't moving. And tripods aren't exactly discreet: Just try to set up a tripod in a museum and see how quickly you grab the attention of the security quards.

That leaves us with raising the ISO (**Figure 8.1**). By now you know how to change the ISO: Turn the ISO dial on the top of the camera. In typical shooting situations, you should keep the ISO in the 100–400 range. This will keep your pictures nice and clean by keeping the digital noise to a minimum. But as the available light gets low, you might find yourself working in the higher ranges of the ISO scale, which could lead to more noise in your image.

The G12 performs decently at higher ISOs, so you can probably get away with shots made at ISO 800 or 1600. Turn the dial to ISO 3200 for the most light sensitivity, although the amount of noise may be unacceptable. Shooting with the Low Light mode can crank the ISO above 3200 (such as 12800!), but again, the camera will introduce a lot of noise.

STABILIZING THE SITUATION

Thanks to the image stabilizer (IS), you can squeeze two stops of exposure out of your camera when shooting without a tripod (**Figures 8.2** and **8.3**). Typically, the average person can handhold their camera down to about 1/60 of a second before blurriness results due to hand shake. As the lens is zoomed, the ability to handhold at slow shutter speeds (1/60 and slower) and still get sharp images is further reduced. Keep in mind that the IS compensates for camera shake; it won't magically clarify moving objects in your scene.

FIGURE 8.1
A moderate or high
ISO level enables
you to shoot in
low-light situations
without incurring
motion blur.
[Photo: Simon Zino]

FIGURE 8.2 This image was shot handheld without the IS turned on. [Photo: Jeff Carlson]

FIGURE 8.3 Here's the same subject shot with the same settings, but this time with the IS enabled. [Photo: Jeff Carlson]

ACTIVATING THE IS MODE

- 1. Press the Menu button.
- 2. In the Shooting menu, scroll down to the IS Mode option.
- 3. Press the Right or Left button to select Continuous, which applies image stabilization whenever you're shooting. You can also choose Shoot Only, which activates the IS only when you press the shutter button halfway, or Panning, which corrects for vertical movement when you're panning the camera horizontally (such as when you're following a fast-moving object).
- 4. Press the Menu button again to exit the menu.

SELF-TIMER

Whether you are shooting with a tripod or even resting your camera on a wall, you can increase the sharpness of your pictures by taking your hands out of the equation. Whenever you use your finger to press the shutter release button, you're increasing the chance that there will be a little bit of shake in your image. To eliminate this possibility, set your camera's self-timer. Press the Self-Timer button and use the Control dial to choose an option. You can choose a delay between 1 second or 30 seconds using the Front dial. Pressing the left or right button lets you specify how many shots to fire. Yet another option is available: Face Self-Timer, which activates the shutter when the camera detects a face in the scene.

FOCUSING IN LOW LIGHT

Occasionally the light levels might be too low for the camera to achieve an accurate focus. There are a few things that you can do to overcome this obstacle.

First, you should know that the camera utilizes contrast in the viewfinder to establish a point of focus. This is why your camera will not be able to automatically focus when you point it at a white wall or a cloudless sky. It simply can't find any contrast in the scene to work with. Knowing this, try positioning the AF Frame over an area of contrast that is of the same distance as your subject. Then, hold that focus by holding down the shutter button halfway and recomposing your image.

Sometimes there isn't anything to focus on. A perfect example is a fireworks display. If you point your lens to the night sky in any automatic focus (AF) mode, it will just

keep searching for—and not finding—a focus point. On these occasions, enable the manual focus (MF) feature and manually focus the lens (Figure 8.4).

Don't forget to put it back in AF mode at the end of your shoot.

FIGURE 8.4 Focusing on the night sky is best done in manual focus mode. [Photo: John Wayne Lucia III]

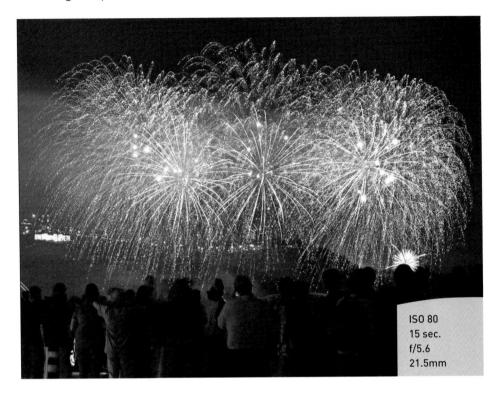

AF-ASSIST BEAM

Another way to ensure good focus is to enable the AF-assist Beam. The built-in lamp shines some light on the scene, which assists the autofocus system in locating more detail. It won't always flash; if the autofocus system finds enough contrast, the lamp stays off. The beam should be enabled by default, but you can check the menu just to make sure.

ENABLING OR DISABLING THE AF-ASSIST BEAM

- 1. Press the Menu button.
- 2. Use the Control dial to scroll down to the AF-assist Beam option.
- 3. Press the Right or Left button to turn the feature On or Off.
- 4. Press the Menu button to return to the Shooting mode.

SHOOTING LONG EXPOSURES

We've covered some of the techniques for shooting in low light, so let's go through the process of capturing a night or low-light scene for maximum image quality. The first thing to consider is that in order to shoot in low light with a low ISO, you will need to use shutter speeds that are longer than you could possibly handhold (longer than 1/15 of a second). This requires the use of a tripod or stable surface for you to place your camera on. For maximum quality, the ISO should be low—somewhere below 200; you don't need to rely on sensor sensitivity when you have plenty of time for the light to build up the image.

Set your camera to Aperture Priority (Av) mode so you can concentrate on the aperture that you believe is most appropriate and let the camera determine the best shutter speed. If it is too dark for the autofocus to function properly, manually focus the image. Finally, consider using a cable release to activate the shutter. If you don't have one, check out the sidebar on using the self-timer earlier in this chapter.

Unlike shooting fast-moving objects or portraits, long-exposure photos allow you to take your time and see which settings work best for the shot. Your patience will be rewarded (Figure 8.5).

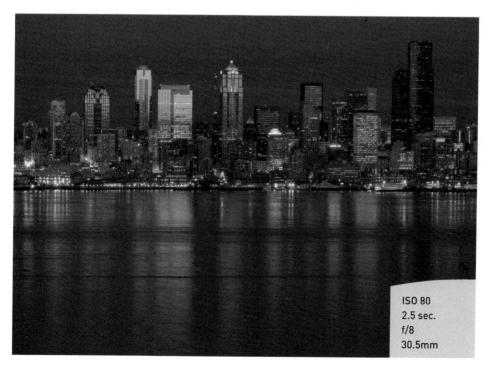

FIGURE 8.5 A fairly long exposure and a tripod were necessary to catch this nighttime skyline. [Photo: Jeff Carlson]

USING THE BUILT-IN FLASH

There will be times when you have to turn to your camera's built-in flash to get the shot. The flash on the G12 is not extremely powerful, but with the camera's advanced metering system it does a pretty good job of lighting up the night...or just filling in the shadows.

The controls for the built-in flash are accessible in two ways. I'll cover the *how* first, and then shortly move on to the *why*.

ACCESSING THE FLASH CONTROL, THE FAST AND EASY WAY

- 1. Press the Flash button.
- 2. Use the Control dial to select a flash setting. Depending on the current shooting mode, in addition to On and Off, you may see an icon for Auto or Slow Synchro. (I go into more detail about Slow Synchro later in this chapter.)
- 3. Press the Function/Set button to apply the setting.

ACCESSING MORE FLASH CONTROLS

- 1. Press the Flash button, and then press the Menu button to access the Built-in Flash Settings screen.
 - This menu is also accessible by first pressing the Menu button and then choosing Flash Control.
- 2. Use the Control dial to select a flash setting, which I'll discuss more in this chapter.
- **3.** Press the Menu button to return to the shooting mode.

AUTO VS. MANUAL POWER OUTPUT

In most cases, the On setting is the same as saying the flash is set to Auto: The camera determines how much power to give the flash to control its brightness. However, as with so many features, you're not locked into the automatic option. If you're shooting in Manual (M) mode, you can choose three intensities for the flash. That option is also available when shooting in other modes.

SETTING AUTO OR MANUAL FLASH MODE

 Press the Flash button, or navigate to the Built-in Flash Settings screen using the menus as described earlier.

- 2. Highlight the Flash Mode option. (Note that it doesn't appear in the largely automatic Program mode.)
- 3. Press the Left or Right button to switch between Auto and Manual.
- 4. When Manual is enabled, the Flash Exp. Comp (exposure compensation) menu item becomes the Flash Output item; highlight it and use the Left or Right button to choose between Minimum, Medium, and Maximum.

You can easily change the Flash Output setting later without navigating all the menus by pressing the Flash button and using the Front dial. Or, press the Function/Set button, highlight the Flash Output icon (fourth from the top), and use the Left or Right button to adjust the level.

SHUTTER SPEEDS

The standard flash synchronization speed for your camera is between 1/60 and 1/2000 of a second. When you are working with the built-in flash using the Automatic modes, the camera typically uses a shutter speed of 1/60 of a second. The exception to this is when you use the Night Snapshot mode, which fires the flash with a slower shutter speed so that some of the ambient light has time to record in the image.

The real key to using the flash to get great pictures is to control the shutter speed. The goal is to balance the light from the flash with the existing light so that everything in the picture has an even illumination. Let's take a look at the shutter speeds for the Creative modes.

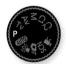

Program (P): The shutter speed stays at 1/60 of a second, unless you're shooting into a bright environment (or the meter is evaluating a bright area) that would normally require an aperture higher than f/8.

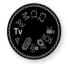

Shutter Priority (Tv): You can adjust the shutter speed to as fast as 1/2000 of a second all the way down to 15 seconds. (Actually, you can set the shutter speed to the camera's maximum 1/4000 setting, but the shot uses a maximum speed of 1/2000.) The aperture adjusts accordingly, but typically at long exposures the lens will be set to its smallest aperture.

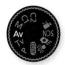

Aperture Priority (Av): The whole point of this setting is to allow you to use the aperture of your choice while still getting good flash exposures. With the flash turned on, the shutter speed adjusts from 1/2000 all the way down to 15 seconds, depending on the available light. As the aperture gets smaller, the shutter speeds get longer.

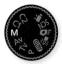

Manual (M): Manual mode works the same as Tv mode, with a range of 1/2000 down to 15 seconds. The difference, of course, is that you must manually set the f-stop.

Generally speaking, I like to have my Mode dial set to the Shutter Priority (Tv) mode when shooting pictures with flash. This enables me to balance the existing light with the flash, which sometimes requires longer shutter speeds.

FE LOCK

If you have special metering needs, such as a background that is very light or dark, you might consider using the Flash Exposure (FE) Lock to meter off your subject and then recompose your image. This feature works much like the Automatic Exposure (AE) Lock function that was discussed in Chapter 6.

USING THE FE LOCK FEATURE

- 1. Point the camera at the area you want to base the flash exposure on. This is normally your subject.
- 2. Press the * AE/FE Lock button (near the top right on the back of the camera) to obtain the exposure setting. The flash fires a small burst to evaluate the exposure, and you will see the AE/FE Lock symbol (*) along with the recommended exposure settings.
- 3. Recompose the scene as you like, and press the shutter button to take the shot.

The FE Lock cancels after each exposure, so you have to repeat these steps each time you need to lock the flash exposure. (If you're shooting several shots in that situation, make a note of the settings and switch to the Manual shooting mode.)

Using this metering mode might also require that you tweak the flash output by using the Flash Exposure Compensation feature. This is because the camera will be metering the entire scene to set the exposure, so you might want to add or subtract flash power to balance out the scene.

COMPENSATING FOR THE FLASH EXPOSURE

Just as with exposure compensation, flash compensation allows you to change the flash output in increments of 1/3 of a stop. You will probably use this most often to tone down the effects of your flash, especially when you are using the flash as a subtle fill light (Figures 8.6 and 8.7).

The Flash Exposure Compensation feature does not reset itself when the camera is turned off, so whatever compensation you have set will remain in effect until you change it. Your only clue to knowing that the flash output is changed will be the presence of the Flash Exposure Compensation symbol on the LCD, so make sure you check it. (It disappears when the compensation is set to zero.)

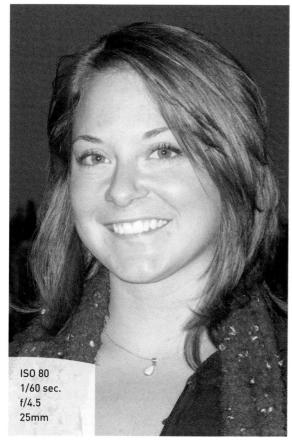

FIGURE 8.6
The built-in flash can be too aggressive when lighting a subject. [Photo: Jeff Carlson]

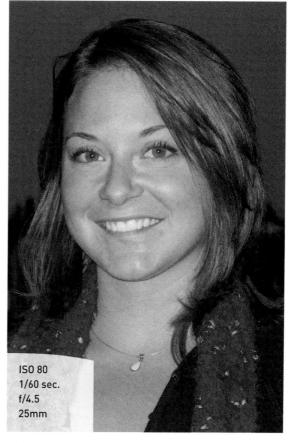

FIGURE 8.7
This image was taken with the same exposure settings.
The difference is in the -1 stop of compensation set for the flash. [Photo: Jeff Carlson]

USING THE FLASH EXPOSURE COMPENSATION FEATURE

- 1. Press the Flash button.
- 2. Rotate the Front dial to adjust the flash compensation in 1/3-stop increments (left to subtract and right to add) from –2 to +2.
- 3. Take the photo.
- **4.** Review your image to see if more or less flash compensation is required, and repeat these steps as necessary.

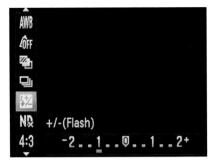

FLASH SYNC

The basic idea behind the term *flash synchronization* (*flash sync* for short) is that when you take a photograph using the flash, the camera needs to ensure that the shutter is fully open at the time that the flash goes off. This is not an issue if you are using a long shutter speed such as 1/15 of a second but does become more critical for fast shutter speeds. To ensure that the flash and shutter are synchronized so that the flash is going off while the shutter is open, the G12 implements a top sync speed of 1/2000 of a second. That's quite an improvement over most DSLRs that use a physical shutter and sync only at 1/200 of a second. If you did use a faster shutter speed, the shutter would actually start closing before the flash fired, which would cause a black area to appear in the frame where the light from the flash was blocked.

REDUCING RED-EYE

We've all seen the result of using on-camera flashes when shooting people: the dreaded red-eye! This demonic effect is the result of the light from the flash entering the pupil and then reflecting back as an eerie red glow. The closer the flash is to the lens, the greater the chance that you get red-eye. This is especially true when it is dark and the subject's eyes are dilated. There are two ways to combat this problem. The first is to get the flash away from the lens. That's not really an option if you're using the built-in flash.

Turn to the Red-Eye Lamp. This is a simple feature that shines a light from the camera at the subject, causing their pupils to shrink, thus eliminating or reducing the effects of red-eye. The feature is set to Off by default and needs to be turned on in the shooting menu.

TURNING ON THE RED-EYE LAMP

- 1. Press the Menu button and then use the Control dial to highlight the Flash Control item. Press the Function/Set button.
 - You can also press the Flash button, and then press Menu to bring up the Built-in Flash Settings screen.
- 2. Scroll down to Red-Eye Lamp and use an arrow button to turn the feature On.
- 3. Press the Menu button twice to return to shooting mode.

TURN ON THE LIGHTS!

When shooting indoors, another way to reduce red-eye, or just shorten the length of time that the reduction lamp needs to be shining into your subject's eyes, is to turn on a lot of lights. The brighter the ambient light levels, the smaller the subject's pupils will be. This shortens the time necessary for the red-eye reduction lamp to shine. It will also allow you to take more candid pictures, because your subjects won't be required to stare at the red-eye lamp while waiting for their pupils to reduce.

Your camera also includes a Red-Eye Correction feature (found in the same Built-in Flash Settings screen), but I'm wary of it. The camera adjusts the image after it's shot, and so other red areas of the photo could also be "corrected."

Truth be told, I rarely shoot with red-eye reduction turned on because of the time it takes before being able to take a picture. If I am after candid shots and have to use the flash, I will take my chances on red-eye and try to fix the problem in my image-processing software.

SLOW SYNCHRO

One problem when shooting with a flash in low light is that often there will be a large discrepancy between your subject, which is well lit from the flash, and the background, which sinks into black. The Slow Synchro feature provides a way to light the foreground and background in the same shot (**Figure 8.8**). The flash fires briefly at the start of the shot to get a better meter reading of the scene. Next, the shutter opens to allow in enough light to expose the background. Finally, the flash fires again to freeze your subject in focus. The catch with Slow Synchro is that the subject needs to remain still during the exposure to prevent motion blur. (So that pretty much rules out toddlers for this feature.)

FIGURE 8.8 This shot was taken during the same session as those in Figures 8.6 and 8.7, but this time I enabled the Slow Synchro mode. The shutter stays open longer to gather light, and then the flash fires to freeze the subject in focus. [Photo: Jeff

Carlson]

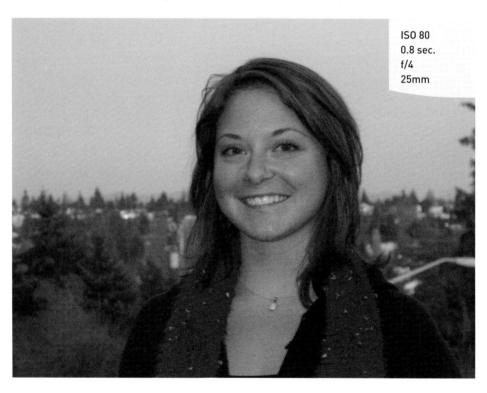

FLASH AND GLASS

If you find yourself in a situation where you want to use your flash to shoot through a window or display case, try placing your lens right against the glass so that the reflection of the flash won't be visible in your image. This is extremely useful in museums and aquariums.

2ND CURTAIN SYNC

You've probably noticed there are two flash synchronization modes in the G12: *first* curtain and second curtain.

When your camera fires, two curtains (yes, similar in theory to curtains you'd find in front of a window) open and close to make up the shutter. The first curtain moves out of the way, exposing the camera sensor to the light. At the end of the exposure, the second curtain moves in front of the sensor, ending that picture cycle. In flash photography, timing is extremely important because the flash fires in milliseconds, and the shutter is usually opening in tenths or hundredths of a second. To make sure these two functions happen in order, the camera usually fires the flash just as the first curtain moves out of the way (see the sidebar earlier in the chapter about flash sync).

In 2nd Curtain Sync mode, the flash will not fire until just before the second shutter curtain ends the exposure. So, why have this mode at all? Well, there might be times when you want to have a longer exposure to balance out the light from the background to go with the subject needing the flash. Imagine taking a photograph of a friend standing in Times Square at night with all the traffic moving about and the bright lights of the streets overhead. If the flash fires at the beginning of the exposure, and then the objects around the subject move, those objects will often blur the subject a bit. If the camera is set to 2nd Curtain Sync, though, all of the movement is recorded by the existing light first, and then the subject is "frozen" by the flash at the end by the exposure.

There is no right or wrong to it. It's just a decision on what type of effect it is that you would like to create. Many times, 2nd Curtain Sync is used for artistic purposes or to record movement in the scene without it overlapping the flash-exposed subject. To make sure that the main subject is always getting the final pop of the flash, I leave my camera set to 2nd Camera Sync.

Shooting 2nd Curtain Sync can also be a great creative tool when shooting moving objects. Because the flash fires at the end of the exposure, the result is your subject lit and in focus, but with a trailing blur of motion.

SETTING YOUR FLASH SYNC MODE

- 1. Press the Menu button, select Flash Control, and press the Function/Set button.
- 2. Scroll down to select the Shutter Sync option, and then select either the 1st-curtain or 2nd-curtain option for the type of flash sync that you desire.
- 3. Press the Menu button twice to return to the shooting mode.

Chapter 8 Assignments

Now that we have looked at the possibilities of shooting after dark, it's time to put it all to the test. These assignments cover the full range of shooting possibilities, both with flash and without. Let's get started.

How steady are your hands?

It's important to know just what your limits are in terms of handholding your camera and still getting sharp pictures. This will change depending on the focal length you are working with. Wider angles are more forgiving than telephoto settings, so check this out for your longest and shortest zoom ranges. Set your lens to its maximum zoom and then, with the camera set to ISO 80 and the mode set to Tv, start taking pictures with lower and lower shutter speeds. Review each image on the LCD at a zoomed-in magnification to take note of when you start seeing visible camera shake in your images. It will probably be around 1/125 of a second.

Now do the same for the wide-angle setting of the lens. My limit is about 1/50 of a second. These shutter speeds are with the Image Stabilization feature turned off. Try it with and without the IS feature enabled to see just how slow you can set your shutter while getting sharp results.

Pushing your ISO to the extreme

Find a place to shoot where the ambient light level is low—this could be at night or indoors in a darkened room. Using the mode of your choice, start increasing the ISO from 80 until you get to 3200. Make sure you evaluate the level of noise in your image, especially in the shadow areas. Only you can decide how much noise is acceptable in your pictures. I can tell you from personal experience that I try not to stray above that ISO 800 mark if I can avoid it.

Long exposures in the dark

If you don't have a tripod, find a stable place to set your camera outside and try some long exposures. Set your camera to Av mode and then use the self-timer to activate the camera (this will keep you from shaking the camera while pressing the shutter button).

Shoot in an area that has some level of ambient light, be it a streetlight or traffic lights, or even a full moon. The idea is to get some late-night low-light exposures.

Testing the limits of the built-in flash

Wait for the lights to get low, and then enable the built-in flash. Try using the different shooting modes to see how they affect your exposures. Use the Flash Exposure Compensation feature to take a series of pictures while adjusting from -2 stops all the way to +2 stops so that you become familiar with how much latitude you will get from this feature.

Getting the red out

Find a friend with some patience and a tolerance for bright lights. Have them sit in a darkened room or outside at night, and then take their picture with the flash. Now turn on the Red-Eye Lamp to see if you get better results.

Getting creative with 2nd Curtain Sync

Now it's time for a little creative fun. Set your camera up for 2nd Curtain Sync and start shooting. Moving targets are best. Experiment with Tv and Av modes to lower the shutter speeds and exaggerate the effect. Try using a low ISO so the camera is forced to use longer shutter speeds. Be creative and have some fun!

ISO 200 1/40 sec. f/5.6 9.8mm

Creative Compositions

IMPROVE YOUR PICTURES WITH SOUND COMPOSITIONAL ELEMENTS

Creating a great photograph takes more than just the right settings on your camera. To take your photography to the next level, you need to gain an understanding of how the elements within the frame come together to create a compositionally pleasing image. Composition is the culmination of light, shape, and to borrow a word from the iconic photographer Jay Maisel, gesture. Composition is a way for you to pull your viewing audience into your image and guide them through the scene. Let's examine a few methods you can use to add interest to your photos by utilizing some common compositional elements.

Photo: Paul Perton 175

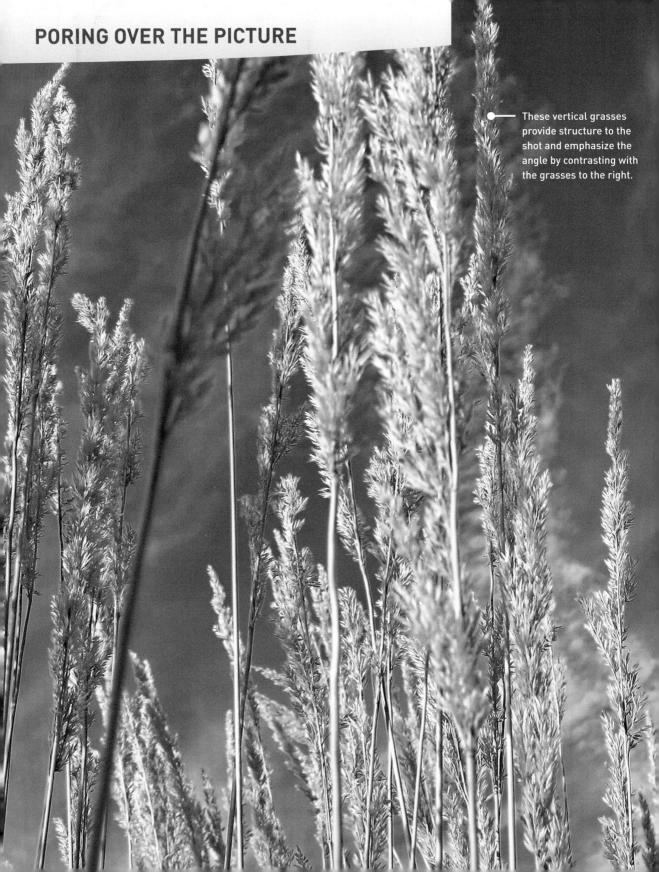

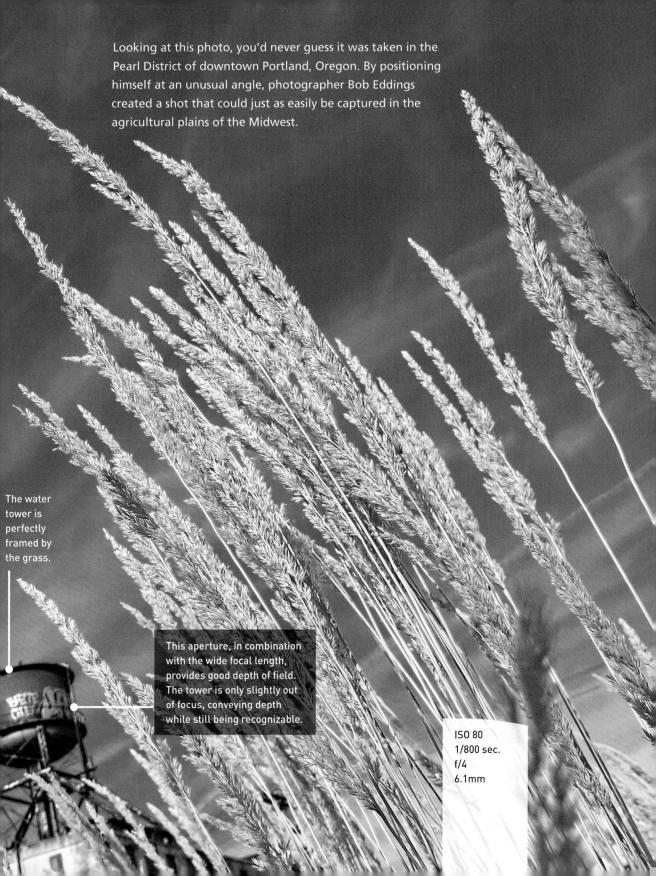

DEPTH OF FIELD

Long focal lengths and large apertures allow you to isolate your subject from the chaos that surrounds it. I utilize the Av mode for the majority of my shooting. I also like to use a longer focal length to shrink the depth of field to a very narrow area. The blurred background and foreground force the viewer's eye toward the sharper, in-focus areas, which gives greater emphasis to the subject (Figure 9.1).

Occasionally a greater depth of field is required to maintain a sharp focus across a greater distance. This might be due to the sheer depth of your subject, where you have objects that are near the camera, but sharpness is desired at a greater distance as well (Figure 9.2).

Or perhaps you are photographing a reflection in a puddle. With a narrow depth of field, you could only get the reflected object or the puddle in focus. By making the aperture smaller, you will be able to maintain acceptable sharpness in both areas (Figure 9.3).

FIGURE 9.1
The combination of a large aperture and zoomed lens can create a shallow depth of field to isolate the subject.
[Photo: Charlwood Photography]

FIGURE 9.2
The closer you are to your subject, the smaller the aperture you will need to achieve a large depth of field.
[Photo: James Williams]

PHOTOGRAPHING REFLECTIONS

A mirror is a two-dimensional surface, so why do you have to focus at a different distance for the image in the mirror? The answer is pretty simple, and it has to do with light. When you focus your lens, you are focusing the light being reflected off a surface onto your camera sensor. So if you wanted to focus on the mirror itself, it would be at one distance, but if you wanted to focus on the subject being reflected, you would have to take into account the distance that the object is from the mirror and then to you. Remember that the light from the subject has to travel all the way to the mirror and then to your lens. This is why a smaller aperture can be required when shooting reflected subjects. Sit in your car and take a few shots of objects in the side-view mirrors to see what I mean.

FIGURE 9.3
Getting a distant
subject in focus
in a reflection,
along with the
reflective surface,
requires a small
aperture. [Photo:
Anthony Goto]

ANGLES

Having strong angular lines in your image can add to the composition, especially when they are juxtaposed to each other (**Figure 9.4**). This can create a tension that is different from the standard horizontal and vertical lines that we are so accustomed to seeing in photos.

FIGURE 9.4
The strong angular lines of the building create a dynamic composition.
[Photo: Ryan Paul/phenotyp.com]

POINT OF VIEW

Sometimes the easiest way to enhance your photographs is simply to change your perspective. Instead of always shooting from a standing position, try moving your camera to a place where you normally would not see your subject. Try getting down on your knees or even lying on the ground. This low angle can completely change how you view your subject and create a new interest in common subjects (Figure 9.5).

FIGURE 9.5
Put your camera
in a position
that presents an
unfamiliar view
of your subject.
[Photo: Bob
Eddings]

PATTERNS

Rhythm and balance can be added to your images by finding the patterns in everyday life and concentrating on the elements that rely on geometric influences. Try to find the balance and patterns that often go unnoticed (**Figure 9.6**).

COLOR

Color works well as a tool for composition when you have very saturated colors to work with. Some of the best colors are those within the primary palette. Reds, greens, and blues, along with their complementary colors (cyan, magenta, and yellow), can all be used to create visual tension (**Figure 9.7**). This tension between bright colors adds visual excitement, drama, and complexity to your images when combined with other compositional elements.

You can also use a color as a theme for your photography. If you're out shooting when the skies are blue, for example, try to use the sky as part of the background for some element of your image. The blue sky can serve as a pleasing contrast, incorporating visual interest and introducing isolation to the subject. Or, find shots that include several variations of the same hues.

FIGURE 9.6
These concrete
steps are nice
enough when
viewed from
above, thanks
to their curved
design, but I found
them to be even
more interesting
when viewed
straight on. [Photo:
Jeff Carlson]

FIGURE 9.7
The yellow and green colors contrast in a bold way; the washed texture of the green adds visual interest. [Photo: Paul Perton]

CONTRAST

We just saw that you can use color as a strong compositional tool. You can also introduce contrast through different geometric shapes that battle (in a good way) for the attention of the viewer. You can combine circles and triangles, ovals and rectangles, curvy and straight, hard and soft, dark and light, and so many more (Figure 9.8). You aren't limited to just one contrasting element either. Combining more than one element of contrast will add even more interest. Look for these contrasting combinations whenever you are out shooting, and then use them to shake up your compositions.

FIGURE 9.8
The angular lines
of the building play
nicely against the
softer edges of the
shadow. [Photo:
Bob Eddings]

One of the most effective uses of color is to combine two contrasting colors that make the eye move back and forth across the image (**Figure 9.9**). There is no exact combination that will work best, but consider using dark and light colors, like red and yellow, or blue and yellow, to provide the strongest contrasts.

FIGURE 9.9
The bright orange wall contrasts with the gray cement and weathered wood, which also focuses your eye on the brightly colored boots. [Photo: Jeff Carlson]

LEADING LINES

One way to pull a viewer into your image is to incorporate leading lines. These are elements that come from the edge of the frame and then lead into the image toward the main subject (Figure 9.10). This can be the result of vanishing perspective lines, an element such as a river, or some other feature used to move from the outer edge in to the heart of the image.

FIGURE 9.10
The road leads the eye directly toward the mountains and water in the distance. [Photo: Evan Spellman/ Earth Light Photography]

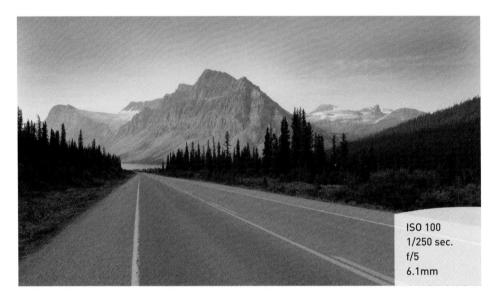

SPLITTING THE FRAME

Generally speaking, splitting the frame right down the middle is not necessarily your best option. While it may seem more balanced, it can actually be pretty boring. You should utilize the rule of thirds when deciding how to divide your frame.

With horizons, a low horizon will give a sense of stability to the image. Typically, this is done when the sky is more appealing than the landscape below (Figure 9.11). When the emphasis is to be placed on the landscape, the horizon line should be moved upward in the frame, leaving the bottom two-thirds to the subject below.

Also, don't think everything needs to be split along horizontal lines. Even though the horizon line in **Figure 9.12** is roughly centered, the frame is split into thirds vertically by positioning the bridge and its reflection at the right edge.

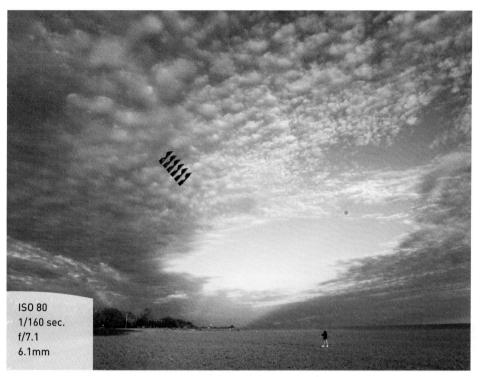

FIGURE 9.11
The sky dominates the top two-thirds of the frame, drawing your eye down the kite line to the beach below. [Photo: Anneliese Voigt]

FIGURE 9.12
The rule of thirds
also applies to
the left and right
sides of the frame.
Here, the bridge
and reflection
counterbalances
the light source
and clouds. [Photo:
Jeff Carlson]

FRAMES WITHIN FRAMES

The outer edge of your photograph acts as a frame to hold all of the visual elements of the photograph. One way to add emphasis to your subject is through the use of internal frames. Depending on how the frame is used, it can create the illusion of a third dimension to your image, giving it a feeling of depth.

Chapter 9 Assignments

Apply the shooting techniques and tools that you have learned in the previous chapters to these assignments, and you'll improve your ability to incorporate good composition into your photos. Make sure you experiment with all the different elements of composition and see how you can combine them to add interest to your images.

Learning to see lines and patterns

Take your camera for a walk around your neighborhood and look for patterns and angles. Don't worry so much about getting great shots as much as developing an eye for details.

The ABCs of composition

Here's a great exercise: Shoot the alphabet. This will be a little difficult, but with practice you will start to see beyond the obvious. Don't just find letters in street signs and the like. Instead, find objects that aren't really letters but have the shape of the letters.

Finding the square peg and the round hole

Circles, squares, and triangles. Spend a few sessions concentrating on shooting simple geometric shapes.

Using the aperture to focus attention

Depth of field plays an important role in defining your images and establishing depth and dimension. Practice shooting wide open, using your largest aperture for the narrowest depth of field. Then find a scene that would benefit from extended depth of field, using very small apertures to give sharpness throughout the scene.

Leading them into a frame

Look for scenes where you can use elements such as leading lines, and then look for framing elements that you can use to isolate your subject and add both depth and dimension to your images.

ISO 80 1/125 sec. f/8 10.8mm

Advanced Techniques

IMPRESS YOUR FAMILY AND FRIENDS

We've covered a lot of ground in the previous chapters, especially on the general photographic concepts that apply to most, if not all, shooting situations. There are, however, some specific tools and techniques that will give you an added advantage in obtaining a great shot. Additionally, we will look at how to customize certain controls on your camera to reflect your personal shooting preferences and always have them at the ready.

Photo: Jake Jessey 191

PORING OVER THE PICTURE

Although I own a DSLR, I don't have a good macro lens that lets me get really close to subjects like this leaf. The Macro mode on the G12, however, is stupendous. I shot this image at a playground one morning while my daughter played on a swing. It was the first sunny day after about a week of rain. I almost stepped on the leaf before the glint of the water droplets caught my eye.

I live in rainy Seattle, but you can get this shot anywhere. Fill a spray bottle with water and take it with you shooting.

The closest foreground element is slightly out of focus, so your eye is drawn to the middle of the leaf.

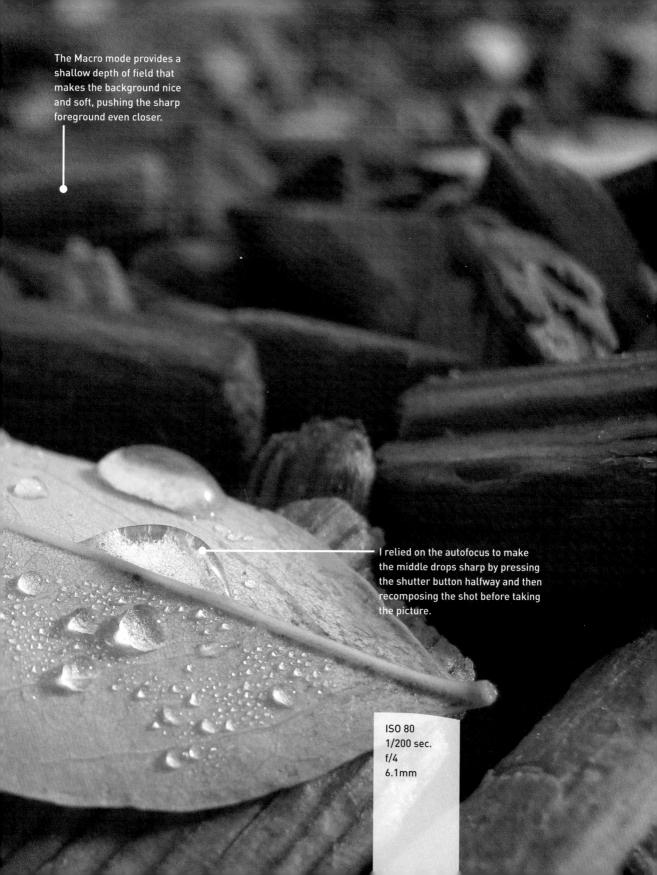

SPOT METER FOR MORE EXPOSURE CONTROL

Generally speaking, Evaluative metering mode provides accurate metering information for the majority of your photography. It does an excellent job of evaluating the scene and then relaying the proper exposure information to you. The only problem with this mode is that, like any metering mode on the camera, it doesn't know what it is looking at. There will be specific circumstances where you want to get an accurate reading from just a portion of a scene and discount all of the remaining area in the frame. To give you greater control of the metering operation, switch the camera to Spot metering mode. This allows you to take a meter reading from a very small circle in the center of the viewfinder, while ignoring the rest of the viewfinder area.

So when would you need to use this? Think of a person standing in front of a very dark wall. In Evaluative metering mode, the camera would see the entire scene and try to adjust the exposure information so that the dark background is exposed to render a lighter wall in your image. This means the scene would actually be overexposed and your subject would then appear too light. To correct this, you can place the camera in Spot metering mode and take a meter reading right from—and *only* from—your subject, ignoring the dark wall altogether.

Other situations that would benefit from Spot metering include:

- Snow or beach environments where the overall brightness level of the scene could fool the meter
- Strongly backlit subjects that leave the subject underexposed (Figures 10.1 and 10.2)
- Cases where the overall feel of a photo is too light or too dark

SETTING UP AND SHOOTING IN SPOT METERING MODE

- 1. Press the Metering Light button.
- Rotate the Control dial until the Spot meter icon appears, and then press the Metering Light button again to apply the change.
- 3. Point the center focus point at the subject that you wish to use for the reading.
- 4. Press the * button to enable the AE Lock, which holds the exposure value while you recompose and then take the photo.

FIGURE 10.1
The sun in the background is causing the meter to be fooled into underexposing the image. [Photo: Jeff Carlson]

FIGURE 10.2 A spot meter reading on the face improves the exposure, but at the expense of losing background detail. The next thing to try would be to adjust the Exposure Compensation Dial to regain the texture of the sky. [Photo: Jeff Carlson]

When using Spot metering mode, remember that the meter believes it is looking at a medium gray value, so you might need to incorporate some exposure compensation of your own to the reading that you are getting from the camera. This will come from experience as you use the meter.

METERING FOR SUNRISE OR SUNSET

Capturing a beautiful sunrise or sunset is all about the sky. If there is too much foreground in the viewfinder, the camera's meter will deliver an exposure setting that is accurate for the darker foreground areas but leaves the sky looking over-exposed, undersaturated, and generally just not very interesting. To gain more emphasis on the colorful sky, point your camera at the brightest part of it and take your meter reading there. Use the AE Lock and then recompose. The result will be an exposure setting that underexposes the foreground but provides a darker, more dramatic sky (Figure 10.3).

FIGURE 10.3 Metering for the brightest part of the sky will give you better sunset pictures. [Photo: Jake Jessey]

AVOIDING LENS FLARE

Lens flare is one of the problems you will encounter when shooting in the bright sun, showing up as bright circles on the image. Often you will see multiple circles in a line leading from a very bright light source such as the sun. The flare is a result of the sun bouncing off the multiple pieces of optical glass in the lens and then being reflected back onto the sensor. You can avoid the problem in a couple of ways:

- Try to shoot with the sun coming from over your shoulder, not in front of you or in your scene.
- Use some sort of shade to block the unwanted light from striking the lens. That can be your hand or some other element; you'll be able to see the flare in the LCD. You don't have to have the sun in your viewfinder for lens flare to be an issue. All it has to do is strike the front glass of the lens to make it happen.

Of course, the other option is to *not* avoid it; lens flare can be quite beautiful, even if you didn't intend for it to appear (Figure 10.4).

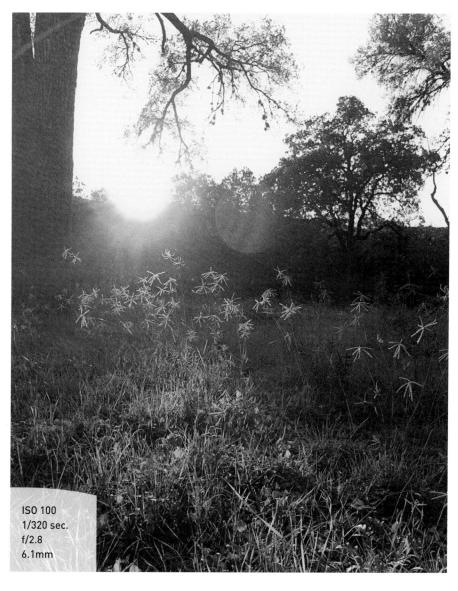

FIGURE 10.4
The bright sun
in the upper-left
corner has created
flare spots that are
visible as colored
circles. [Photo:
Ryan Paul/
phenotyp.com]

BRACKETING EXPOSURES

So, what if you're doing everything right in terms of metering and mode selection, yet your images still sometimes come out too light or too dark? A technique called "bracketing" will help you find the best exposure value for your scene by taking three exposures: one normal shot, one overexposed, and one underexposed. Having these differing exposure values will most often present you with one frame that just looks better than the others. I use the Bracketing function all the time.

With Bracketing enabled, you can choose how much variation is applied to the exposure compensation, from one-third of a stop all the way to two stops per bracketed exposure. Bracketing helps you zero in on that perfect exposure, and you can just delete the ones that didn't make the grade (Figures 10.5–10.7).

FIGURE 10.5 One stop of exposure below normal. [Photo: Jeff Carlson]

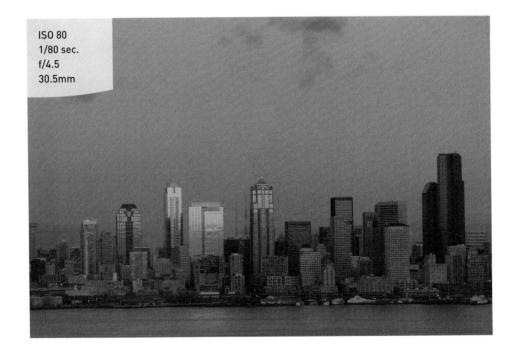

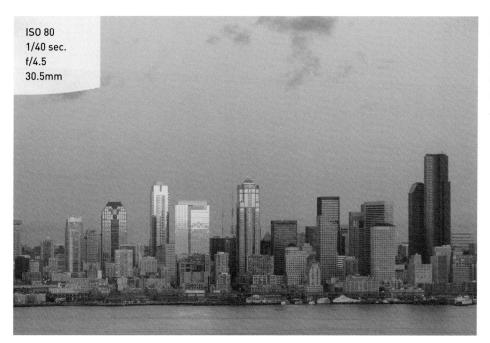

FIGURE 10.6 The normal exposure as indicated by the camera meter. [Photo: Jeff Carlson]

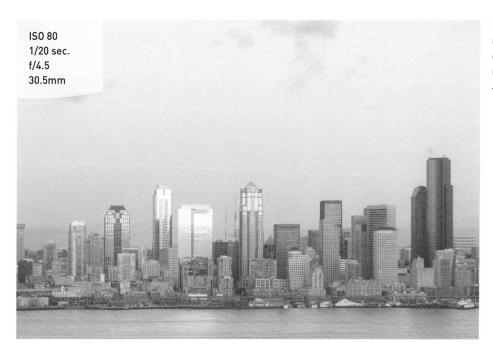

FIGURE 10.7 One stop of exposure above normal. [Photo: Jeff Carlson]

SETTING AUTO-EXPOSURE BRACKETING

- Press the Function/Set button and select the Bracketing icon (third from the top) (A).
- 2. Use the Control dial to choose the Auto-Exposure Bracketing (AEB) mode.
- Press the Display button to access the AEB settings.
- **4.** Turn the Control dial to choose how many stops from zero the exposure compensation should be (B).
- **5.** Press the Function/Set button to return to the shooting mode.
- **6.** When you're ready to capture the shot, press the shutter button once; the camera takes all three exposures.

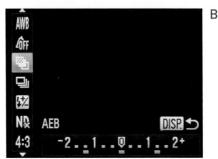

The camera takes the normal image first, then the underexposed image, and finally the overexposed image. When I am out shooting, I typically shoot with my camera set to an exposure compensation of -1/3 stop to protect my highlights.

FOCUS BRACKETING

In addition to exposure bracketing, the G12 includes a bracketing mode for focusing. Choose Focus-BKT mode from the Bracketing menu item described above. Pressing the Display button lets you set the focus depth of the bracketed shots: large, medium, and small. Switch to Manual Focus in your shooting mode and press the shutter button. The camera takes three shots with varying focus depths.

MACRO PHOTOGRAPHY

Put simply, macro photography is close-up photography. The G12 features a Macro mode that you can enable in most shooting modes. (The Auto mode, for example, switches to Macro if it senses objects are close to the lens. The Low Light, Quick Shot, and some of the Scene modes do not support Macro.)

You'll likely want to work with a tripod, because handholding can make focusing difficult. Also, I recommend shooting in Av mode so you can achieve differing levels of depth of field. If you are shooting outside, try shading the subject from direct sunlight by using some sort of diffusion material, such as a white sheet. By diffusing the light, you will see much greater detail because you will have a lower contrast ratio (softer shadows), and detail is often what macro photography is all about (Figures 10.8 and 10.9).

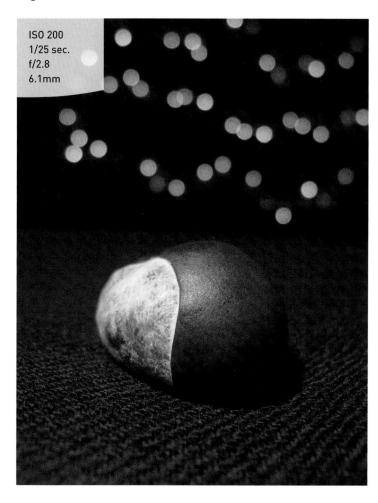

FIGURE 10.8
The detail of
this "conker,"
or chestnut, is
enhanced by a
shallow depth of
field and sharp
focus on the
surface. [Photo:
Morag Stark]

FIGURE 10.9
By using the Macro mode, I was able to get extreme detail on these raindrops clinging to a leaf. [Photo: Jeff Carlson]

To enable Macro mode, press the Macro button in most shooting modes. A large flower icon appears. Get close to your subject (be careful you don't nudge it with the lens!), focus, and shoot.

SHADOW CORRECTION AND DYNAMIC RANGE (DR) CORRECTION

Your camera provides two functions that can automatically make your pictures look a little better: Shadow Correction and Dynamic Range (DR) Correction. With Shadow Correct, the camera evaluates the tones in your image and then lightens any areas that it believes are too dark or lacking contrast after you take the shot (Figures 10.10 and 10.11). Dynamic Range Correction works in the other direction, attempting to prevent highlights from blowing out to white. The Correct modes work only when shooting JPEG images (not RAW or RAW+JPEG).

The two controls are accessed from the same menu, even though they perform opposite actions.

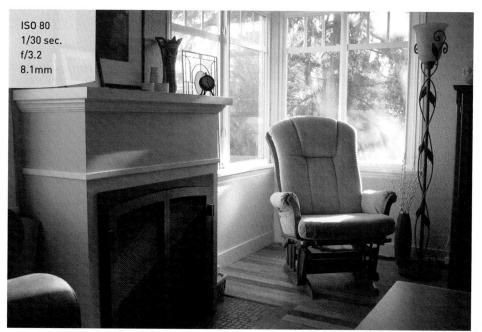

FIGURE 10.10
Without Shadow
Correction, the
shadows on the
chair and the
fireplace are
dark. [Photo:
Jeff Carlson]

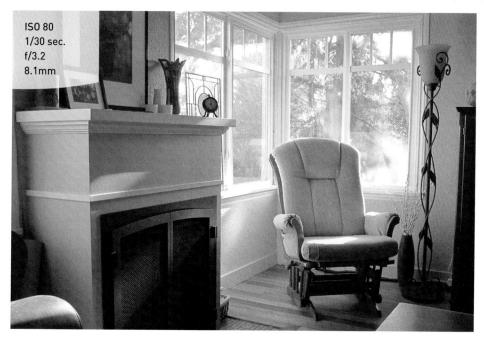

FIGURE 10.11 Although the exposure hasn't changed, the shadows are brighter after enabling the Shadow Correction feature. [Photo: Jeff Carlson]

SETTING UP SHADOW CORRECTION AND DYNAMIC RANGE CORRECTION

- 1. Press the Function/Set button.
- 2. Use the Up or Down button to highlight the DR Correction menu item (just above the white balance setting).
- To enable DR Correction, press the Right or Left button to choose Auto (only if the camera is in Auto mode), 200%, or 400%. The higher the setting, the more correction is applied.

To enable Shadow Correction, press the Display button and then press the Right or Left button to choose the Auto setting.

4. Press the Function/Set button to return to the shooting mode.

SHOOTING WITH AN EXTERNAL FLASH

One feature that sets the G12 apart from most point-and-shoots is also one that most G12 owners will likely never take advantage of: the hot shoe on top of the camera, which is used to mount an external flash (also known as a strobe light or Speedlight). For most people, the built-in flash is perfectly adequate, and that's fine—Chapter 8 discusses several ways to light a scene.

Manual Callout

To learn about flash accessories available for the G12, including Speedlights, mounting brackets, and wireless transmitters, see page 37 of the user guide.

However, the built-in flash tends to be the

light of last resort. For photographing people, it's probably one of the most unflattering light sources. Not because the flash isn't good—it's actually very sophisticated for its size. The problem is that light should come from any direction besides the camera to best flatter a human subject. When the light emanates from directly above the lens, it gives the effect of becoming a photocopier. Imagine putting your face down on a scanner: The result would be a flatly lit, featureless photo. Personally, I far prefer to keep the built-in flash turned off and compensate in low-light situations by raising the ISO, extending shutter times, or increasing aperture.

With the addition of an external flash, you can control the direction of light in your scene, not just moving it higher above the camera but also getting the flash off the camera entirely to create more interesting photos.

POSITIONING THE FLASH

Photography is all about working with light, and the important thing to remember about light is that it *moves*. When we enter a room and flick the switch, or when we step outside, it seems as if light just appears and fills the environment. But, in fact, photons are always in motion, whether they're coming from a lightbulb or the giant strobe in the sky.

AIMING DIRECTLY AT THE SUBJECT

The most obvious way to use an external flash is to mount it on top of the G12 and angle the flash head 90 degrees so it's pointing directly at your subject (Figure 10.12). This position moves the light source up and away from the lens and blankets the scene with light from the direction of the camera.

However, this approach may also serve to just increase the wattage compared to the built-in flash and blow out the subject. If you need this type of a direct angle, consider reducing the flash exposure compensation or setting a lower power output in Manual mode. Adding a diffuser (a semi-opaque plastic cap, for example, or a fabric hood) to the flash softens the light and avoids harsh shadows.

FIGURE 10.12
Directing the flash head at the subject is better than using the built-in flash, but it can be less flattering than you'd like. [Photo: Jeff Carlson]

Shooting directly like this is often helpful when shooting outdoors, even in sunlight. You can set the aperture and exposure values based on the background light and rely on the flash to fill in shadows or prevent subjects in the foreground from becoming silhouettes.

BOUNCING LIGHT AT 45 DEGREES

A far more effective technique is to position the flash head at a 45-degree angle and bounce the light off the ceiling. Instead of striking your subject full-force, the light hits the ceiling and falls over the scene (**Figure 10.13**). This approach assumes you're shooting in a fairly normal room with white ceilings; higher ceilings require more flash output. When I'm capturing photos inside, this is the angle I turn to the most for balanced, even light.

If your flash includes a deflector that pops out at the top of the flash head, use it to direct a portion of that light directly at the subject and create a catchlight (that glint in the eyes). Or, tape a small card in the same spot—no need to get fancy when a business card and a piece of tape will do.

FIGURE 10.13

Bounce light at a 45-degree angle off the ceiling to fill the scene with softer light, without needing a lot of equipment. [Photo: Jeff Carlson]

SHOOTING LIGHT FROM ANY ANGLE

With the addition of an inexpensive cord (or more pricey wireless remote triggers), you can move the flash off the camera entirely and direct the light however you wish (**Figure 10.14**). Position a light just outside the frame and light from the side to create dramatic shadows, or use it to soften dark areas caused by another light source, such as sunlight coming through a window.

FIGURE 10.14

Get that external flash off the camera and place it wherever you want. In this case, I put the flash on a tripod to the side of the subject. [Photo: Jeff Carlson]

SHOOTING WITH THE EXTERNAL FLASH

An external flash opens up all sorts of opportunities for lighting. Perhaps you're looking to add more light to a dim scene, or maybe compose a dramatic portrait where most of the subject is in shadows except for a ray of detail. As you shoot more, you'll develop a better feel for where to position light and how powerful it should be, but in the meantime do what I do: Take plenty of sample shots until you achieve the look you want.

A good starting point is to make sure the background is exposed properly. Press the shutter button halfway to get a reading from the G12's light meter and make note of the exposure and aperture settings. Next, dial the camera to Manual shooting mode and take some test shots to experiment with the settings for flash exposure compensation (in the flash's Auto mode) or flash output (in Manual mode) to get a good balance of light on your subject, as described on the next page.

SETTING THE EXTERNAL FLASH OUTPUT LEVEL

- 1. Attach the flash to the camera and power them both on. An orange flash icon (a lightning bolt) appears to indicate that the two devices are communicating.
- 2. Press the Menu button.
- 3. Choose Flash Control from the main menu.
- 4. Choose a Flash Mode setting: Auto or Manual.
- 5. In Auto mode, highlight the Flash Exp. Comp (exposure compensation) item and use the Left or Right button to change the value in one-third stop increments, between –3 and +3.
 - In Manual mode, the Flash Exp. Comp menu becomes the Flash Output menu; press the Left or Right button to change the output in fractions, from 1/1 (full power, bring your sunglasses) to a minimum of 1/64.

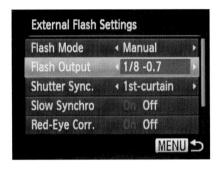

6. Set the other flash controls, such as Shutter Sync and Slow Synchro, as described in Chapter 8.

Compose your photo and take the shot. Depending on the power output, you may need to wait for the flash to recharge; look for a light marked Pilot or Ready that comes on when it's ready, depending on the flash.

SHOOTING STILL-LIFE SUBJECTS AND PRODUCT SHOTS

Flashes are great for shaping light around people, but they're also invaluable for shooting still-life images where you can fuss with the lighting as much as you want without making a person wait while you tweak flash settings (Figure 10.15 and Figure 10.16).

Want to make an item you're selling stand out on eBay or Craigslist? Give it a professional-looking photo, not something that looks like you used a throwaway camera in your basement.

Capturing a *really* good product shot, such that you'd find in an Apple ad or a magazine cover, can entail a lot of time, experience, and equipment—it's truly an art. However, if you need to take a photo of something more modest, you can do it easily and inexpensively by building your own lightbox (**Figure 10.17**).

For instructions on making a box for roughly \$10, see http://strobist.blogspot.com/2006/07/how-to-diy-10-macro-photo-studio.html.

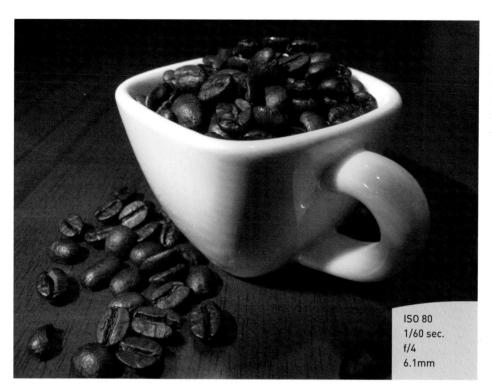

FIGURE 10.15
I positioned the
flash to the left of
the camera to get
a more interesting
lighting angle of
this scene. [Photo:
Jeff Carlson]

FIGURE 10.16

To capture the shot above, I placed the flash above and to the left of the espresso cup. I also turned off the overhead lights to prevent a lot of ambient light interfering with the effect I wanted. Shooting in my kitchen reveals that you don't need a fancy setup. [Photo: Jeff Carlson]

FIGURE 10.17

Speaking of not getting fancy, this is my homemade lightbox that I use for photographing products. If I did more of this type of shooting, I'd invest in better, more durable gear, but for now the cardboard and off-the-shelf lighting combined with a strobe light suits my needs. [Photo: Jeff Carlson]

THE LIGHT UNDER THE DOOR

Lighting with external flashes can quickly become an incredibly deep topic. You start with one strobe, then realize the advantages of using two or more, and pretty soon you could find yourself wanting to trigger multiple synced Speedlights using wireless remotes. For more on this fascinating topic, go read David Hobby's Strobist blog (strobist.blogspot.com), a great resource for all things related to off-camera flash.

THE MY MENU SETTING

There are a lot of items in the menu that you can change, but some are used and changed more frequently than others. The My Menu function allows you to place five of your most used menu items in one place so that you can quickly get to them, make your changes, and get on with shooting.

CUSTOMIZING THE MY MENU SETTING

- Press the Menu button and select the tab with the star using the Right or Left button.
- 2. Select My Menu settings and press the Function/Set button.
- 3. With the Select items option highlighted, press Function/Set (A).
- 4. Scroll through the available menu items, and when you highlight one that you want to add, press the Function/Set button (B). A checkmark appears next to the item. (Press the Function/Set button again to remove an item from the list.)
- **5.** Continue adding the items that you want in the list until you have selected your favorites (up to five of them).
- Press the Menu button to return to the previous screen.

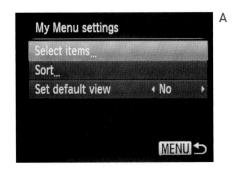

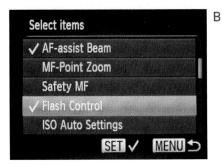

- 7. You can sort your menu items as you see fit by selecting the Sort menu item and pressing Function/Set. Highlight a command, press Function/Set, and then use the Up and Down buttons to reposition it in the list.
- **8.** To view your menu by default when you press the Menu button, choose the Set default view item and change its setting to Yes.

Chapter 10 Assignments

Many of the techniques covered in this chapter are specific to certain shooting situations that may not come about very often. This is even more reason to practice them so that when the situation does present itself you will be ready.

Adding some drama to the end of the day

Most sunset photos don't reflect what the photographer saw, because the camera wasn't metering the scene correctly. The next time you see a colorful sunset, pull out your camera and take a meter reading from the sky and then one from another area of the frame, and see what a difference it makes.

Making your exposure spot on

Using the Spot meter mode can give accurate results but only when pointed at something that has a middle tone. Try adding something gray to the scene and taking a reading off it. Now switch back to your regular meter mode and see if the exposure isn't slightly different.

Bracketing your way to better exposures

Why settle for just one variation of an image when you can bracket to get the best exposure choice? Set your camera up for a 1/3-bracket series, and then expand it to a one-stop series. Review the results to see if the normal setting is the best, or perhaps one of the bracketed exposures is even better.

Moving in for a close-up

Macro photography is best practiced on stationary subjects (flowers are great, readily available, and don't require model licenses). Enable the Macro mode and experiment with how close you can get to the subject before the camera can't maintain focus. Try using a diffuse light source to minimize shadows.

Controlling your light

If you own a Speedlight or other strobe, experiment by taking shots with the flash mounted on top of the camera, with the flash head angled at 45 degrees, and when removed from the camera.

Shooting Video

BECAUSE EVERYTHING IN FRONT OF THE LENS IS MOVING

It's now rare to find a digital point-and-shoot camera that does *not* record video, and in the case of the G12, the high-definition (HD) video is quite impressive. I wouldn't go so far as to say you could completely replace a digital camcorder with it, but the G12 is currently my favorite video recording device for grabbing clips on the go or capturing short projects (and that includes a video-capable DSLR I own that I bought for twice the amount of the G12). Capturing video entails most of the same techniques covered in this book, but as you'll discover, wrangling moving pictures requires a few extra considerations that I cover in this chapter.

SHOOTING VIDEO

To get started, turn the Mode dial to the Movie shooting position. Much like shooting still photos in Auto mode, the camera attempts to make adjustments automatically before starting to record video. Some aspects,

such as manual focus, Macro mode, and to a limited extent, exposure, can be adjusted before you start recording. Just don't expect to wield the same degree of control over video that you enjoy over still photos.

CAPTURING VIDEO

- 1. To focus on something, position it in the middle of the frame and press the shutter button halfway.
- Once your subject is in focus, fully press the shutter button to begin recording. A red ■ Rec indicator appears to let you know you're recording live, along with a count of the time elapsed (Figure 11.1).
- **3.** To stop the video recording, press the shutter button a second time.

The default shooting mode is Standard; you can also choose Miniature Effect (which not only blurs the edges of the frame, but also speeds up playback), Color Accent, or Color Swap mode by turning the Control dial. I prefer to keep the

FIGURE 11.1
The G12 takes a no-frills approach when actually recording video. [Photo: Jeff Carlson]

original video and make any color changes later in computer software such as iMovie (Mac) or Windows Movie Maker (Windows).

VIDEO QUALITY

Here's some easy advice: Leave the video quality set to the default 1280×720 . That HD resolution is also known as 720p, and is a major improvement over previous G-series PowerShot cameras. It also records at 24 frames per second (fps), the same projection rate as movies in theaters.

The camera is also capable of shooting video with the dimensions of 640×480 or 320×240 ; both sizes record at 30 fps (in NTSC format, used in the Americas and many Asian countries) or 25 fps (in PAL format, used mostly in Europe). However, I can think of only two reasons to do that: If a standard-definition TV is the only device on

which you'll view the footage, or if you want to double the amount of video you can save to the memory card. Cards are getting cheaper every month, so I prefer to buy a new higher-capacity card than give up that much resolution. If you want to see the difference between the two, follow these steps to change the quality.

SETTING THE MOVIE QUALITY

- 1. Turn the Mode dial to the Movie shooting position if it's not already set.
- 2. Press the Function/Set button to bring up the shooting options.
- 3. Press the Up or Down button to highlight the video quality setting at the bottom of the column.
- **4.** Use the Control dial to select the desired movie resolution (1280, 640, or 320) and press the Set button again to return to Movie mode.

MEMORY CARDS FOR SHOOTING VIDEO

For the best performance when capturing video, buy SDHC cards that are rated Class 4 or higher. They can transfer data faster and come in larger capacities (which is good for shooting stills, too). According to Canon, a 4 GB card will hold approximately 25 minutes of HD video, whereas a 16 GB card will hold about 1 hour 43 minutes' worth. The 4 GB capacity is important to remember, because the G12 will stop recording automatically once the clip nears that limit; you'd need to start recording a new clip to continue.

AUDIO

The audio captured while shooting video is recorded in stereo using two microphones to the right and left of the hot shoe. And that's about it. There's no option to connect an external, directional microphone to the G12 to record better-quality sound. As a result, expect to hear more of what's closest to the camera (you, and the camera's controls) instead of the action happening in front of the lens.

The G12 does offer one audio-specific setting: Wind Filter. When it's enabled, the camera dampens background noise. Press the Menu button and enable or disable the option in the Shooting menu.

LOCKING FOCUS

Normally, the G12 focuses on whatever is in the middle of the screen. You can manually focus the lens before shooting by pressing the MF button and turning the Control dial.

However, once you begin recording, the focus is set: The camera doesn't adjust the focus if your subject moves toward or away from the camera, which is one of the main drawbacks of shooting video with the G12 versus a dedicated camcorder.

It's also possible to zoom in (but not out) on your subject while recording, but the zoom is digital, not optical, so the quality won't be as good. It's better to frame your subject before you press the shutter button.

LOCKING THE EXPOSURE LEVEL

Not everything is automatically locked once you begin recording. The camera tries to dynamically compensate for exposure fluctuations (moving from bright to shaded areas, for example) as you record, which can often be a distraction. Fortunately, you can manually adjust and lock the exposure level before recording. (Changing the setting on the Exposure Compensation dial, however, has no effect.)

SETTING THE EXPOSURE

- With the camera in Movie mode, press the
 AE Lock button when the exposure level is to your liking.
- 2. With an eye on the exposure shift bar that appears, use the Control dial to adjust the exposure in one-third stop increments.
- Press the shutter button to begin recording, or press the * AE Lock button again to disable the lock. Once you do start recording, you can't adjust the exposure manually.

VIEW TECHNIQUES IN ACTION

To see many of the techniques I describe in this chapter, watch a short video I created called "Painting Leaves": http://www.youtube.com/watch?v=sWwCpDLVaEI&hd=1

VIDEO SHOOTING TIPS

From a technical standpoint, shooting video with the G12 isn't that much different from capturing stills. The Video mode supports adjustments like white balance settings, the ND (neutral density) filter, and even the Self-Timer feature. Instead, shooting video requires a slightly different mind-set.

SHOOTING SMOOTH, NOT JERKY

My best advice is to take your time and be calm while shooting, as much as possible. If you whip the camera around like a caffeinated toddler, you'll end up with blurry, nausea-inducing footage. Be deliberate about holding the camera steady and panning slowly and smoothly. Your viewers will thank you.

If possible, set the camera on something when you need to move as you shoot. It's possible to buy or make rail systems for making smooth dolly moves (a Web search will reveal lots of solutions), but don't discount anything on wheels you may have at hand (Figure 11.2).

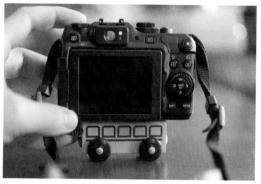

FIGURE 11.2
To pan across a scene, I pressed into service one of my daughter's toy cars. [Photos: Jeff Carlson]

A TRIPOD BECOMES MORE IMPORTANT

In the same spirit as shooting smooth footage, it's often more important to capture video while the G12 is mounted on a tripod. With video, the motion of the camera is as noticeable as what's in the frame. A tripod also gives you the opportunity to make sure the camera is level with the horizon. If a tripod isn't available, I highly recommend bringing up the G12's Electronic Level on the LCD (press the Display button to view the level, which also makes the grid visible).

SHOOTING EXTRA FOOTAGE

I'm assuming that you plan to edit your footage later, so here's another essential tip: Shoot lots of video. Not just of the event happening in front of you, but of what's going on around it. When my wife and daughter were painting leaves last autumn, I made a point to capture footage of visually appealing things nearby (Figure 11.3). A shot of a lone leaf against the blue sky became a nice place to put a title, for example, and an overhead clip of the leaves and paints provided an establishing shot when segueing between gathering the leaves and painting them. These types of supplemental clips add flavor and texture to your movie.

FIGURE 11.3
Shoot plenty of extra video to add visual interest to your movie when editing it. [Photos: Jeff Carlson]

WATCHING YOUR VIDEOS

There are a couple of different options for you to review your video once you have finished recording. The first is probably the easiest: Press the Playback button to bring up the recorded image on the LCD screen, and then use the Set button to start

playing the video. The Left/Right buttons act as the video controller and allow you to rewind and fast-forward as well as stop the video altogether.

If you would like to get a larger look at things, you will need to either watch the video on your TV or move the video files to your computer. To watch on your TV, connect an HDMI cable to the HDMI Out port, or connect the video cable that came with the camera to the A/V Out/Digital port (Figure 11.4).

FIGURE 11.4
The video ports on the G12.

Once you've connected to your TV, simply use the same camera controls that you used for watching the video on the LCD screen.

If you want to watch or use the videos on your computer, you need to download the images using the Canon software or by using an SD card reader attached to your computer. The video files will have the extension ".mov" at the end of the file name. These files should play on either a Mac or a PC using software that came with

Manual Callout

It's possible to use a TV's remote to control playback of video and slide-shows when the G12 is connected. See page 134 in the user manual for details about setting up the Ctrl via HDMI feature.

your operating system or that can be downloaded for free (Apple's QuickTime for Mac and Windows is available at www.apple.com/quicktime/download/).

Chapter 11 Assignments

Shooting video is fun and makes you stretch your photographer's mind-set in ways you don't need to consider when capturing still photos.

Recording some video clips

Set the video quality to 1280 and record a short sequence, and then try it with the 640 and 320 settings.

Locking the exposure

Shoot a scene with the G12 in its automatic video mode, and then shoot the same scene using the A \mathcal{E} Lock feature to see how the exposure levels change.

Grab extra footage

Spend some time intentionally shooting anything but the main focus of the video to see what kinds of footage you can bring to your editing software later.

Watch and enjoy

Open the video clips on your computer or hook the camera up to your TV, and review the different video clips to see how the quality settings affect the video, compared to how they appear on the camera's LCD screen.

INDEX	angles in composition, 177, 181
INDLX	aperture
	DOF (depth of field), 37–40
	Exposure Triangle, 35
Symbols	f/8 limit of G12, 40
2nd Curtain Sync flash, 171	f-stops/stops, 36, 74
5x zoom lens, 30	landscape photography, 71–75
20x zoom, 33	HDR images, 152
30.5mm lens, 32	large landscapes, 137
35mm equivalent lenses, 30	waterfalls, 140
	portrait photography, 71–75, 104
A	review display information, 15
action photography	telephoto lens, 31
Av (Aperture Priority) mode, 71–75, 88–89	Aperture Priority (Av) mode
Continuous drive mode, 92	isolating subjects, 88-89
M (Manual) mode, 90	landscapes, 71–75
Safety Shift, 91	HDR images, 152
sense of motion, 93	large landscapes, 137
motion blur, 95	waterfalls, 140
panning, 94	low-level lighting, 163, 166
Servo AF mode, 91	portraits, 104
subjects	setting up and shooting, 75
blurring, 95	when to use, 71–75, 78
direction of, 84, 96–97	Apple's QuickTime for Mac and Windows, 219
freezing, 37-38, 84-85	aquariums
isolating, 88–89	Aquarium scene mode, 53
panning, 94	flash and glass, 170
placing at side of frame, 96	architectural photography, 71–75
speed of, 84–85	aspect ratio, 8
subject-to-camera distance, 85	audio, shooting video, 215
unique vantage points, 97	auto exposure bracket (AEB) mode, 152
tips, 94–95	Auto Exposure (AE) Lock, 3, 108, 166
Tv (Shutter Priority) mode, 66–71, 78, 86–87	metering modes, 196
video, shooting, 217–218	Spot, 194
Adobe Photoshop	video, 216
exposure-bracketed images, 152	auto focus, overriding, 13
panoramas, combining images, 148	Auto ISO setting, avoiding, 8
AE (Auto Exposure) Lock, 3, 108, 166	Auto mode, 46
metering modes, 196	Program (P) alternative, 64
Spot, 194	reasons for not using, 57
video, 216	Tracking mode, 47
AEB (auto exposure bracket) mode, 152, 199–200	Auto white balance setting, 11
AF (autofocus) Frame modes	autofocus (AF) Frame modes
AF Frame selector, 3	AF Frame selector, 3
Continuous mode, 9–10	Continuous mode, 9–10
Sports scene mode, 49	Sports scene mode, 49
FlexiZone mode, 9–11	FlexiZone mode, 9–11
low-level lighting, 161–162	low-level lighting, 161–162
portraits, 108–109	portraits, 108–109
positioning AF Frame, 108	positioning AF Frame, 108
reasons for not using, 57	reasons for not using, 57
switching to manual focus, 139	switching to manual focus, 139
Tracking AF mode, 47, 112	Tracking AF mode, 47, 112
AF Frame Selector button, 10	Av (Aperture Priority) mode
AF-assist Beam, 162	isolating subjects, 88–89
AF-Point Zoom, 109	landscapes, 71–75
ambient light	HDR images, 152
flash aid, 169	large landscapes, 137
ISO settings, 9	waterfalls, 140

low-level lighting, 163, 166	patterns, 182–183
portraits, 104	point of view, 181–182
setting up and shooting, 75	portrait subjects
when to use, 71–75, 78	cutting off mid-shin or mid-thigh, 119
A/V Out ports, 218	filling frames with, 117
We.	focusing on eyes, 108–109
В	framing, 119
Baake, Thomas, 22–23, 32	positioning off center, 116
backups	spacing between, 120
batteries and chargers, 5	reflections, 179–180, 187
memory cards, 6, 24	rule of thirds
batteries	landscapes, 142–143
charge indicator, 5	splitting frames, 186–187
review display information, 14–15	compression of images, 26
charging, 5	Compression setting options, 7
life and memory, 5	lossless compression, 26
Continuous AF, disabling, 9	lossy compression, 6
Beach scene mode, 52	Continuous AF Frame mode, 9–10
black and white portraits, 110	disabling to preserve batteries, 9
blinkies, 15, 78, 133	SDHC memory cards, 24
bracketing exposures, 153	Sports scene mode, 49
AEB (auto exposure bracket)	Continuous drive mode, 92
mode, 152, 199–200	Continuous IS (image stabilizer) mode, 161
Focus-BKT mode, 200	Continuous Shooting AF/Continuous
^	Shooting LV modes, 92
C	contrasts in composition, 184–185
cameras, holding properly, 18	Control dial, 3
Carlson, Jeff, 1, 29–30, 32–33, 38–40, 39, 40,	Correction modes, DR (Dynamic Range)
42–43, 46, 52–53, 66, 74, 92, 106, 119, 121,	and Shadow, 202–204
130–134, 136, 146, 148–149, 156–157, 160,	Creative modes, 61
163, 167, 170, 183, 185, 187, 192–193, 195,	Av (Aperture Priority) mode
198–199, 202–203, 205–207, 209, 212–214,	isolating subjects, 88–89
217–218	landscapes, 71–75, 137, 140, 152
catchlights, 113	low-level lighting, 163, 166
Center-Weighted metering mode, 107	portraits, 104
chargers for batteries, 5	setting up and shooting, 75
Charlwood Photography, 178	when to use, 71–75, 78
close-up photography. See macro photography	M (Manual) mode, 75, 77
Cloudy white balance setting, 11, 132	action, anticipated, 90
Coates, Lynette, 31, 72	auto focus, overriding, 13
Color Accept vides mode, 51	auto focus, switching from, 139
Color Accent video mode, 214	exposures, 75
Color Swap scene mode, 51	external flashes, 207
Color Swap video mode, 214	low-level lighting, 156, 166
color temperatures, warm and cool, 137. See also white balance	panoramas, 148
	setting up and shooting, 76
composition	when to use, 76
angles, 181 unusual, 177	P (Program) mode versus Safety Shift, 91
color, 182–183	selecting ISO, starting points, 65
contrasts, color and shapes, 184–185	setting up and shooting, 65
DOF (depth of field), 178–179	shutter speeds, 165
frames within frames, 188	when to use, 64
geometric shapes, 184	Servo AF mode with, 91
landscapes, 141–142	Tv (Shutter Priority) mode, 66
depth, sense of, 144	setting up and shooting, 70–71
rule of thirds, 142–143, 186–187	shooting action, 86–87
leading lines, 186	when to use, 67–70, 78
	Wilcii to doc, 07 70, 70

crop factor, 30	exposure
Crystal Photo Memories, 55, 100–101, 120	AEB (auto exposure bracket)
Custom1 and Custom2 white balance	mode, 152, 199–200
settings, 12	calculation method, 35–37
-	EV (exposure value), 34
D	histograms, 16–17
Damiano, Nick, 113	M (Manual) mode, 75
date/time of images, 14–15	reciprocal exposures
Dave Jenson Photography, 109	ISO 100, 36
Day Light white balance setting, 11, 132	ISO 200, 37
deleting images, 18	Exposure Compensation, 78
depth of field (DOF)	Exposure Compensation dial, 4
aperture/motion, 37–40	landscapes, 133–135, 140
Av (Aperture Priority) mode	versus metering modes, 106, 195
isolating subjects, 88–89	review display information, 15
setting up and shooting, 75	Exposure Triangle, 35
when to use, 71–75	external flashes, 204–205
composition, 178–179	hot shoe, attaching, 4
HDR (High Dynamic Range) images, 152	lightboxes, 208–209
landscapes, 128, 135, 137–138, 144	M (Manual) mode, 207
Macro mode, 193	output level settings, 208
panoramas, 148	positioning
zoom lens, 29, 31	from any angle, 207
digital noise, 8–9	bouncing at 45 degrees, 206
ISO settings, 130–131, 137	directly at subjects, 205–206
Sports scene mode, 49	product shots, 208–209
Digital (USB) ports, 218	still-life, 208–209
digital zoom, 33–34	Strobist blog by David Hobby, 210
	Strobist blog by David Hobby, 210
Diopter Adjustment dial, 3, 13	F
DISP. (Display) button, 3	Face AiAF (Artificial intelligence Auto Focus)
DOF (depth of field)	Face Detection mode, 111–112
aperture/motion, 37–40	Face Detection focusing, 111–112
Av (Aperture Priority) mode	-
isolating subjects, 88–89	Face Self-Timer mode, 50, 161
setting up and shooting, 75	favorites. See My Menu settings
when to use, 71–75	FE (Flash Exposure) Lock, 3, 166
composition, 178–179	field of view
HDR (High Dynamic Range) images, 152	crop factor, 30
landscapes, 128, 135, 137–138, 144	wide-angle lens, 29
Macro mode, 193	file names, images, review display
panoramas, 148	information, 14–15
zoom lens, 29, 31	fill flash, portraits, 113–114
DR (Dynamic Range) Correction mode, 202–204	filters, neutral density, 63
Drive modes	Fine setting, JPEG formats, 7
Continuous, 92–93	fireworks, 156–157
Single Shot, 92	Fireworks scene mode, 54
Ducas, Dean, 77, 80–81, 89, 97	Fish-eye scene mode, 51
Dynamic Range (DR) Correction mode, 202–204	Flash Exposure Compensation, 165–168
Stores	Flash Exposure (FE) Lock, 3, 166
E	flash photography. See also external flashes
Earth Light Photography/Spellman, Evan, 136, 186	2nd Curtain Sync, 171
Eddings, Bob, 176–177, 182, 184	Auto control, 164
Edwards, Scott, 96	Auto versus Manual output, 164–165
Electronic Level, 130, 217	Built-in, 164–165, 167
environmental portraits, 114–115	Redeye Correction, 169
EV (exposure value), 34	FE (Flash Exposure) Lock, 166
Evaluative metering mode, 106–107, 194	Flash, 2
<u>.</u>	Flash Exposure Compensation, 165–168

flash synchronization, 168	ISO settings
against glass, 170	ambient light, 9
portraits, 204	Auto modes, avoiding, 8, 57
fill flash, 113–114	Exposure Triangle, 35
Slow Synchro control, 164, 170	ISO Dial, 2, 4
Flash white balance setting, 11–12	landscapes, 130–131, 137
FlexiZone AF Frame mode, 9–11	low setting recommendation, 78
Fluorescent/Fluorescent H white balance	low-level lighting, 158–159
setting, 11	P (Program) mode, 64–65
Focus Check reviews, 15, 90	reciprocal exposures
Focus-BKT mode, 200	ISO 100, 36
Foliage scene mode, 53	ISO 200, 37
formatting memory cards, 24–26	review display information, 15
versus erasing data, 26 Low Level Format option, 25–26	stopping motion, 86–87
freezing motion. See action photography	isolating subjects. See action photography
Front Dial, 4	J ···· K
f-stops, 36	
f/8 limit of G12, 40	Jenson, Dave, Photography, 109 Jessey, Jake, 190–191, 196
reciprocal exposures	JPEG (Joint Photographic Experts Group) format
ISO 100, 36	quality settings, 6–8
ISO 200, 37	versus RAW, 26
FUNC./SET (Function/Set) button, 3, 7	RAW + JPEG, 28
Total and the state of the stat	Shadow and DR (Dynamic Range) Correction
G	modes, 202
geometric shapes, 184	jvlphoto.com, 44–45, 48, 116
Gerpe, Michael, 77	j.,p.,,,,,,,,,,,,,,,,,,,,,,,,,,,,,,,,,,
Gervais, Patrick, 68	Kids & Pets scene mode, 48
glass and flashes, 170	Kyriakides, Thespina, 94
Goto, Anthony, 115, 180	
11	Last Control of the C
H	landscape photography
HDMI Out ports, 218–219	Av (Aperture Priority) mode, 71–75
HDR (High Dynamic Range) scene mode, 51	HDR images, 152
landscapes, 150–153	large landscapes, 137
HFD (hyper focal distance), 137–138	waterfalls, 140
high-key/low-key images, 135	composition, 141–142
Highlight Alert, 78, 133	depth, sense of, 144
Histogram display mode, 16–17	rule of thirds, 142–143, 186–187
blinkies, 15, 78, 133	Exposure Compensation, 133–135, 140
review display information, 15	focus
Hobby, David, Strobist blog, 210	DOF (depth of field), 128, 137–138, 144
hot shoes. See external flashes Hunter, Paul, 138	HFD (hyper focal distance), 137–138
hyper focal distance (HFD), 137–138	switching to manual focus, 139
hyper rocal distance (III D), 137–136	tack sharp, 137
No.	HDR (High Dynamic Range) scene mode, 150–153
image compression	high-key and low-key images, 135
Compression setting options, 7	ISO settings, noise, 8–9, 130–131, 137
lossless compression, 26	lighting, sunrise and sunset, 126, 135–136
lossy compression, 6	ND (Neutral Density) filter, 140–141
Image Erase button, 18	panoramas
Image Review button, 3, 90	fake, 145–146
Image Type menu, RAW + JPEG, 28	multi-image, shooting techniques, 148–150
iMovie (Mac), 214	multi-image, sorting shots, 150
IS (image stabilizer), 158, 160–161	multi-image, with Stitch Assist
HDR (High Dynamic Range) scene mode, 51	mode, 146–147
tripods, 129	temperatures, warm and cool, 137

landscape photography, continued	MF (manual focus) mode, 162
tripods, 128, 137	red-eye reduction, 168–169
buying tips, 128	Red-Eye Correction, 169
digital level (built-in) alternative, 130	Red-Eye Lamp, 169
HDR (High Dynamic Range) scene	Self-Timer, 157-158, 161
mode, 150–153	shutter speeds
IS (image stabilizer), 129	Av (Aperture Priority) creative mode, 166
stability of, 128–129	M (Manual) creative mode, 166
switching to manual focus, 139	P (Program) creative mode, 165
water, making fluid, 139–141	Sync options, 171
white balance, 132–133	Tv (Shutter Priority) creative mode, 165
wide-angle lens, 29	tripods, 157–158, 163
Landscape scene mode, 48–49	Lucia III, John Wayne, 54, 154–155, 162
Large (L) JPEG format settings, 7	luminance histograms, 16
LCD screen, 3	Lynch, Jeff, 38, 124-125, 140, 141, 144
battery charge level, 5	2) (2 2)
deleting images, 18	M
Function menu, 7	M (Manual) mode, 75, 77
reviewing images	anticipated action, 90
Focus Check display, 15, 90	auto focus
Playback mode, 14–15	overriding, 13
Quality display, 14–15	switching from, 139
review time settings, 14	exposures, 75
leading lines, 186	external flashes, 207
Legg, Rich, 117	low-level lighting, 156
lens flare, 196–197	panoramas, 148
lens	setting up and shooting, 76
35mm equivalent, 30	when to use, 76
focal length, 28–32	Macro mode, 3, 192–193, 201–202
-	macro photography
Lens (location), 2	Av (Aperture Priority) mode, 71–75
Lewis, Rick, 50	Macro mode, 192–193, 201–202
light meters, M (Manual mode), 76–77	
lightboxes, 208–209	Maisel, Jay, 175
lossless compression, 26	manual focus (MF) button, 3 auto focus
lossy compression, 6	overriding, 13
Low Level Format option, 25–26	
Low Light mode, 54–55, 158	switching from, 139
low-key/high-key images, 135	fireworks, 162
low-level lighting	Manual (M) mode, 75, 77
AF (autofocus) Frame modes, 161–162	anticipated action, 90
AF-assist Beam, 162	auto focus overriding, 13
ambient lighting, 169	3.
Av (Aperture Priority) mode, 163	switching from, 139
flash	exposures, 75
2nd Curtain Sync, 171	external flashes, 207
Auto control, 164	low-level lighting, 156
Auto versus Manual output, 164–165	panoramas, 148
Built-In, 164–165, 167	setting up and shooting, 76
Built-in, Red-Eye Correction, 169	when to use, 76
FE (Flash Exposure) Lock, 166	Medium 1 (M1) and Medium 2 (M2)
Flash Exposure Compensation, 165–168	JPEG format settings, 7
flash synchronization, 168	megapixels
against glass, 170	image resolution, 27
Slow Synchro control, 164, 170	memory card selection, 24
IS (image stabilizer), 158, 160–161	memory
ISO, raising, 158–159	batteries, 5
Low Light mode, 158	internal or buffer, 92
M (Manual) mode, 156, 166	

memory cards	Panning IS (image stabilizer) mode, 161
backups, 6, 24	panoramas
formatting, 24–26	fake, 145–146
versus erasing data, 26	multi-image
Low Level Format option, 25–26	shooting techniques, 148–150
messages	sorting shots, 150
"Cannot read," 6	with Stitch Assist mode, 146–147
"No memory card," 6	patterns, 182–183
SD (Secure Digital)	Paul, Ryan/phenotyp.com, 181, 197
SDHC, for video, 215	Perton, Paul, 174–175, 183
SDHC or SDXC, 24, 49	phenotyp.com/Paul, Ryan, 181, 197
selection criteria, 24	Photomatix Pro, exposure-bracketed images, 152
Menu button, 3	pixels/megapixels, 27
Messersmith, Jan, 126–127, 143	Playback mode, 14–15
Metering Light button, 3, 47, 194	point of view, 181–182
metering modes, 106–107	portrait orientation, 117
Center-Weighted, 107	portrait photography, 102–103
Evaluative, 106–107, 194	AE (Auto Exposure) Lock, 108
review display information, 15	AF (autofocus) Frame, positioning, 108
Spot, 106-107, 194-195	AF-Point Zoom, 109
for sunrises and sunsets, 196	Av (Aperture Priority) mode, 71–75, 104
MF (manual focus) button, 3	black and white, 110
auto focus	camera positioning
overriding, 13	background awareness, 119
switching from, 139	close ups, 122
fireworks, 162	at subject's level, 121
Millan, Manolo, 102–103, 122	vertical (portrait) orientation, 117
Miniature Effect scene mode, 52	composition of subjects
Miniature Effect video mode, 214	cutting off mid-shin or mid-thigh, 119
Mode dial, 2, 4	filling frames, 117
.mov file extension, 219	focusing on eyes, 108–109
Movie Maker, Windows, 214	framing, 119
Movie shooting mode, 215	positioning off center, 116
My Colors setting, 110	spacing between, 120
My Menu settings, 210–211	environmental portraits, 114–115
M	Face Detection focusing, 111–112
N	focal length, 116
ND (Neutral Density) filters	lighting
Video mode, 217	catchlights, 113
water motion, 63, 140–141	fill flash, 113–114
noise, 8–9	flash, 204
ISO settings, 130–131, 137	healthy glows, 120
Sports scene mode, 49	shade instead of direct sunlight, 118
Normal setting, JPEG formats, 7	metering modes, 106–107
Nostalgic scene mode, 51	Center-Weighted, 107
NTSC video format, 214	Evaluative, 106–107
0-P	Spot, 106–107
	nonhuman subjects, 105
On/Off button, 4	Portrait scene mode, 48, 104
D (D)	Smart Shutter scene mode, 50, 104
P (Program) mode	tips, 114–122
versus Safety Shift, 91	Tracking AF mode, 112
selecting ISO, starting points, 65	wide angle lens, 114–115
setting up and shooting, 65	Portrait scene mode, 48, 104
when to use, 64 PAL video format, 214	Poster Effect scene mode, 51
panning, 94	product shots, 208–209

Program (P) mode	Smart Shutter, 50, 104
versus Safety Shift, 91	Snow, 52
selecting ISO, starting points, 65	Sports, 47, 49–50
setting up and shooting, 65	Stitch Assist, 146–147
when to use, 64	Super Vivid, 51
	Underwater, 53
Q	SD (Secure Digital) memory cards, 24
Quality display mode, 14–15	SDHC memory cards, for video, 215
Quick Shot mode, 55–56	SDHC or SDXC memory cards,
white balance, 57	Continuous AF Frame mode, 24, 49
QuickTime for Mac and Windows (Apple), 219	Self-Timer, 3, 157-158, 161
QuickTime for Mac and Windows (Apple), 213	Self-Timer Lamp, 2
R	Video mode, 217
RAW + JPEG mode, 28	semiautomatic mode, 70
memory card selection criteria, 24	Servo AF mode, 91
	Setup menu, Format screen, 25
RAW mode/file format, 7	Shadow Correction mode, 202–204
advantages, 26–27	shadows, fill flash, 113–114
advice, 27–28	Shoot Only IS (image stabilizer) mode, 161
HDR (High Dynamic Range) scene mode,	shooting action. See action photography
landscapes, 150–153	Shortcut button, 3
versus JPEG format, 26	Shutter Priority (Tv) mode, 66
memory card selection criteria, 24	setting up and shooting, 70–71
P (Program) mode, 64	
reasons for not using, 57	shooting action, 86–87 when to use, 67–70, 78
red-eye reduction, 168–169	
Red-Eye Correction, 169	Shutter Release, 2, 4
Red-Eye Lamp, 169	shutter speeds
Red-Eye Reduction Lamp, 2	Exposure Triangle, 35
reflections, 179–180, 187	reciprocal exposures
reviewing images on LCD screen	ISO 100, 36
Focus Check, 90	ISO 200, 37
Playback mode, 14–15	review display information, 15
review time settings, 14	subjects
zooming to check for sharp images, 90	direction of, 84
rule of thirds, 142–143, 186–187	isolating, 88–89
	speed of, 84–85
S	subject-to-camera distance, 85
Safety Shift versus P (Program) mode, 91	Sync options, 171
Safety Zoom, 34	silhouettes, M (Manual) mode, 76–77
Sainz, Oscar, 82–83, 85	Single Shot drive mode, 92
Scene (SCN) modes, 47	Slow Synchro control, 164, 170
Aquarium, 53	Small (S) JPEG format settings, 7
Beach, 52	Smart Shutter scene mode, 50, 104
Color Accent, 51	Smile mode, Smart Shutter scene mode, 50
Color Swap, 51	Snow scene mode, 52
Fireworks, 54	sound, shooting video, 215
Fish-eye, 51	Speedlights. See external flashes
Foliage, 53	Spellman, Evan/Earth Light Photography, 136, 186
HDR (High Dynamic Range), 51	sports photography. See action photography
landscapes, 150–153	Sports scene mode, 47, 49–50
Kids & Pets, 48	Spot metering mode, 106–107, 194–195
Landscape, 48–49	Standard video mode, 214
Miniature Effect, 52	Stark, Morag, 201
Nostalgic, 51	still-life, 208–209
Portrait, 48, 104	Stitch Assist mode, 146–147
Poster Effect, 51	stopping motion. See action photography
reasons for not using, 57	stops. See f-stops
reasons for flot asing, s,	

strobe lights. See external flashes Strobist blog by David Hobby, 210	shooting extra footage, 218 shooting tips, 217–218
"sunny 16" rule, 36	tripods, 217–218
Super Vivid scene mode, 51	watching, 218–219
	viewfinder, Diopter Adjustment dial, 3, 13
T	Voigt, Anneliese, 20–21, 29, 60–61, 69, 73, 87,
tack sharp, 137	95, 187
telephoto lens, 31, 33	VAX
30.5mm lens, 30, 32	W
shutter speed requirements, 85	Ward, Caroline, 118
televisions, viewing video, 218–219	waterfalls/moving water
temperatures. See color temperatures	Av (Aperture Priority) mode, 140
third-party products	Tv (Shutter Priority) mode, 66–71, 78
chargers for batteries, 5	white balance, 11–12. See also color
image recovery, 25	temperatures
Thomas, Chris, 143, 151	adjusting, 12, 132
thumbnail of images, 15	landscapes, 132–133
tilt-shift scene mode. See Miniature Effect	reasons for not using, 57
scene mode	review display information, 15
Time Value mode. See Tv (Shutter Priority) mode	setting, 12
time/date of images, 14–15	Video mode, 217
Tracking AF mode, 47, 112	wide-angle lens
tripods, 137	6.1mm lens, 30
buying tips, 128	field of view, 29, 83
digital level (built-in) alternative, 130	HFD (hyper focal distance), 138
HDR (High Dynamic Range) scene	indoors, 29
mode, 51, 150–153	landscapes, 29, 83
IS (image stabilizer), 129	low position vantage point, 97
low-level lighting, 157–158, 163	panoramas, 145, 147–148
motion blur, 95	portraits, 114–115
stability of, 128–129	wildlife photography
switching to manual focus, 139	Av (Aperture Priority) mode, 71–75
video, shooting, 217–218	portraits, 105
Tungsten white balance setting, 11, 132	Williams, James, 179
Tv (Shutter Priority) mode, 66	Wind Filter audio setting, 215
setting up and shooting, 70–71	Windows Movie Maker, 214
shooting action, 86–87	Wink Self-Timer mode, Smart Shutter scene
when to use, 67–70, 78	mode, 50
TVs, viewing video, 218–219	Wooten, Deak, 49, 129
U-V	X-Z
Uchiyama, Hiroyuki, 62–63, 67	Young, Nicole S., 110
Underwater scene mode, 53	
Underwater white balance setting, 12	Z
g,	Zhao, Wan-Ting, 105
Van Leeuwen, Justin, 44–45, 48, 116	Zino, Simon, 159
video	zoom lens, 28–32
aspect ratio, 8	35mm equivalent, 30
audio, 215	digital zoom, 33–34
capturing, 214	middle range, 30–31
locking	Safety Zoom, 34
exposure level, 216	telephoto, 30–31
focus, 216	wide angle, 29
memory cards, 215	Zoom Lever, 2, 4
quality, 214–215	

Meet Creative Edge.

A new resource of unlimited books, videos and tutorials for creatives from the world's leading experts.

Creative Edge is your one stop for inspiration, answers to technical questions and ways to stay at the top of your game so you can focus on what you do best—being creative.

All for only \$24.99 per month for access—any day any time you need it.

peachpit.com/creativeedge